AMERICAN MODERN

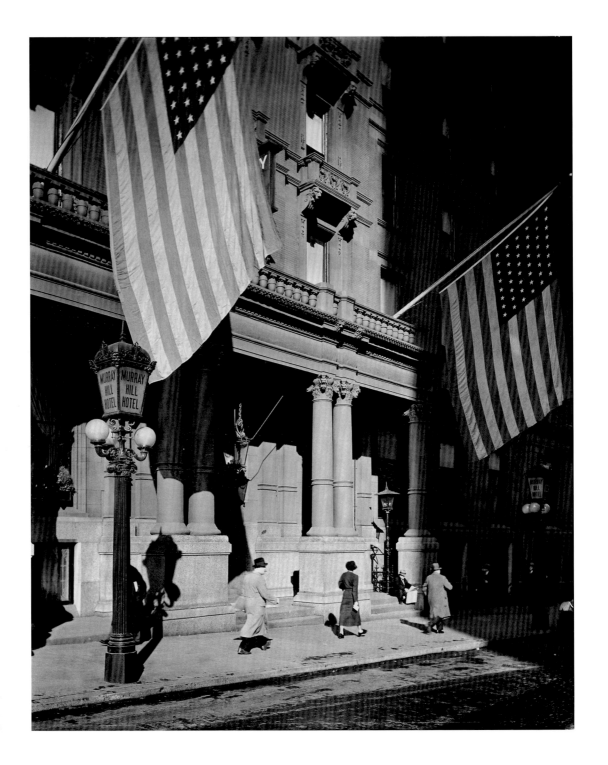

Berenice Abbott,
Murray Hill Hotel, 1935.
Gelatin silver print. Museum
of the City of New York,
40.140.176

SHARON CORWIN

JESSICA MAY

TERRI WEISSMAN

AMERICAN

DOCUMENTARY PHOTOGRAPHY BY ABBOTT, EVANS, AND BOURKE-WHITE

MODERN

UNIVERSITY OF CALIFORNIA PRESS

BERKELEY, LOS ANGELES, LONDON

AMON CARTER MUSEUM

FORT WORTH, TEXAS

COLBY COLLEGE MUSEUM OF ART

WATERVILLE, MAINE

University of California Press, one of the most distinguished university presses in the United States, enriches lives around the world by advancing scholarship in the humanities, social sciences, and natural sciences. Its activities are supported by the UC Press Foundation and by philanthropic contributions from individuals and institutions. For more information, visit www.ucpress.edu.

University of California Press
Berkeley and Los Angeles, California

University of California Press, Ltd.
London, England

Amon Carter Museum
Fort Worth, Texas

Colby College Museum of Art
Waterville, Maine

Published in conjunction with the exhibition *American Modern: Abbott, Evans, Bourke-White,* on view at:

Amon Carter Museum
October 1, 2010–January 2, 2011

The Art Institute of Chicago
February 5–May 15, 2011

Colby College Museum of Art
July 9–October 2, 2011

Photographs by Berenice Abbott on pages 16, 17 (both), 19, 20, and 35–45 are © Berenice Abbott/Commerce Graphics, NYC. Photographs by Berenice Abbott on pages ii (frontispiece), 23, and 46–59 were made for *Changing New York,* funded by the Federal Art Project of the Works Progress Administration and sponsored by the Museum of the City of New York.

Photographs by Walker Evans on pages 63, 66, 71, 74, 75, and 83–107 are © Walker Evans Archive, The Metropolitan Museum of Art.

Photographs by Margaret Bourke-White on pages 111, 114, 133–36, 138–45, and 148–57 are © Estate of Margaret Bourke-White/Licensed by VAGA, New York, NY. Photographs by Margaret Bourke-White on pages 123, 137, 146, and 147 are © Time & Life Pictures/Getty Images.

Additional credit information for plates by Abbott, Evans, and Bourke-White appears in the Exhibition Checklist.

Library of Congress Cataloging-in-Publication Data

Corwin, Sharon.
American modern : documentary photography by Abbott, Evans, and Bourke-White / Sharon Corwin, Jessica May, and Terri Weissman.
 p. cm.
"Published in conjunction with the exhibition on view at Amon Carter Museum, Fort Worth, Tex., and other venues Oct. 1, 2010 to Oct. 2, 2011."
Includes bibliographical references and index.
ISBN 978-0-520-26562-2 (cloth : alk. paper)
 1. Documentary photography—United States—Exhibitions. 2. Abbott, Berenice, 1898–1991—Exhibitions. 3. Evans, Walker, 1903–1975—Exhibitions. 4. Bourke-White, Margaret, 1904–1971—Exhibitions. 5. Modernism (Art)—United States—Exhibitions. 6. Photographers—United States—Biography—Exhibitions. 7. United States—History—1933–1945—Exhibitions. I. May, Jessica, 1977– II. Weissman, Terri, 1969– III. Amon Carter Museum. IV. Title.
TR645.F672A463 2010
770.973—dc22 2010020058

Manufactured in Canada

19 18 17 16 15 14 13 12 11 10
10 9 8 7 6 5 4 3 2 1

The paper used in this publication meets the minimum requirements of ANSI/NISO Z39.48-1992 (R 1997) (*Permanence of Paper*).

CONTENTS

Directors' Foreword vii
SHARON CORWIN AND RON TYLER

Acknowledgments ix

Lenders to the Exhibition xiii

Introduction: Modern Documents I

**Berenice Abbott, Elizabeth McCausland,
and the "Great Democratic Book"** 10
TERRI WEISSMAN

"The Work of an Artist":
Walker Evans's *American Photographs* 60
JESSICA MAY

Constructed Documentary:
Margaret Bourke-White from the Steel Mill to the South 108
SHARON CORWIN

Afterword 158

Chronology 163
ANDREA NELSON

Exhibition Checklist 177

Index 189

As museums dedicated to the collection and display of American art, the Amon Carter Museum and the Colby College Museum of Art are pleased to collaborate on *American Modern: Documentary Photography by Abbott, Evans, and Bourke-White*. The idea for this book and exhibition originated out of discussions between Jessica May and Terri Weissman concerning the nature of documentary photography in the 1930s. That decade, in the grips of the Great Depression, saw photographs move fluidly between the emerging mass media, government-sponsored projects, and institutions of fine art such as museums and commercial galleries. While the practice of documentary photography preceded the 1930s, it emerged as a major strain of American photographic practice at this time. The terms and stakes of the genre were changing; photographers—those featured here, as well as important and influential practitioners in Europe—proposed multiple, sometimes conflicting notions of what a documentary photograph could be. In these pages, the authors propose a close study of documentary photography structured around case studies of three American photographers whose ideas about the genre emerged with particular force over the decade. This catalogue and exhibition consider Berenice Abbott, Walker Evans, and Margaret Bourke-White because, for each, the demands of the commercial realm, the struggles to propose a socially relevant art, and the lure of modernism were influential and operative forces in their work from the late 1920s and 1930s.

Drawing upon these three case studies, *American Modern* offers an anal-

ysis of 1930s American documentary photography through the lenses of commercialism, government patronage, and modernism. While each artist engaged with these terms in different ways, the examination of the three figures together illuminates the capacious nature of documentary photography at this moment. Each moved beyond the tradition of Progressive reform politics that dominated the history of social documentary photography in America, and they took up the formal propositions of modernism, thus pushing the visual terms of documentary photography in decidedly new directions—including vertiginous cityscapes, careful studies of vernacular American architecture, and dramatic views of American industry and labor.

We are grateful to the many lenders to this exhibition, both public and private, for the opportunity to bring together works by these three great American photographers and to offer a glimpse onto this remarkable moment in American history and art. We are further grateful to the National Endowment for the Arts, the Mr. and Mrs. Raymond J. Horowitz Foundation for the Arts, and the Robert Mapplethorpe Foundation for their generous support of this project and to the Art Institute of Chicago for joining us on the exhibition tour.

Sharon Corwin
Carolyn Muzzy Director and Chief Curator
Colby College Museum of Art

Ron Tyler
Director, Amon Carter Museum

ACKNOWLEDGMENTS

The three case studies that frame this exhibition and catalogue are drawn from our doctoral research on Margaret Bourke-White, Walker Evans, and Berenice Abbott, respectively, and we are deeply grateful to our dissertation advisors: Anne Middleton Wagner, Margaretta M. Lovell, and Benjamin H. D. Buchloh. The opportunity to bring these three photographers' work together—in a dialogue around the status of documentary photography in the 1930s—has been a true pleasure, and we are profoundly grateful to our own institutions and their staff for making the exhibition possible.

At the Colby College Museum of Art, special thanks go to Erin Beasly, curatorial intern; Marci Bernard, director of corporate and foundation relations; Hannah Blunt, curatorial assistant; Kimberly Bentley, Betterment Fund education coordinator; Elizabeth Finch, Lunder Curator of American Art; Julianne Gilland, editor; Stew Henderson, preparator; Marty Kelly, visual resource librarian; Patricia King, assistant director for administration and collections management; Lauren Lessing, Mirken Curator of Education; Uri Lessing, research assistant; Isabelle Smeall, Anne Lunder Leland Curatorial Fellow; Darcy Van Buskirk, research assistant at Syracuse University; Karen Wickman, administrative secretary; Greg Williams, assistant director for operations; and to Joseph N. Newland of Q.E.D., editor. The support of President William D. Adams, Board Chair Barbara L. Alfond, and the museum's board of governors is also greatly appreciated.

At the Amon Carter Museum, we wish to thank Ruth Carter Stevenson, chair of the board of trustees, and the museum's board, for their gracious

support of this exhibition. Our gratitude extends to the museum staff who worked to make this exhibition possible: Director Ron Tyler, Chief Operating Officer Lori Eklund; Chief Financial Officer Randy Ray; Rebecca Lawton, curator of painting and sculpture; Jane Myers, senior curator of prints and drawings; John Rohrbach, senior curator of photographs; Rick Stewart, senior curator of Western art; Sylvie Penichon, photographs conservator; Pam Graham, outreach division coordinator; Marci Driggers Caslin, exhibition coordinator; Carol Noel, director of development; Coy Fagras, grants writer; Will Gillham, director of publications; Elizabeth LeConey, publications coordinator; Lorraine Bryda and Trang Nguyen, designers; Samuel Duncan, director of the library; Mary Jane Harbison, library technician; Jonathan Frembling, museum archivist; Melissa Thompson, registrar; Jana Hill, associate registrar; Lacey Imbert, assistant registrar; Steve Watson and Rynda Lemke, museum photographers; Jim Belknap, director of installation services; Greg Bauer, lead preparator; Steve Price, preparator; Les Hofheinz, preparator and carpenter; Stacy Fuller, head of education; and Brady Sloane, public programs manager. Our former colleague, Wendy Haynes, helped get the exhibition off the ground.

At the University of Illinois, Urbana-Champaign, we wish to thank the Research Board for providing their generous support, and Dave Thomas and Amalia Pursell for their research assistance. Jane Goldberg and Diana Zion in the slide library also provided invaluable support. At the Phillips Collection Center for the Study of Modern Art, a collaboration between the University of Illinois at Urbana-Champaign and the Phillips Collec-

tion, we are grateful to the director of the center and the museum, Dorothy Kosinski; the director of Illinois at the Phillips, Jonathan Fineberg; and the associate director, Ruth Perlin. Research assistance from Phillips Collection librarians Karen Schneider and Sarah Bender was invaluable. And finally, Kathleen Pyne, at the University of Notre Dame, deserves a special note of gratitude for her support and advice, as does Denise Massa, slide curator at the University of Notre Dame's Art Image Library.

Our thanks also go to Andrea Nelson for her thorough chronology, which reveals the many intersections between these three photographers. At University of California Press, we want to acknowledge Stephanie Fay, Elizabeth Berg, Sue Heinemann, and Eric Schmidt for their guidance and support of this volume. We are also indebted to the anonymous readers who gave our manuscript their careful attention.

We are extremely grateful to the many lenders to this exhibition and their representatives, including Allison N. Kemmerer, Addison Gallery of American Art; Liza Kirwin and Marisa Burgoin, Archives of American Art; Matthew S. Witkovsky, Katherine Bussard, Michal Raz-Russo, and Newell Smith, Art Institute of Chicago; Clare Rogan, Davis Art Center, Wesleyan University; Karen Hellman and Judith Keller, J. Paul Getty Museum; John Tain, Getty Research Institute; Julian Cox, High Museum of Art; Roger Kingston; Norma Marin; Gary Davis; Malcolm Daniel, Meredith Friedman, Lucy von Brachel, and Jeff L. Rosenheim, Metropolitan Museum of Art; Sean Corcoran and Melanie Bower, Museum of the City of New York; Eva Respini, Dan Leers, and Leslie J. Ureña, Museum of Modern Art,

New York; Sarah Greenough and Sarah Kennel, National Gallery of Art, Washington, D.C.; Stephen Pinson and David Lowe, New York Public Library; Russell L. Martin III and Cynthia Franco, DeGolyer Library, Southern Methodist University; Linda Briscoe Myers and David Coleman, Harry Ransom Humanities Research Center, University of Texas, Austin; Nicolette Dobrowolski, Special Collections Research Center, Syracuse University; David Acton, Worcester Museum of Art; Natalie Evans and Ronald A. Kurtz, Commerce Graphics; Karen Marks and Howard Greenberg, Howard Greenberg Gallery; Whitney Bradshaw, Bank of America; and Laura Humphries and Cat Celebrezze.

Finally, projects of this scope require funding, and for major project support we are indebted to the National Endowment for the Arts, the Mr. and Mrs. Raymond J. Horowitz Foundation for the Arts, and the Robert Mapplethorpe Foundation. Local support has been generously provided by the Maine Arts Commission (Colby venue) and the Terra Foundation for American Art (Chicago venue). In addition to funding, a crucial form of support that institutions offer one another is a willingness to add an exhibition to their own calendars and thus share it with their audiences. We are grateful to James Cuno, president and Eloise W. Martin Director of the Art Institute of Chicago, and to Matthew S. Witkovsky, curator and chair of the museum's Department of Photographs, for their gracious embrace of this exhibition.

LENDERS TO THE EXHIBITION

Addison Gallery of American Art, Andover, Massachusetts

Amon Carter Museum, Fort Worth, Texas

Archives of American Art, Washington, D.C.

The Art Institute of Chicago, Chicago

Bank of America

Colby College Museum of Art, Waterville, Maine

Commerce Graphics, New York

Davison Art Center, Wesleyan University, Middletown, Connecticut

DeGolyer Library, Southern Methodist University, Dallas, Texas

Gary Davis Collection

Harry Ransom Humanities Research Center, University of Texas, Austin

High Museum of Art, Atlanta, Georgia

Howard Greenberg Gallery, New York

The J. Paul Getty Museum, Los Angeles

Roger Kingston

Norma B. Marin

The Metropolitan Museum of Art, New York

Museum of the City of New York, New York

The Museum of Modern Art, New York

National Gallery of Art, Washington, D.C.

New York Public Library, New York

Syracuse University Library, Syracuse, New York

Worcester Art Museum, Worcester, Massachusetts

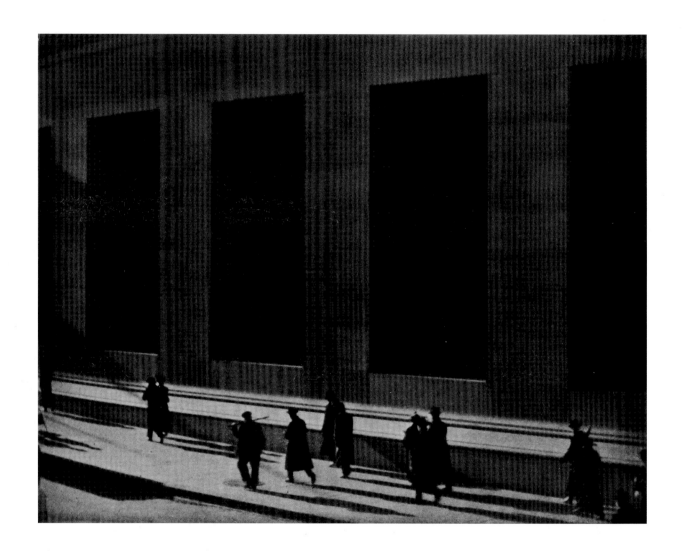

Paul Strand, *New York*, 1916. Photogravure, reproduced in *Camera Work* 48.
Amon Carter Museum, Fort Worth, Texas, P2005.33.23.

Introduction: Modern Documents

In November 1935 Berenice Abbott (1898–1991) stood on Park Avenue and photographed a stream of people in front of New York City's once-grand Murray Hill Hotel (see frontispiece). The fading 1884 hotel was festooned with American flags, and Abbott's photograph of its columned façade immediately calls to mind Paul Strand's *New York,* an autumn 1916 photograph of anonymous passersby in front of the severely geometric J. P. Morgan building at 23 Wall Street. Deep shadows and an oblique perspective structure the compositions of both photographs, and Abbott's later work offers a knowing wink toward Strand's achievement at marrying the bustle of street life with urban infrastructure. Still, Abbott's *Murray Hill Hotel* is its own animal: shot from street level, four pedestrians in professional attire walk past the hotel. Represented as an integral part of the city, they are also rendered anonymous by it: one figure, for instance, is partially eclipsed by the hotel's fancy streetlamp, while another sits on the edge of the hotel steps reading the newspaper. Together, these figures and the scene around them provide a vivid reminder of the economic crisis that dominated everyday life in 1935. Overall, Abbott's photograph eschewed the geometric formality of Strand, her modernist predecessor, in favor of an immediate response to urban life during a period of extraordinary change—New York City was modernizing amid the Great Depression.

The details in Abbott's *Murray Hill Hotel* add up to a story about everyday life within a modern metropolis—life caught between the architectural forms and economic forces of history and a dynamic, even rocky, present. Although she was informed by a tradition of photographic modernism, this photograph reveals Abbott as an image-maker seeking a way to communicate the social, economic, and infrastructural conditions that govern everyday culture. This type of photographic practice, which Abbott and her peers embraced in the 1930s, is broadly identified as documentary, and it distinguished itself from earlier ideas of photographic modernism in that it privileged the immediate, the transitory, and the urgent over more traditional ideals of beauty and timelessness. Further, energized by their engagement with a broad field of visual practices, this group of artists—these new documentarians—also sought new audiences for their work, which brought photographic imagery to a wider and more diverse viewing public.

In this publication and accompanying exhibition, we focus on three American photographers in the 1930s, Abbott, Walker Evans (1903–1975), and Margaret Bourke-White (1906–1971), and tell the story of how they established new documentary practices that balanced political, popular, and modernist impulses. In so doing, we seek to probe the term *documentary* as it was understood during America's

Great Depression and to explore the capaciousness of the genre and the diversity of ideas it engendered. Organized around the historical experiences of Abbott, Evans, and Bourke-White, three important twentieth-century photographers, *American Modern* reveals how documentary practice developed in relation to modern visual vocabularies, how it operated across mass media and new institutions of fine art, and how, through its dual emphasis on the everyday scenes of urban growth and vernacular culture, it acquired a distinctly American voice.

Abbott, Evans, and Bourke-White were not the only successful or dynamic American documentary photographers during this period, nor did they form close, consistent relationships with one another. They are brought together here not because of personal bonds that join them biographically but because the legacy of each career defines an aspect of the genre of documentary photography and, paradoxically, challenges its parameters. In other words, each photographer contributed a fundamental, independent, and novel idea about documentary to the common pool of artistic practice: for Abbott, it was the notion that photography was a means of critical dialogue and communication; Evans thoroughly investigated the idea that photography has a unique and essential relationship to time; and Bourke-White developed a repertoire wherein documentary could fuse the logic and pageantry of modern industry with drama and the individual narratives of its subjects. Although these ideas have become crucial to the practice of documentary as it extends to the present, they do not dominate our quotidian characterizations of the medium of photography or the genre of documentary, which tend to rely upon an interrogation of what is pictured rather than a study of how the picture works. However, as the essays in this volume attest, all three are central to understanding the meaning and look of docu-

mentary photography in the 1930s, as well as to how that term is understood today.

Taken together, then, the early careers of Abbott, Evans, and Bourke-White distill key narratives of their generation. Each invented a photographic practice while navigating a multitude of forces, including the boon of government sponsorship, the rise of the mass media, the emergence of museums dedicated to modern art, and new technologies and theories of photography. Empowered by a cultural largesse that embraced photography as an integral part of a modernizing society, they had real latitude in how and what to photograph, and so maneuvering around such diversity was often frictionless. In some instances, however, the process was difficult and led to painful rejection and misunderstood intentions, as was often the case when their projects failed to come to fruition or to command sustained critical attention. Although these three photographers had very different career arcs, the essays in this catalogue demonstrate both the lasting contributions made by each artist and the aspects of their legacies that have been historically overlooked, derided by their contemporaries, or overshadowed by other projects.

The 1930s were undoubtedly the golden age of American documentary photography, as well as a very rich period in the development of photographic history in general. As the United States and much of the modern world struggled with an economic depression that was inaugurated (symbolically at least) by massive drops in the U.S. stock market on October 24 and 29, 1929, and deepened through the following years, photographic activity flourished in America, and the genre of documentary emerged as a mode of understanding contemporary culture. Perhaps this was to be expected, as Americans had embraced cameras and photography with energy and enthusiasm from the very start of its then almost one-hundred-year history. By the

early 1920s, American photographic practice was diverse but divided, and there were few substantial points of connection between artist-photographers and the rising wave of amateurs who took advantage of increasingly easy-to-use cameras to record their lives, families, and communities. Advertising and other commercial photography gained traction in public culture, but the tradition of social documentary photography, most commonly associated with the work of Jacob Riis and Lewis Hine, was an increasingly marginalized practice, predominantly linked to Progressive reform politics.

Documentary photography emerged as a named genre in the 1930s because an entire generation of young photographers embraced and reinvented it, but its central tenets were already a distinct part of the American photographic tradition.[1] At its most basic, the practice of documentary merged two ideas of what photographs can do: first, they can provide an image of a social fact that is far away or otherwise hidden from view; and second, they can reflect and document a social investigation—which most often involved the vexed issues of class, labor, race, and ethnicity. Hence, two key early practitioners—Riis and Hine—both used photography to expose forms of economic disparity. Riis took photographs of the impoverished immigrants of New York City's Lower East Side, and Hine made photographs of the labor conditions of miners and factory workers, often children, in western Pennsylvania and elsewhere. Despite dramatic differences in the two men's temperaments and their individual goals, both essentially made photographs that dealt with the social and material circumstances of the poor and the working classes, and both appealed to predominantly white, middle-class audiences with reformist sympathies.

Between the 1890s and the first decades of the twentieth century, however, the practice that we now identify as social documentary was thrown into relief by the first wave of American art photography, Pictorialism. That movement, influenced and given public voice by Alfred Stieglitz, steadily emerged as the most intellectually prestigious manifestation of photography in America and essentially cleaved the record-making role of photography from its expressive potential. Although Pictorialism, with its predominantly domestic subjects, soft focus, and fine printing techniques, had become less prominent in advanced circles by the mid-1910s (largely as a result of Stieglitz's renunciation of the practice in favor of an unretouched, sharp-focus, and largely unmediated practice that he referred to as "straight photography"), the idea that photography could rub shoulders with the traditional hierarchy of artistic media permanently transformed the medium. With this emerging model of art photography, preexisting traditions of photographic practice, such as the work of Riis and Hine, were largely occluded.[2]

While myriad conflicts about photography's proper form and shape took place within a relatively small community of dedicated art photographers, photographs became more and more ubiquitous in everyday life as the first decades of the twentieth century progressed. Americans increasingly saw them reproduced in their daily newspapers, and by the end of the 1930s magazines had thoroughly incorporated photography into their editorial and advertising programs and hired professional photographers onto their staffs. *Fortune* magazine, launched in 1929, set new standards for the use of photographs in magazines, and its success proved a bellwether for the fortunes of publisher Henry Luce's magazine empire (which would also include *Life* and *Time*). Because of this bounty of demand, American photographers increasingly found work making advertisements and corporate promotional materials. These new

public outlets for photographic work meant that there were more professional opportunities than ever before, which was appealing to young photographers eager to make a living. For instance, already by 1929 Margaret Bourke-White had seized the new market for her industrial photographs. As Sharon Corwin demonstrates in her essay in this volume, the young Bourke-White's first forays into industrial photography at Cleveland's Otis Steel Mills proved a professional catalyst for her but also yielded a template for the major social and formal issues that her practice would engage throughout the ensuing decade: massive scale, repetition of forms, and a focus on the place of laborers within industrial capitalism.

The explosion of photography in the mass media in the 1930s was matched by a corresponding expansion of different kinds of photographs that were suitable for display in public spaces, including art exhibitions. In New York alone, commercial galleries hosted dozens of exhibitions of photographs by young, previously unknown photographers—often including Abbott, Evans, and Bourke-White (who first showed together not in New York but in Cambridge, Massachusetts, in 1930, at an exhibition sponsored by the Harvard Society for Contemporary Art). Museums, in particular New York's Museum of Modern Art (MoMA; founded in 1929), also furthered this trend. All kinds of photographs seemed to be on view: portraiture and urban landscapes as well as photographs that were literally pulled from newspapers and magazines, advertisements, aerial photographs and x-rays, industrial scenes, and even European-influenced photomontage. Walker Evans in particular found the changing relationship between photography and the art museum promising as a means of stabilizing the labor of photography, and in an essay on Evans's 1938 exhibition at MoMA, *American Photographs,* Jessica May notes that he made an aggressive, and still controversial, professional claim for the artistic status of photography.

Viewers and young photographers also became interested in historical photographs, such as those by Mathew Brady, the nineteenth-century American portraitist and Civil War photographer, and the Parisian photographer Eugène Atget. Many embraced the work of Brady and his associates because it provided a specifically American example of early documentary practice and allowed artists to claim a connection to an established, if discontinuous, national tradition. Carving out such a relationship to America's own traditions was especially important for Abbott, who by the very end of the 1920s had begun to distance herself from the European modernism with which she had been previously associated. Abbott spent most of the 1920s in Paris; during her time there, she bought, with the assistance of American art dealer Julien Levy, Atget's archive of prints and negatives. Atget's photographs of Paris from the turn of the century through the early 1920s documented the banality and elegance of the city in exhaustive detail. His archive provided a powerful formal impetus for Abbott, whose photographs of New York City during the 1930s reveal her consistent dialogue with the deceased Frenchman. But while Abbott functioned as Atget's chief champion—she carefully maintained his archive (until selling it to MoMA in 1968), wrote articles about him, and made sure his work was regularly included in exhibitions on modern photography—her exposure to and pursuant interest in Brady was transformative. Once Abbott discovered Brady's collection at the War Department in Washington, D.C., she embraced his example as evidence of an early American documentary tradition and sought to position herself in such a lineage. Similarly, other young photographers, particularly Walker Evans, were inspired both by the American Brady and by

the European Atget, whose straightforward, formally clever photographs focused on elements from everyday life. These images remained a crucial forerunner to Evans's own approach.

Other Europeans also had an outsized role in the expansion of American photography during the 1930s. Bourke-White visited the Soviet Union as early as 1930 and returned twice in consecutive years, and the formal character of her work resonates with Russian Constructivist photography and film with its repetitive industrial and urban subjects shot from dizzying perspectives. In western Europe as well as the USSR, journals and book publishers presented new theories of the relationship between photography and mass culture; photography and the graphic arts; and photography and modernism. The new theoretical models differed widely, but they shared a general orientation toward the photograph as a medium that could engage mass culture directly by means of its reproducibility and its immediate relationship to everyday life.[3] The special nature of photography was put under close investigation as a potentially revolutionary art form. Thus Abbott, upon her return to the United States after nearly a decade in Paris, had sophisticated insight into the dynamic possibilities for photographic work that would challenge the fragile hierarchy of high and low in American photography and art. As Terri Weissman demonstrates in her essay on Abbott, questions about the very nature of photography and realism, including how photographs communicate with their audiences and how the medium could represent the dynamic nature of society, were crucial to her practice. Interestingly, like many other artists and writers of her generation, Abbott returned from Europe with the specific desire to describe the American cultural landscape, or what the historian Robert Taft, after novelist Henry James, called "the American scene."[4]

Nearly simultaneously, our three subjects found their footing as photographers in New York: Evans in 1928–29, Abbott in 1929, and Bourke-White in 1929–30. The timing was both good and bad. Although in New York, the early 1930s was an exhilarating time for young photographers due to both the relative stability of the publishing industry and openness in the art world, years of economic decline followed the stock market crash, and high joblessness and poverty rates were inescapable aspects of everyday life. The Depression and its many effects became central to these photographers' repertoire of subjects, both in and beyond the city. In November 1932, Franklin Delano Roosevelt won the presidency and promised to change the course of the Depression and reinvigorate American economic life. After taking office the following spring, Roosevelt immediately established the New Deal, a massive government program whose core idea was that the federal government could be a source of economic stimulation through development and infrastructure building, regulation, and direct relief to citizens. Senior administrators of the New Deal government, including Rexford Tugwell, head of the agricultural unit called the Resettlement Administration (RA, later called the Farm Security Administration, FSA), built their programs on the theories of the Progressive reform movement: they posited that rational, centralized reorganization of the nation's macro- and micro-economic entities—everything from banks to farms—was the key to modernizing and strengthening the American economy.

By 1935, the first federally funded programs to support artists, including painters and sculptors, theater professionals, writers, and photographers, got underway. By the end of the year, Abbott and Evans both worked for federal agencies, Abbott for the Federal Art Project (FAP) and Evans for the RA.[5] The federal government's art projects

occupied a small part of the larger relief programs, but they were a lightning rod for public and congressional criticism of the entire New Deal project as expensive and superfluous. Perhaps for this reason, one of the main responsibilities shouldered by the photographers on the project was literally to document the work of the different agencies for publicity purposes; thousands of photographs recorded bridge building, road construction, the opening of new post offices, agricultural conservation initiatives, and the like. Thus federally funded photography had two main practical and ideological debts: first, to an older model of social documentary which posited that Progressive reformers could make use of the information in a candid documentary photograph to persuade those in power of the urgency of reform; and second, to commercial photography, which reached, and undoubtedly influenced, vast audiences through newspaper and magazine distribution.

Both Abbott and Evans maintained a distance from their respective agencies' broad ideological programs, and that distance (augmented by their established reputations) translated into real latitude in the field. As a result, both were able to consistently focus their energies on developing techniques to encode the image of a changing society into their photographic practices. Although they did so separately, both photographers, and Bourke-White, too, recognized that within the crisis of the Depression was the ferment of social transformation. These practitioners mined and expanded the genre with their sophisticated toolboxes of modern art and the tactics of mass media in order to make sense of that transformation. In doing so, they combined different photographic traditions—both historical and contemporary—and thus, against the backdrop of federal patronage, documentary was self-consciously reinvented as a modern genre.

The essays and this exhibition attest to the fact that while these young photographers drew from an emerging and international dialogue about photography, they articulated their own versions of a distinctly American modern—one tied to the social circumstances of a country simultaneously experiencing the modernization of city and factory alongside the social effects of economic collapse. In short, Abbott, Evans, and Bourke-White took the lessons of American and European modernism and developed their own iterations of a modernist program. While they ultimately did not share a definition of what constituted a documentary photograph, each believed that using the camera to record the ordinary dramas of the world could provide enough material to sustain a complex, energized, and intellectually sophisticated photographic practice.

Of course, what their precise standards of documentary were and how they communicated these standards differed: for Abbott the proper goal of a documentary photograph was not only to record social fact but also to produce social *interaction;* for Bourke-White, documentary photography offered an opportunity to organize the subjects of industrial America, as well as the landscapes and inhabitants of the Great Depression, into modernist tableaux of repetition, theatrical angles, and often dramatic narratives; and for Evans, the goal was primarily a formal one: a composed picture that recorded social fact, suspended in time. At stake in their differences was the question of how photographs would function in society and be used by cultural institutions, such as modern art museums, magazines, newspapers, and popular exhibitions. From the distance of our current era, one unifying characteristic of their work is that it has come to represent not just the specificity of individual subjects but the 1930s in general. Indeed, part of the appeal of documentary photographs from the 1930s

is that they seem to have recorded and preserved the singular events portrayed in each image, as well as a larger national or cultural memory of the Depression.

Perhaps the centrality of documentary in Americans' broad cultural memory is what accounts for the surge of interest and energy in the genre in recent decades, but the essays in this volume take as a given that the precise nature of documentary practice was subject to debate in the 1930s because the genre developed in active dialogue with the very patrons who had a stake in its outcome, including the federal government and magazines such as *Fortune* and *Life.* Young photographers, including Abbott, Evans, and Bourke-White, willingly worked for these institutions because they provided regular and dependable commissions, yet their missions were often at cross-purposes with those of their employers as well as one another. The situation was inevitably complicated by the fact that when photographers worked on commission, the photographs they produced (and the right to reprint them in new contexts or suppress them altogether) belonged to their employers. Letters documenting conflict over the use of and rights to photographs between Evans and his supervisor at the RA, Roy Stryker, between Bourke-White and the editors of *Fortune,* and between Abbott and the publisher of her photo-book *Changing New York* attest to the ways in which the seemingly mundane issue of ownership often translated into a contest over authorship.

These conflicts reveal that increasingly through the 1930s both commissioning agencies and individual photographers claimed the mantle of documentary as their own—often at the expense of one another. In retrospect, the genre was sufficiently expansive that photographic projects as distinct as Bourke-White's *Fortune* stories on industrial America, Walker Evans's portraits of southern tenant farmers, and Abbott's images of the modernizing city comfortably share the designation, but the photographers were not always peaceful in their approach to each other or to their patrons, and the essays in this volume trace several moments when photographers and administrators drew the line between "correct" documentary practice and what they considered its opposite. Thus, to ensure professional success and maintain authority over their work, Abbott, Evans, and Bourke-White were forced to navigate the contradictions of documentary practice. Each was mostly successful—for instance, by working for government-sponsored programs without wholly identifying with their goals, or by producing photographs for picture magazines while continuing to pursue noncommercial projects. Nevertheless, as they challenged the distinctions that would seem to guarantee one's understanding of an image and its meaning and function in society, Abbott, Evans, and Bourke-White all experienced irresolvable moments of tension: Abbott struggled to find funding for her book projects; Evans's repeated conflict with Stryker contributed to his dismissal from the RA in 1937; and editors at *Fortune* discouraged Bourke-White's inquiries into labor and its human face in the mid-1930s, which prompted her to pursue independent projects, such as *You Have Seen Their Faces* (1937), her collaborative book project with the writer Erskine Caldwell.

A final significant thread that connects these three figures is their use of the photo-book as a mode through which to conceptualize and distribute their photographic projects. Abbott, Evans, and Bourke-White all produced important books during the 1930s. Though they were hardly alone in this regard, our photographer subjects all sought to give their work narrative arcs that extended beyond the individual image into a play between carefully scripted clusters of images, as the essays in this volume recount. Bourke-White's *You Have Seen Their Faces* was re-

leased in 1937; Evans's exhibition catalogue *American Photographs* came out in 1938 (and *Let Us Now Praise Famous Men*, Evans's collaboration with James Agee, came out in 1941); and Abbott's *Changing New York* was published in 1939. (Evans and Bourke-White both made documentary films as well, though neither seriously pursued the medium.) As Weissman points out, the mid- to late 1930s were a heyday of such photo-books, and photographers and writers alike mined the relationship between words and image sequences in their efforts to describe contemporary culture and to narrate the social and cultural effects of the Great Depression.

Importantly, their book projects as well as their deep connections to the larger web of mass media and modern art institutions kept these photographers anchored in New York City, which was, then as now, the center of American publishing and America's arts economy. This fact seems counter to the cultural memory of documentary photography in the 1930s, as a large percentage of the commissioned documentary work during the 1930s was executed in rural areas, mostly because of the importance of the RA/FSA within the constellation of New Deal projects. (Indeed, one particularly notable story told by 1930s photography is of the mechanization of the agricultural landscapes of the American West, Midwest, and South.) As a consequence of this dominance, the centrality of urban areas, and especially New York, has been relatively underexamined. Perhaps regrettably, this catalogue does not address the role of other cities in the development of documentary in the 1930s, but it does make the case that New York played a crucial role in the genre's development. Abbott, Evans, and Bourke-White all worked in the city as well as the country, a fact that helps explain why documentary's reinvigoration during the 1930s was indebted to urbanity and modernization from the start. Further, as

a new generation of museum leaders, art collectors, critics, and gallery owners expressed interest in documentary photography, images that focused on previously debased subjects—such as industry, labor, and poverty—were suddenly as likely to be hung on a wall in a modern art gallery or museum as reproduced in illustrated dailies. For instance, the key museum project of the decade, Beaumont Newhall's massive 1937 exhibition at MoMA, *Photography, 1839–1937,* exemplified the new comprehensive and historical view of photography; the exhibition included not only art photographs but also advertisements, science photographs, reportage, and documentary. The sheer diversity of the photographic objects found in the exhibition signaled a sea change, making it clear that the traditional order of American photographers faced marginalization as a younger generation embraced media and reproduction, and showed considerably more flexibility about the proper goals of photography.

Newhall's inclusion of work from social and technological fields, in addition to aesthetic realms, was not wholeheartedly accepted by critics, and their questions laid bare the field's unstable new hierarchy (or lack thereof). Lewis Mumford, for instance, complained in the *New Yorker* that Newhall's exhibition was indistinguishable from a science museum.[6] For photographers, however, this instability proved productive, as it allowed them to slip in and out of categories and to draw on a broad range of sources, undermining the very idea of a categorical distinction between art and function in photography. Of course, a countermovement was already afoot as Evans presented his exhibition of documentary photographs as a fresh model of decidedly artistic production; this movement would have radical implications for Abbott, who found it harder and harder to exhibit her work in museums. Thus the exuberance of the moment was short lived: as the 1930s and the

Depression gave way to the United States' entry into World War II, the radical promise of documentary was inexorably transformed into history. With that transformation, all three photographers moved on to something new: Abbott began a major project of scientific inquiry, increasingly focusing her work on developing new techniques for observing scientific phenomena; Evans literally went underground, spending the final years of the 1930s and the early 1940s making photographs of subway passengers in New York City; and Bourke-White covered the war extensively in Europe, refining her reportage skills and embodying the model of the modern photojournalist.

American Modern presents case studies of these three photographers at a very special moment in their careers—each was young and highly ambitious and created a significant body of work within just a few overlapping years. Although their careers would diverge completely in the following decades, the juxtaposition of their independent trajectories through the 1930s offers access to a rich and complex moment in the history of photography. The narrative of this catalogue, like all historical accounts, leaves many tales untold and contingencies unexplored. Yet it is driven by the core goal of looking carefully at a brief period in which the idea of documentary, the institutionalization of modern art, and the rapid expansion of photography in mass media all took root, intertwined, and flourished.

Notes

1. For a substantive account of the concept of documentary in the 1930s, see Sarah M. Miller, "Inventing 'Documentary' in American Photography, 1930–1945" (Ph.D. diss., University of Chicago, 2009). For the history of the social documentary tradition in America up to and beyond the 1930s, see Maren Stange, *Symbols of Ideal Life: Social Documentary Photography in America, 1890–1950* (New York: Cambridge University Press, 1989). For a general history of 1930s photography, see John Raeburn, *A Staggering Revolution: A Cultural History of Thirties Photography* (Urbana: University of Illinois Press, 2006).

2. Hine struggled to make a living through the 1930s, and Riis's work had fallen into deep obscurity. On Riis's obscurity in the 1930s, see Bonnie Yochelson, "What Are the Photographs of Jacob Riis?" *Culturefront* 3, no. 3 (Fall 1994): 28–38.

3. For a concise overview of the intellectual development of

photography in Europe in the early twentieth century, see the introduction to Christopher Phillips, ed., *Photography in the Modern Era: European Documents and Critical Writings, 1915–1940* (New York: Metropolitan Museum of Art in association with Aperture, 1989).

4. In 1938 Robert Taft published *Photography and the American Scene: A Social History, 1839–1889* (New York: Macmillan, 1938). His title was based on Henry James's 1907 book, *The American Scene.*

5. Evans was fired from the agency in 1937, just as its name was changed from RA to FSA, so in this volume readers will note that Evans worked for the RA, but the agency itself is referred to as the RA/FSA.

6. Lewis Mumford, "The Art Galleries," *New Yorker,* April 3, 1937, p. 67, cited by Andrea Nelson, "Reading Photobooks: Narrative Montage and the Construction of Modern Visual Literacy" (Ph.D. diss., University of Minnesota, 2007), 151.

TERRI WEISSMAN

Berenice Abbott, Elizabeth McCausland, and the "Great Democratic Book"

Between 1936 and 1941 American photographers, in collaboration with writers, critics, poets, and social scientists, produced an enormous number of photo-books, or what more specifically might be called photo-textual documentaries.[1] As seeming testament to the genre's success and lasting legacy, many of the images presented in this catalogue first appeared or at some point were reproduced in such photo-book contexts. Tremendously popular, these books combined sequences of images with text of varying lengths and styles, and sought to present their readers and viewers with an argument about the American experience. The types of arguments put forth were wide-ranging, though many focused on the devastating economic effects of the Great Depression, including the mass migrations caused by dramatic changes in agricultural conditions, changing race relations, and the growth and transformation in the country's urban centers.

Although a range of photographers produced photo-books in the 1930s, here I want to focus on two by Berenice Abbott and her collaborator, Elizabeth McCausland. One of these books, designed as a portrait of the nation, never received enough financial or institutional support to make it to production; the other, Abbott's best-known work, *Changing New York,* focuses on New York City's shifting landscape.

Like many photo-books from the era, Abbott and McCausland's reflects on the transformation of American society from one based in local economies to one dependent on mass consumption and (wittingly or not) on the institutionalization of documentary photography as a style embraced by museums and distinct from other popular forms of photography, such as the images that filled the pages of new picture magazines, including Henry Luce's hugely successful *Life* magazine.[2] Abbott and McCausland's unfinished project provides particular insight here. The *inability* of the text to attract support at a time when both publishers and the public enthusiastically embraced its form and subject matter suggests it differed from its peers in some critical if subtle way. What was the nature of this difference? And what can it tell us about the methods that photo-books used to communicate or about their intended messages? In general, what sets Abbott's projects apart from those of her contemporaries, including Walker Evans and Margaret Bourke-White, was her simultaneous commitment to documentary, modernism, and realist aesthetics.

Abbott (and McCausland) used the words *realism, real-life,* and *reality* frequently—and sometimes idiosyncratically; in fact, to Abbott the terms often meant different things at different times. At one moment *realism* might refer

10

straightforwardly to the photograph's visual accessibility—its easy-to-read-ness. At another moment it might reference the state of the union: the economy, war, the Depression, that is, the timely content of the image. At still another point, *realism* might point to advances in science and technology, where the speed of the telegraph, radio, or telephone found its visual counterpart in the speed of lenses, shutters, and films.[3] However, despite these quirky fluctuations, Abbott's idea of a realist image did possess certain unvarying characteristics, such as an emphasis on the relationship of photography to history and an orientation toward a communicatively directed practice. The image's communicative role was especially important to Abbott: she conceived pictures not as one-way messages but as participants in a dialogue, and, correspondingly, she expected her viewers to question—and act on—their own perceptions. This forms the heart of Abbott's realist aesthetic. Rather than distinguish between the socially and communicatively oriented and the modern, or the documentary and the realist, or the realist and the avant-garde, Abbott hoped to eliminate these boundaries. Indeed, for Abbot such a synthesis constituted the great potential meaning behind the words *American Modern.*

In 1929 Abbott planned to travel from Paris, where she had established herself as one of the most important portraitists of the artistic and literary avant-gardes, to New York. The purpose of the trip was to locate an American publisher for a book she was assembling on the photographer Eugène Atget, whose estate she had purchased shortly after the photographer's death in 1927.[4] Though her trip was not staged as a homecoming, Abbott was no stranger to New York. From 1918 until 1921 she had lived in Greenwich Village among a group of politically active and culturally radical artists, writers, playwrights, and critics.[5] As a young woman living in the city, she had—at least initially—felt inspired by the urban environment and politicized arts scene. By 1921, however, frustrated by what she perceived as the city's lack of support for the arts and generally disillusioned by America's increasingly commercial culture, Abbott had decided to move to Europe, where friends assured her the atmosphere was more artist-friendly.

When Abbott ventured back to New York in 1929, now the proprietor of a successful portrait business, she had no intention of staying. But the city had changed during her absence, and almost immediately upon arrival, Abbott fell in love with the place she had left eight years earlier, stating in an interview, "The sights of the city sent me mad with joy and I decided to come back to America for good."[6] As photo-historian Bonnie Yochelson reports, Abbott's "friends 'thought [she] was crazy' to give up her Paris-based business and reputation," but Abbott was confident she could succeed in New York, and within weeks of her arrival she had rented a studio, returned to Paris, sold her furniture, and packed up the Atget collection for transport to the United States.[7]

Once settled, Abbott immediately began to photograph New York's urban landscape. Unsure of what she wanted to capture in these photographs, she simply started snapping pictures with a handheld camera and compiling the prints (which Abbott identified as "just notes") in a scrapbook (plates 2 and 3).[8] In their emphasis on the abstractions of pattern and light, their vertiginous angles and odd perspectives, and their casual quickness, these early New York images pictured a more frenzied and spontaneous city than that represented in her later *Changing New York* project, where her subjects—which are largely architec-

11

tural—at times feel almost static (plates 14 and 24).[9] Finding time to develop this work proved difficult, however. Abbott intended to support herself in New York by setting up a portrait studio, much as she had in Paris, but history intervened. Shortly after she established her studio (off Central Park at West 67th Street) the stock market crashed and, with it, her ability to attract a clientele willing to pay fifty dollars (at the time an exorbitant amount) for a portrait session.

For years Abbott struggled financially, though she managed to keep herself afloat with various commissions. In 1933 she also accepted a teaching post at the New School for Social Research, which provided her with some security. During these financially strenuous years, the hustle to survive often overwhelmed her ability to pursue independent projects. Though she applied for a number of grants and fellowships (for example, from the John Simon Guggenheim Foundation) and made proposals to a number of museums (including the Museum of the City of New York and the New-York Historical Society), none of her applications was ever accepted. However, through these efforts Abbott did receive important moral support from Hardinge Scholle, the director of the Museum of the City of New York, as well as the museum's curator, Grace Mayer. Eventually Scholle and Mayer gave Abbott her first one-person museum exhibition, which featured her New York pictures, in October 1934, just five years after the market crash.

In the show, Abbott displayed a number of her early scenes of the city, such as those taken of the Lower East Side and the construction of Rockefeller Center. The modest-sized buildings and pushcart venders that fill the narrow streets in the Lower East Side photographs (plate 5)—where only a small distance separates people, architecture, cars, and consumer goods—provide a striking contrast to the gigantism of Rockefeller Center's massive excavation pit (plates 6 and 7)—where cranes and pulleys claw at rock beneath the earth's surface to secure a solid foundation for a new human-made visual world, where skyscrapers are as likely as mountains to form canyons and cavernous valleys. Unlike the gentle bustling and picturesque quality of the photographs of old New York, Abbott's Rockefeller images seem to speak history, to say as much about ruin as about construction—the ruin of old New York, of the natural-cultural landscape, of what is known, and of the image's capacity to show all that is being sacrificed for this colossal transformation. Rockefeller Center's excavation pit becomes a ruin disguised as a construction: it hints at all that we do not know or understand about the processes of development and decay, expansion and destruction, articulation and miscommunication. History is sealed within the image—Abbott captures a moment or a manifestation of cultural transformation—but it is a history that makes incomplete sense, a history whose end remains unknown.

Shortly after this 1934 exhibition, Abbott met Elizabeth McCausland. McCausland, today a much understudied figure, was well known in the 1930s through her weekly art columns in a small Massachusetts newspaper, the *Springfield Republican*.[10] In spite of the paper's small size, McCausland's columns were extremely popular, and she developed a reputation as both a serious critic of American art who possessed a sophisticated understanding of modernism and a social critic and active promoter of left-wing causes. Waldo Cook, McCausland's boss at the *Republican,* was a progressively minded editor (publicly supporting Sacco and Vanzetti, for instance), and he encouraged McCausland, from the moment she accepted the *Republican* job in 1923, to break with traditional women's subjects and write politically charged articles. McCausland's 1935 de-

scription of her published articles gives a sense of the radically democratic nature of her interests:

the abolition of capital punishment; unemployment insurance; book censorship; movie censorship; the D.A.R. black list . . . the New Bedford strike of 1928; child labor in the tobacco plantations of the Connecticut Valley; sweatshops in the Massachusetts textile industry; minimum wage laws enforcement; the right of married women to work in industry; birth control; free speech; feminism . . . the National Association for the Advancement of Colored People . . . the industrial democracy scheme in effect at the Pequot mills in Salem in 1931; the Massachusetts commission to study the stabilization of employment; the sweatshop conditions in Easthampton cotton mills.[11]

It should come as no surprise, then, as Bonnie Yochelson has pointed out, that McCausland was the first author to endow Abbott's vision of New York with political meaning. In one early essay, for instance, she described how Abbott's photographs showed the vulgarity of "the Chrysler Building, the Daily News Building [plate 12], Rockefeller Center, the Stock Exchange, and any other of a hundred similar displays of ostentatious and vulgar wealth . . . [existing] side by side with those Central Park shanties of the unemployed which she has also photographed."[12] Not long after seeing Abbott's 1934 exhibition, McCausland praised it in her weekly art column and then sent a copy of the review to Abbott. The gesture initiated a friendship, one maintained first through correspondence and then in person after the two women met through a mutual friend, Marchel Landgren, editor of *Trend* magazine, who had asked McCausland to write an article on Abbott.

The introduction transformed both women's personal and professional lives. A relationship began that lasted until McCausland's death in 1965, each woman describing the other as her closest friend, best critic, and most im-

portant intellectual influence. Though linked romantically, Abbott's repudiation of the term *lesbian,* along with her profound desire not to be pigeonholed as *simply* a woman-artist, has limited serious investigation into how her committed relationship with McCausland may have affected her production. Most of the scholarship that addresses Abbott's sexuality focuses on her Paris portraits (completed before she met McCausland), images that clearly confront the sexual savvy and complexity of subject formation in Paris's avant-garde and lesbian communities.[13] In any case, Abbott and McCausland's intellectual relationship undoubtedly led each woman toward a more nuanced understanding of three key terms under investigation here: documentary, realism, and modernism.

For McCausland, collaboration with Abbott prompted her to reexamine the connection between documentary and fine art photography. Abbott's approach—straightforward and dispassionate to a degree that McCausland had never seen before—encouraged her to link photographic documentation to written journalism and to think of its potential in terms of communicative possibilities more than high-art reception, with its ensuing emphasis on aesthetic quality and subjective expression. The reassessment led McCausland to become outspokenly critical of overly precious photographic practice and to break from the Stieglitz group and its focus on photography's artistic value, of which she had become increasingly critical after being loosely associated with the group in the early 1930s.[14] As McCausland began to reject models of artistic isolation and Stieglitz-style individualism, she started to see her job as constructing a new identity for the artist *and* art critic as engaged advocate rather than passive bohemian.[15] Abbott provided the ideal example through which to develop this model of engaged producer.

For Abbott, the partnership with McCausland forced her

to think about documentary photography in more theoretically rich terms: after their meeting, Abbott's work began to raise, in concrete ways, the question of how a photographic practice might represent history, catalyze change in the world, and inspire action or reaction in viewers. In other words, after meeting McCausland, Abbott thought not only about what made a good or bad "straight," or unmanipulated, photograph but also about its historical significance, use-value, and communicative legibility.[16] We see evidence of this both in her photographs and in her writing. "This is a moment in history . . . a great and terrifying moment," she wrote in 1937. "We can go backward or we can go forward, but we cannot stand still, rooted in time and space."[17] She refers here to America's economic devastation and to the rise of Fascism in Europe, of which Abbott would have been well aware through her involvement with the American Artists' Congress, an association of American artists formed in 1936 to protest attacks on civil liberties and condemn Fascism in Italy and Germany.[18] As Abbott came to understand her work as an artist through this historical framework, she began to see her images as simultaneously recording, participating in, and potentially affecting historical change.

But even before Abbott and McCausland met in person, their correspondence was flirtatious, and in this flirtation it is possible to detect a burgeoning collaboration, the nascent idea of a joint project focused on the country's vast social landscape. For instance, in response to a note from Abbott describing her passion for New York, McCausland wrote:

I'm glad you have a fantastic passion for New York. . . . I have a fantastic passion for the county court house in Bolivar, Missouri. . . . I have a fantastic passion for some funny facades in Troy, N.Y. I especially have a fantastic passion for the rows and rows of brownstone fronts with stoops that make up the first view of New York for people coming in from the north on the train. I have a fantastic passion for Nantucket and Cape Cod and all the little hill towns in the Sangre de Cristo mountains, Chimayo, Cordova, Los Trampos, Truchas. But most of all I have a fantastic passion for AMERICA. (One needs much larger capitals.)[19]

The expression of such unrestrained patriotism may at first strike one as surprising, particularly given McCausland's political views. But in the 1930s, a variety of authors, critics, and artists, including McCausland, were inspired by the term *usable past*. Van Wyck Brooks first developed the idea in 1918 as a way to understand America's past as part of a long and venerable tradition of spontaneous and democratic art created by and for the people.[20] Brooks believed that if one examined American literature and art for "tendencies" rather than "masterpieces," for the vernacular and folk rather than the erudite and commercial, then a deeply democratic impulse within American culture would emerge, and with it the promise of national tradition based not only on creativity but also on the principles of equality.[21] Proponents of a usable past—scornful of the Victorian period, when art and literature functioned as symbols of wealth—sought to mine America's past for an indigenous, democratic, creative urge that they hoped would be maintained and emulated in the modern era.[22] The nationalist sentiment of McCausland's words, her enthusiasm—her capitalization of "AMERICA"—must be understood as an expression not of chauvinism or jingoism but rather of openness to historically undervalued popular traditions and to an art of the people. Nationalism, in other words, was inextricably linked to the radically democratic. The architectural landmarks McCausland named in her letter—the county courthouse in Bolivar, Missouri; the brownstones in Troy, New York; the little hill towns in New Mexico—each represented precisely the

14

type of vernacular building these critics sought to retrieve from America's past.

Not surprisingly, Abbott too had absorbed the idea of the usable past, most likely through Holger Cahill, whom she had befriended in the 1920s while living in Greenwich Village and with whom she maintained a friendship throughout the 1930s. Cahill was an art critic, curator, and authority on the folk art of the United States and Central America; he also worked (from 1935 until 1942) as the national director of the Federal Art Project of the Works Progress Administration (WPA), the agency that employed Abbott from 1935 until 1939. Obviously an important contact for Abbott, Cahill—like Brooks—believed that the work of indigenous American artists, amateurs, and craftspeople expressed the democratic aesthetic of the common man. He insisted that the work of such "popular artists has special significance for our generation because we have discovered that we can take seriously, once more, the idea of art for the people."[23]

This shared idea about America and America's democratic origins galvanized the two women in the summer of 1935 to take a month-long excursion through the Upper South and parts of the Midwest to see together the places McCausland had described in her letter. In an old Ford, Abbott and McCausland drove from New York to Mississippi, briefly on to Arkansas, north through Illinois, and then back through Indiana, Ohio, Pennsylvania, and home to New York. During this trip, which sealed the women's relationship, Abbott and McCausland began to plan in more tangible terms their photo-book portrait of the nation.

While traveling, Abbott took approximately two hundred photographs and McCausland wrote a mix of essays—some personal, some more descriptive and observational. None have been published, though "Dusk over America" was probably intended as the book's introduc-

tion, and "The Barns Travel West" was most likely written as a caption.[24] These images have received little exposure and virtually no critical attention (although in 1980 the scholar Michael Sundell organized an important exhibition and catalogue that included a selection of Abbott's photographs from this southern tour). Yet it is here that Abbott began to develop a syntax or grammar for the realist language that would guide her documentary practice. Traveling with McCausland in 1935, Abbott adopted for the first time in a recognizable pattern a series of artistic strategies that made her photographs *appear* unself-consciously "real." That is, her photographs function as indisputable statements of unique events even as they acknowledge deficiency, contingency, and uncertainty. They appear to be straightforward but slyly point to their own representational status.

In *Dirt Farmer, Hertzel, West Virginia* (1935), for instance, Abbott shoots her subject from the middle distance, a position that was fundamental to her visual language at this time. The photograph depicts a man standing firmly with his hands on his hips, looking out at the camera with a direct, confident gaze that challenges our expectations of what an African American farmer in the 1930s in West Virginia is supposed to look like. His posture, in conjunction with the camera's not too close, not too distant position, focuses attention on his condition as a rural worker (we see his clothes, his land, elements of his farm) and, more broadly, on the issue of race in America's South of the 1930s. The fence that runs across the photograph's horizontal plane divides the space in two, separating the viewer from the viewed and making manifest an implicit yet deep divide between the white photographer and her black subject.[25] The shaved-off branches that form the fence have sharp thorns that resemble barbed wire, thus complicating the image's relationship to questions of race

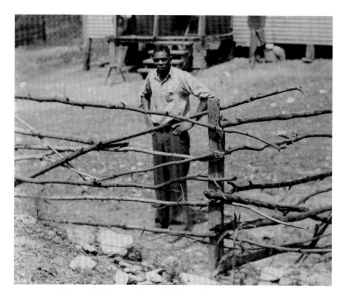

Berenice Abbott, *Dirt Farmer, Hertzel, West Virginia,* 1935.
Gelatin silver print.

viewer, the camerawoman and her subject—all are entangled and implicated in the image's production. The photograph's emphasis here on a viewer aware of his or her role in the representational process is a critical component of Abbott's realism in that it signals a reciprocal communication. The image is representational but subtly fragmentary and uncertain, and thus relies on the viewer to realize his or her agency by interpreting the image. There is a potential paradox here—and it is part of what makes Abbott's work interesting: Abbott insisted that her images were representational, yet she exploited the tension between knowable representation and uncertain fragmentation because she understood this space to be necessary for a communicative exchange, the kind of exchange she felt was fundamental to effective documentary practice. Embedded within her realist, documentary aesthetic, then, was an element of the unknown and the abstract.

The influence McCausland exerted on Abbott's work during the early months of their relationship in 1934–35 also seems to have pushed Abbott toward developing a pictorial framework that expanded upon her ideas of the usable past and consequently moved her work toward a more overt criticism of capitalism. From correspondence and drafts of McCausland's first reviews and articles on Abbott's work, it is apparent that she responded especially well to Abbott's photographs of men working on the construction of Rockefeller Center because she read in these images a critique of labor in an era of growing corporate wealth.[26] *Coke Ovens, Cascade, West Virginia* (1935), taken during Abbott and McCausland's summer trip, builds on such themes of alienated labor—here in Appalachia instead of New York City. The image depicts a uniformly lit gravel field. A middle-tone gray washes over the picture's surface, intensifying the monotony of the anonymous worker's job shoveling coal. This unforgiving, clear light,

and national identity; the fence looks more like a protective border around a barracks or prison than an architectural element demarcating a farm's boundary.

This is not a close-up image telling a story of hardship and heroism, like much of the Farm Security Administration (FSA) imagery of southern agricultural workers, which was designed to show, through the drama of individual lives, the distresses caused by the Depression. In Abbott's image, we are faced instead with something much more like a document or, rather, a picture deliberately made to resemble one. But, unlike an archivist's photographic document, Abbott's image does not cast its subject irrevocably into the dusty past. Rather, the image inscribes him into a collective, public space—our space. Abbott's middle-distance site—which serves as one of her realist strategies—positions the viewer as a distant historical observer at the same time as it reveals the process of representation. The viewer and the viewed, the camerawoman and the

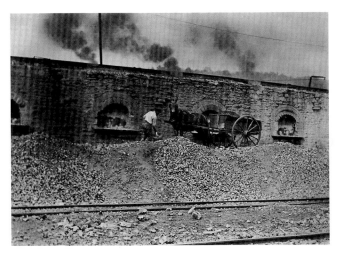

Berenice Abbott, *Coke Ovens, Cascade, West Virginia,* 1935.
Gelatin silver print.

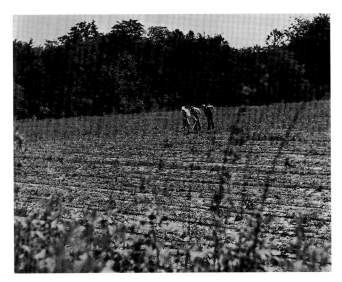

Berenice Abbott, *Primitive Cultivation, Arkansas,* 1935.
Gelatin silver print.

like the middle-distance shot, becomes another trademark strategy used by Abbott to signal that this is a picture and not reality itself. It is an effective strategy that in *Coke Ovens* achieves several results: the hard, even illumination produces a cheerless atmosphere, clarifies and reveals detail (such as the individual rocks that stand out against the ground), and outlines buildings and contrasts forms (such as the wagon wheels against the oven's façade). Most important, however, the uniformly lit surface establishes a position of cool distance, a uniform surface that submerges the laborer shoveling coal in his social world. The grayness both draws the viewer in with details that make the image feel real and creates a barrier that underlines the image's status as representation.

After Abbott and McCausland's return to New York in late summer 1935, people performing work slowly vanish from Abbott's repertoire. In fact, people virtually disappear, replaced by depictions of the structural conditions—sociopolitical, agricultural, environmental, urban—that contribute to the subject's formation. But, during the trip,

Abbott took a number of pictures of people, some of which seem to illustrate McCausland's essay "Dusk over America." "Everywhere there is this chronicle of waste land of soil put to wrong uses, of human labor expended where returns cannot possibly repay the investment of effort and material," McCausland wrote. "In a Mississippi field, two men and a woman hoe corn with listless gestures. The earth is strewn with small rocks; it is as weary as and depleted as the human laborers."[27] *Primitive Cultivation, Arkansas* (1935), as we know from the title, does not show the Mississippi cornfields described by McCausland, yet the depicted figures, two men and a woman, move with the same listless gestures she describes having seen there. Overwhelmed by the field that fills the foreground space, the three small figures lean over their tools in choreographed rhythm. Although their bodies, which appear purely instrumental, threaten to fold in onto themselves and close off the exterior world, the workers maintain

their upright postures. The preservation of this legibility prevents the photograph from collapsing into abstraction and keeps it connected to the world outside. Out-of-focus elements speckled across the image's bottom edge call attention to the photographer's presence, again drawing attention to the image's status as representation and to our responsibility as viewers. The photograph presents the indeterminate zone between event—the thing observed, in this case the laborers' work—and image. In this indeterminate zone, viewers can contemplate what is shown and decide how or whether they want to take responsibility for their relationship to the scene. This is, for Abbott, the social utility of photographs.

Not all Abbott's photographs from her summer trip with McCausland represent labor with the kind of abjection pictured in *Primitive Cultivation,* however. Some, such as *Norris Dam, Tennessee* (1935), clearly celebrate the exhilaration of modern technology, depicting labor as a dynamic collective experience in which men interact in groups, strong and upright muscular bodies exhibit their prowess, and human work joyously makes industrial power serve beneficent social ends.[28] Like Abbott's earlier pictures of the Rockefeller Center construction site, *Norris Dam's* compositional structure—its strong diagonal and horizontal lines—highlights both the sheer physical size of the building project and, by implication, the enormity of its social ramifications. Here the social implications of the dam's manufacture are portrayed as potentially positive. Whereas the steel girders in a photograph such as *Rockefeller Center* (ca. 1932, plate 7) separate and compartmentalize the workers' space, *Norris Dam* locates laborers in social relation to one another; there is a sense of camaraderie, or at least excitement and togetherness, as we see the figures building what they must have understood to be an important symbol of power, authority, and progress. In a proposal for funding, McCausland describes having watched the construction of Norris Dam (plate 9):

We went to Tennessee and looked at the Tennessee Valley Authority or mostly at that part of it around Norris Dam. A dam is beautiful, not like a barn, but beautiful like a dam, built by the concerted effort of thousands of workers and technicians. We heard how elaborate and minute geological tests were made to prevent the dam's being washed out. We watched the huge concrete bucket dump five tons of concrete at a scoop. . . . We heard the great cables creak as the bucket rushed out over the dam. . . . The men working were tiny figures. The waters of the diverted Clinch River went running. That was America.[29]

Although Abbott and McCausland started work on their project to document America's forty-eight states in the summer of 1935, it was not until they applied for a Guggenheim fellowship that fall (and then again in 1937) that they clearly expressed in writing why they thought such a project was worth pursuing.[30] Their proposals outline how they might place the social ills, as well as the hopeful or inspiring moments they observed (such as the construction of Norris Dam), in the context of American national identity and as examples of broad historical change.[31] McCausland's account of their summer trip in their first Guggenheim application of 1935 is particularly illuminating:

So last spring Berenice Abbott and I decided to go out and see a little part of America. We thought that America was worth seeing, was worth loving, was worth writing about and worth photographing. So we started off with a Ford and went as far as we could in a month. . . .

. . . We went through eastern Pennsylvania and looked at the beautiful stone barns. We went to West Virginia and looked at the subsistence homesteads at Reedsville. Then we looked at coal mining villages and coal miners, at filthy shacks where miners have to live, at miners' children broken out with running sores

from lack of proper food and hygiene. It was not pleasant. . . . But that is part of the portrait of America, nevertheless.

So we went on, living in tourist homes and tourist cabins. . . . We were always coming to a town with a square dusty in the summer sun. There would always be mules standing hitched to hitching posts. There were Negroes lounging against store-fronts or playing a guitar. There were signs [for] "Negro comfort stations." . . . I had been born and brought up in Kansas, Berenice in Ohio. We had lived away from the South and knew nothing about the South, not even the intermediate South which does not seem to be so authentically the South as the deep South. So we learned about America, about Jim Crow laws.

But always it was like coming home. I never came into one of these dusty, sunny, lazy squares but that I felt it was a place I had known long ago. It was like a remembered place, a place I had visited as a child.[32]

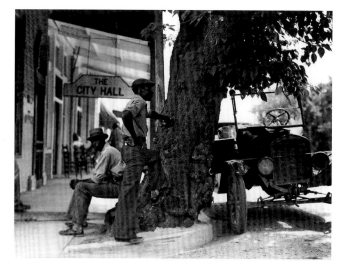

Berenice Abbott, *Sunday Afternoon, Colliersville, TN,* 1935. Gelatin silver print.

But the "dusty, sunny, lazy squares" that McCausland dreams of having visited as a child, when pictured by Abbott, lack the feeling of homecoming McCausland describes. Abbott's *Sunday Afternoon, Colliersville, TN* (1935) is a case in point. Five elements fill the image's frame: a sign marked "The City Hall"; a sitting figure; a standing figure; a large tree trunk, against which both figures lean; and a parked car. Though fragments touch or butt up against one another, they seem to exist in separate worlds. Even though the sitting figure gazes out and the directness of his glance indicates acknowledgment—he watches Abbott as she photographs him—the gap between Abbott and her subject, between him and us, feels unbridgeable. The announced publicness of the depicted space (this is in front of the City Hall, after all) emphasizes its remoteness: this may be a shared physical space, but the internal lives of the figures remain private. Abbott's imagery thus suspends McCausland's assumed familiarity, just as McCausland's assumed familiarity suspends Abbott's objectivity. Together, the two perspectives

and the two forms of expression (text and image) present the reader/viewer with multiple and simultaneous acts of viewing and with a greater (though still incomplete) historiographic perspective than each could have produced on its own. The gap between text and image might also be understood as reinforcing the earlier-described fragmentary quality of Abbott's documenatary, realist approach.

In addition to McCausland's narrative account of their American exploration, we also have McCausland's unpublished essay "The Barns Travel West," which, as Sundell argues, was probably a draft or example caption.[33] The essay describes the Pennsylvania barn as an example of folk art and the key symbol of rural German-American cultural and economic traditions:

And indeed Pennsylvania barns have been famed for their beauty as long as there has been any national self-consciousness of beauty. For a century or more their solid forms have stood beside the road or on distant hillsides; they have withstood storms and hot summer suns and the changing fashions of men. Today they

stand among the most beautiful architectural monuments produced in America. Even the most rapidly passing motorist cannot help but be charmed by them.

More than for their intrinsic beauty they are famous; for as the American nation moved westward, they also cut a trail into the wilderness. Into Maryland and Virginia, into the valley of the Ohio, on into the West and even north into New York state and Canada, the Pennsylvania barn marched. On remote Tennessee roads, one will come suddenly upon a century-old barn which, except for its location, might be in Lancaster County, Pa., so faithful is it to the essential form of the Pennsylvania barn. So far-reaching, in fact, has this influence been that the German barn and the German farm wagon have been called the pillars of our agricultural economy and our inland trade.[34]

Berenice Abbott, *Barn, Halfway House, near Allentown, Pennsylvania*, 1935. Gelatin silver print.

The caption expresses pride in America's native architecture, while suggesting how past traditions are pushed forward into the present. McCausland points to how the reproduction of place (the German barn in Pennsylvania, the Pennsylvania barn in Tennessee) signals a cultural adaptation that she feels typifies American identity. Abbott's *Barn, Halfway House, near Allentown, Pennsylvania* (1935) seems a likely candidate to accompany McCausland's text. In the image, we appear to be looking at the barn's banked side (a typical feature of Pennsylvania barns); to the right—framed off the edge of the image— three hex signs reside above the barn's door. Though there is debris in the foreground space, the shadow cast by the centrally located tree adds a picturesque, even melancholic, element to the image. Are we looking at a place full of lost stories—a ghost object—or a living, working farm? The picture's stillness, an effect of its middle-distance, in-between perspective, allows it to be read as an image of both past and present.

Abbott and McCausland applied jointly to the Guggenheim Foundation for support for their portrait of the nation project, but it was McCausland who outlined in her half of the proposal how she thought photo-books should be structured and why she believed they could become the preeminent medium of the future. In one application, McCausland defined the ideal photo-book as an object that is "not a picture book, not a treatise or a burst of splendid rhetoric with illustrations, not a series of beautifully reproduced plates with tabloid captions and tricks of montage, but a book with words and photographs marching along beside each other, complementing each other, reinforcing each other."[35] On a different occasion she explained that language is an essential component to photo-books because only through language can social relations be made clear: "The whole identification of subjects in their context of real life must be made by language. For it is obvious that the camera cannot record the repetitive mass and distribution of social maladjustment; it can show social decay by individual instance. But if the beholder does not know how often this story is repeated, he loses something of the mass impact of the phenomenon."[36] In other words,

McCausland understood that the visceral power of the visual threatens to overwhelm the written, reason-giving explanations of social circumstance. She thus emphasized the potential of using image and text together to layer visual and written information so that abstract concepts of all kinds can be clearly and powerfully communicated to "the masses of people conditioned by reading newspapers and tabloids."[37] McCausland's writing also stressed that the photographic document is fated to be incomplete, never capable of capturing the full picture, in the same way that words are insufficient for delivering the visual power of an image. For McCausland, then, the photo-book would be an invention of incomplete parts building a greater whole—the book itself, an event in construction.

McCausland's attention to the layering of textual and visual information might also be thought of as a layering of realities in the sense that the photographic image supplies the reader/viewer with one vision of the external world, while another is provided by the written text, which might utilize a variety of discourses—sociological (or "scientific"), poetic, personal, private recollection, and so on.[38] As we have seen, McCausland's written description of visiting and inhabiting the spaces of town squares and city halls contrasts with Abbott's photographic portrayal of the same kinds of spaces. Where McCausland experienced familiarity, and even perceived a sense of community—a commonality among fellow Americans—Abbott pictured people distanced from one another and from the viewer. For McCausland, then, it is only through the imbrications of these two modes that a full picture of the given subject is achieved and the depth of the social reality communicated. In this way the doubling effect of the layering process allows the photo-book to disturb our sense of order and open up another interpretative space.

More important, McCausland suggests that the photo-book as a genre has the potential to develop into "the great democratic book." "Planned with some understanding of typographical display and design, produced by means of recently perfected methods of reproduction," she wrote, "[the photo-book] really could turn out to be the great democratic book, great not in the sense of depth of perception or intensity, perhaps, but great in the sense of reaching out to great numbers of people."[39] In one sense, the statement is a clear assertion that the photo-book's social content is bound up with wide distribution and affordability. McCausland sees in the photo-book an opportunity for artists to utilize new technologies of reproduction and distribution to create an accessible mass media that will reach a broad population, presenting arguments about the most pressing social issues of the day. However, the idea of the "democratic" could also be turned back onto the photo-book's structure and the term interpreted as a description of the desired image-text relationship—a relationship of equality and dialogue between elements—and as a comment on the type of photograph to be included. That is, how might the photographs in such a photo-book be pieced together? Does one take precedence over others, or do all images function as equally important fragments that achieve consensus of meaning and effect through their interaction?

Abbott's photographs answer these questions in fundamentally different ways than did her contemporaries. More or less absent from her work during the 1930s is a single iconic image such as the cover of Lange and Paul Taylor's 1939 photo-book, *American Exodus: A Record of Human Erosion*. Or Bourke-White's *Belmont, Florida* (1937), an image from her and Caldwell's 1937 photo-book, *You Have Seen Their Faces*. Or Walker Evans's portrait of Allie Mae Burroughs, *Alabama Tenant Farmer Wife* (1936), shot during his tenure at the FSA and reproduced in his photo-book *American Photographs* (1938). For Abbott, both in terms of

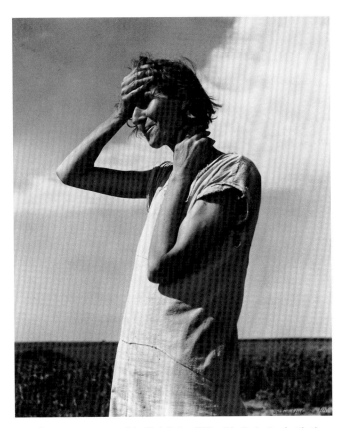

Dorothea Lange, *Woman of the High Plains, "If You Die, You're Dead—That's All," Texas Panhandle,* 1936. Gelatin silver print. Amon Carter Museum, Fort Worth, Texas. P1965.172.8. © The Dorothea Lange Collection, Oakland Museum of California, City of Oakland, Gift of Paul S. Taylor.

her oeuvre as a whole and in relation to the photographs she took for her and McCausland's proposed photographic portrait of the nation or for *Changing New York,* no one single image stands out as the quintessential ideal.[40] And in this, perhaps, we can begin to understand what a "democratic" photograph might be or look like. For it is not simply that Abbott's pictures resist the symbolic drive present in so much 1930s documentary; rather, in this resistance her images offer up an implicit critique of that drive.

As such, Abbott's photographs reveal that the charac-

teristic iconic appeal of pictures such as Lange's *Woman of the High Plains* is essentially part of a drive toward the mass media image, an image that is easily consumable and simplistically and demagogically symbolic—and that exaggerates the passivity of the viewer. By analogy, we could regard the photographs in a democratic photo-book as equal citizens, with no content or specific person's view elevated above others; that is, the meaning in Abbott's democratic photo-book results from a "consensus" among its constituent photographs. As a consequence of this consensus, the viewer's experience of such a text is distinctive because it is active and participatory rather than seductive, consumerist, or domineering (as in competing models of capitalist publicity and the socialist realism of totalitarianism). A *democratic* book, unlike other books, enables its audience to construct arguments, to experience something like intellectual emancipation, and to engage in self-government. Or, as McCausland herself said in 1935, a truly democratic book "might be of inestimable value for educational purposes . . . purposes of awakening millions of adult Americans to themselves."[41]

It also makes sense to conceive of the democratic here in relation to Abbott and McCausland's interest in Van Wyck Brooks's idea of the usable past. When McCausland declared that the photo-book might be "the great democratic book" but then qualified this, explaining that she meant greatness in the sense, not of a masterpiece, but of "reaching out to a great number of people," she was expressing a position clearly in harmony with Brooks's (and Holger Cahill's) emphasis on the importance of popular "tendencies" in creating an art for the people. So McCausland's choice of the word *democratic* was not just a comment on the relationship of images to text or a description of the structural qualities of Abbott's photographs. McCausland, it could be argued, was also using *democratic* in

its substantive sense as a commitment to self-government—a radical idea fundamental to the self-conception of the United States as a nation-state that does not define itself by blood relationships or national origins. In this sense the formally democratic elements of the photo-book might be thought of as prefiguring the ideally democratic self-governing society that McCausland and Abbott wanted to create *with* the photo-book, and which they saw as incipient in the social movements of the 1930s.

When McCausland first used the phrase "great democratic book," she was careful to temper her enthusiasm, fully aware that this achievement remained a promise unfulfilled. Photographers and writers, she pleaded at the end of her "Photographic Books" essay, must now convince the publishers that there is a public waiting for such books and that they "can be—should be—published now . . . on the history being made today."[42] It is easy to imagine that personal experience led McCausland to this assessment, as she and Abbott never found support (financial, editorial, or otherwise) for their proposed collaborative photo-book of the nation. Nonetheless, after returning to New York in 1935 Abbott did receive some good news: her application for support from the Federal Art Project to record New York City's changing landscape had been accepted. She was now an employee of the federal government, with a steady salary of $145 per month—enough for her to photograph the city full-time.[43] The resulting project, *Changing New York,* remains Abbott's best known. The photo-book of 97 images was published in 1939 by E. P. Dutton, with captions by McCausland. The full project includes a larger archive of 305 photographs supported by historical data compiled by a staff of researchers.

In her proposal to New York City's Emergency Relief Bureau (which later became the Federal Art Project), Abbott stated that she wanted to create a "synthesis" in

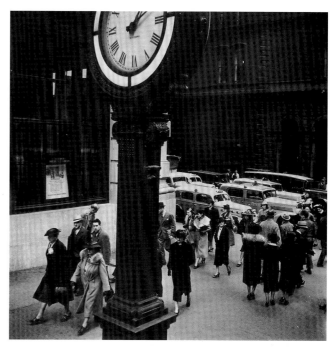

Berenice Abbott, *Tempo of the City: I. Fifth Avenue and 44th Street, Manhattan, 1938.* Gelatin silver print. Photography Collection, Miriam and Ira D. Wallach Division of Art, Prints and Photographs, The New York Public Library, Astor, Lenox and Tilden Foundations.

23

photographs, to show "the skyscraper in relation to the less colossal edifices which preceded it." She aspired to catch "the spirit of the metropolis . . . its hurrying tempo, its congested streets, the past jostling the present."[44] True to this description, *Changing New York* largely documents New York's transformation from a nineteenth-century city to a modern metropolis, with all the incongruities, the inequalities, the excitement, and the unexpected juxtapositions that typically characterize such change (plate 17). Indeed, the book's staying power resides in the way it combines documentation of the changing face of New York City in the 1930s with a broader commentary on the reconfiguration of space in urban modernity. While Abbott

depicts shifting and disappearing economic relation-ships—such as the demise of individual proprietorship (plate 23)—she also shows the rise of corporate or govern-ment-controlled skyscrapers (plate 13), grand bridges, and massive construction projects. *Changing New York* thus illustrates the awesomeness of technological progress and the hope that such progress might bring a better future, at the same time as it represents moments of discord when individuals experience modernization as isolating rather than empowering. The tension created between these two different experiences of modernity reveals *Changing New York*'s conceptual framework and that of her and McCaus-land's earlier proposed photo-book portrait of a nation but on a micro-scale: what does the outward face of the city, of New York City, reveal about the interior culture of America (especially American cities) in the 1930s, its sense of history and myth, and its beliefs?

The image that opens the photo-book component of *Changing New York* introduces a number of Abbott's con-cerns. The picture, titled *DePeyster Statue, Bowling Green, New York* (1936, plate 14), portrays a nineteenth-century bronze statue of a seventeenth-century political figure sitting defiantly in front of rising twentieth-century sky-scrapers. The statue, representing Colonel Abraham De Peyster, mayor of New York from 1695 to 1699, is bathed in a light that emphasizes the figure's sturdiness and strength. Clutching a rolled document in his left hand—a mark of political authority—De Peyster gazes out, facing the sun with the calm confidence that only a man secure in his knowledge of the future could possess. But the photograph is not all confidence and bombast: the massive scale of the nineteenth-century buildings, which fill the left and right edges of the image, lack steady resolve. The two enormous structures, one cast in shadow by the other, awkwardly tilt forward, as Abbott's poignant perspective subverts De

Peyster's apparently timeless durability. In the center of the composition a newer skyscraper, with a modified step-back structure that allows light and air to reach the street below, ascends behind and above the darkness of the ear-lier construction.[45] In this single photograph multiple historical moments interface and communicate with one another to tell a story about New York's various pasts and possible futures. The constellation of historical referents, new urban spaces, and ongoing construction projects is designed to provide a political and civic education to a generation of Americans lacking in historical perspective and uninformed about how their cities were being modern-ized. The photograph's ostensible subject—the De Peyster statue—is again photographed from a middle distance, which, as with Abbott's 1935 portrait of the nation images, situates the viewer as a historical observer.

Throughout *Changing New York*, Abbott's photographs illuminate aspects of the city's past development, but they also suggest possible futures, as well as patterns of growth and decline. Because large-scale building projects such as skyscrapers and bridges have always defined so much of New York's built environment, their representation played an inevitably significant role in Abbott's effort to com-municate characteristics of the city's expansion and his-torical development. Her 1938 image of the Flatiron Build-ing, for example, clearly expresses an understanding of the cycle of construction, demolition, and reconstruction of skyscrapers, as well as how that cycle reflects the city's social and economic change (plate 25). Against a gray sky, the Flatiron Building's tower shoots upward like an arrow, suggesting the progress and exhilaration its construction in 1902 signaled to New York residents. But on second look, the building appears to lean to the right: it teeters, and in this teetering the photograph betrays any earlier cul-tural memory or experienced ascendance.[46] As the build-

ing waves in the wind, susceptible to destruction by the very forces that helped produce it, the picture expresses ambivalence about the processes of modernization and hints at the impermanence of all things, particularly in New York, where the boom-and-bust cycles of capitalism left repeated overlay on the city's landscape.

But this sort of skepticism represents only one of several positions in *Changing New York*. Other photographs revel in the city's continual transformation process. The disorienting perspectives, the focus on new kinds of urban spaces, and the disruption of traditional figure-ground relationships in images such as *Manhattan Bridge Looking Up* (1936, plate 20) or *Canyon: Broadway and Exchange Place* (1936, plate 15), for example, clearly signify the technological glamour of modernity and urbanism, and recall German and Russian radical photography from the 1920s.[47] In *Manhattan Bridge,* the smooth, fresh look and feel of the bridge's steel, combined with the equally sleek pattern formed by its bolts, girder, and cables, reads as somehow self-evidently good and exemplary of a new kind of modern technological beauty. Abbott similarly depicts the thrill of experiencing the city's new spaces in *Broadway and Exchange Place,* where Wall Street's canyons are presented as modernity's latest form. In these images, as she aims her camera almost directly up at the sky, Abbott implies that such spaces are made visible only through photography, the most modern of mediums. Abbott's pictures of New York's new urban spaces thus point to her interest not only in New York's changing landscape but also in technologically mediated cultural experience, experience that for Abbott was part and parcel of the realist age in which she lived.

Although *Changing New York* highlights the city's built environment, some of Abbott's most striking images portray figures, underscoring the relationship between subjects and their physical surroundings. Among these, many depict the painful process of urban development, the decline in the sovereignty and autonomy of individuals, and the rise of corporate power at the expense of human-scaled and family-owned business. As with the images taken on her 1935 southern trip with McCausland, the figures in *Changing New York* are never seen up close; they are always at least one level removed from us and connected to a historical process. In *Bread Store, 259 Bleecker Street* (1937, plate 23), handmade loaves of bread line the window of a family-owned bakery—Zito's—giving an impression of abundance, activity, and financial well-being. Yet the shopkeeper, who stares out at us, and a second figure who stands next to her seem to vanish (or be in the process of vanishing), as if overwhelmed by the encroaching city. The photograph gives the impression that, like the steam of the fresh bread, these figures will soon evaporate, disappearing into the nervous atmosphere of the expanding city.

This sense of dislocation and emptiness reappears in one of the photo-book's only interior views, *"El" Station Interior: Sixth and Ninth Avenue Lines, Downtown Side, 72nd Street and Columbus Avenue* (1936, plate 18). Confronted by a large entrance sign and then a turnstile that offers admission into the photograph, the viewer encounters three figures standing in the interior of an El station. An additional three can be seen standing outside, glimpsed through the waiting-room doors. The interior figures, though more clearly defined than the shadowy silhouettes outside, still appear mysterious: covered in heavy coats, their bodies register as much like dark formless masses as they do specific shapes. Their expressions are equally inscrutable. A woman who gazes out sideways from beneath the rim of her hat looks directly at the camera, but her face reveals nothing. Half in shadow, she seems to withhold rather than dispense information. We are simultaneously shown and denied access to another world—the

physical world of the station's interior as well as the interior psychological and emotional world of the figures.

Changing New York was hugely successful for Abbott. Yet much about the photo-book's final appearance—the introduction's author, the book's layout, even its captions and choice of images—differs from Abbott and McCausland's original concept and design plans.[48] Abbott and McCausland planned their photo-book of New York's shifting landscape along the same lines as their proposed photo-book portrait of the nation: image and text were designed to work together to create a contrapuntal layering of languages and to foster communication and civic education, thereby living up to the ideals of the "great democratic book." However, E.P. Dutton, the book's publisher, wanted to produce an object that would sell to tourists visiting New York for the 1939 World's Fair. The ultimate format resembled a guidebook in which short captions on one page described a photograph on the adjacent page. To promote the book, Dutton launched an advertising campaign that presented *Changing New York* as a great book "for those who love the city and have a romantic interest in its historic past." It was described as "for the Visitor from Out-of-Town—the perfect book about New York to take home to friends and family."[49]

A distressed Abbott responded in a letter to Dutton that she "never had in mind a book of this type," enclosing a list of New York guidebooks already available at the New York Public Library.[50] McCausland also criticized Dutton's version of *Changing New York*. In her assessment, Dutton's design caused the text to appear static compared to the photographs, which felt dynamic.[51] Certainly it is not surprising that a publisher should want to market its products, and in fact the published *Changing New York* did not completely abandon Abbott and McCausland's format. But in the process of editing *Changing New York,* much of the uniqueness of their

approach to documentary, modernism, and realism was diminished. Had Abbott and McCausland not invested so much time in the project, and had they not needed the book to reach the press for practical and financial reasons, it is hard to imagine that they would have permitted the changes.

By excavating aspects of the unpublished version, particularly its text, we can retrieve elements of Abbott and McCausland's understanding of photography's potential to affect viewers. If we continue, for instance, with an analysis of *"El" Station* by examining its unpublished caption, we can begin to see how McCausland's unpublished text extends *Changing New York*'s interpretative possibilities. This reconstruction process also reveals a consistency of vision for Abbott and McCausland in the sense that *Changing New York* suddenly appears more in keeping with their earlier plan for a portrait of a nation: in both they sought to create a modern, realist and activating photo-book.

The space in *"El" Station* is defined by three architectural areas: an alcove and a coal-burning stove delineate the center space, while the areas on the left and right are defined by glass-paneled doors. These doors also divide the interior from the exterior. Running across the entire width of the room is a series of decorative wood panels, each carved with an abstract blossom motif. McCausland's published caption for this image reads:

Unaltered, except for an occasional coat of paint, from the day it was opened to the public 60 years ago, is the typical "El" station interior. The turnstile is a fairly recent innovation, having come into use as lately as 1923. Noisy and awkward to handle, it seems as antiquated as the architectural layout and heating apparatus.[52]

The unpublished version reads:

To look at this scene is like looking through a stereopticon. Were it not for the modern dress, the curious student of the photograph

could easily believe himself to be examining a relic of the past. Everything is primitive, the kerosene lanterns, the coal-burning stove, the lavatories, the rattling, squeaking turnstiles, the décor. From the era of the fashionable Bohemian glass decanter dates the scheme of interior decoration. Red, white and blue glass in the window panes; frosted scroll design—the architect's fancy ran wild when the station was built in 1879. Yet curious as the taste of the period seems today, outdated as the transportation facilities certainly are, the impulse itself was legitimate and creative. The American artist misguided in his youth was forced to turn to foreign precedents for authority, denied recognition of his own authentic if untutored expressions, yet genuinely hungry for beauty and energetic in its pursuit. For such reason we look on scenes like these with a tender and humorous tolerance.[53]

Like most of the published captions, the one for "El" Station is shorter and more to the point, but also stiffer than the unpublished one. It is almost as if two different understandings of documentary photography were operative—the first sees it as precise and instrumental; the second, as aesthetic, conceptual, communicative, and archeological. In the published version, we are told that this is an El station that opened sixty years ago and that its most recent feature, the turnstile, is awkward and difficult to handle. And the description does neatly fit the image, in which a centrally located turnstile, extra large and clunky, appears out of scale in relation to the people who stand behind it. While this is not uninteresting information, the unpublished caption is more involved and demands more from the reader/viewer. It points, for instance, to the simultaneous existence of disjointed temporal moments, and in so doing disrupts the conception of an always forward-moving historical narrative. "To look at this scene is like looking through a stereopticon," McCausland writes. "Were it not for the modern dress, the curious student of the photograph could easily believe himself to be examining a relic of the past."

The familiar theme of the old intermingling with the new in a nonchronological way takes on a supplemental meaning that transcends the literalness with which it is typically associated. We see not only this old building pushed up against that new skyscraper but also the more abstract "anachronistic-now" interfacing with the "modern-now." The figures, however, which are the markers of the "modern-now," refuse to address us or even interact with one another; instead, they drift in a horizontal band across the central axis of the photograph in a blank, unreadable, phantom state. Like the undead, they punctuate the photographic surface by reminding the reader/viewer not only of the interior's obsolescence but of theirs as well. Upon reaching the figure farthest to the right, we find a body already headless and nearly invisible. One side of his (or her?) body is translucent, and it is easy to imagine that were one to observe the "push" sign written on the door directly in front, the figure's entire body would dissolve into air. In this way, the markers of contemporaneity fade away, while the outmoded signs of the "anachronistic-now" maintain their solidity. The explicit link, then, between the modern-now and the transitory leads the photograph/caption combination to speak about the fragility, perhaps even the inadequacies, of modernity: the El station's interior empties out before the viewer's eyes so that only a material shell remains. This is the survival of past history within and beyond the present, as ruins. As the text asks more of its audience, engaging the photograph and layering information, the book's design as a whole begins to approach Abbott and McCausland's model of a realism based in communicative exchange.

The text and image in the "El" Station caption and photograph demonstrate an understanding of the impermanence of things—or at least of modern things. They also position photography to capture multiple temporalities—

27

the residual and the emergent. In the same way that many of Abbott's images from the summer of 1935 positioned the viewer as a historical observer, the *"El" Station* picture and caption present New York as if one were looking back from the future over the remains of the present. Similarly, Abbott's photograph *Fourth Avenue, no. 154* (1936, plate 19) produces, when paired with McCausland's unpublished caption, an archeological perspective, here with regard to the deterioration of housing conditions. Reading this image, which depicts dilapidated tenement housing, with its published caption reveals what was lost during *Changing New York's* editing process. The published caption reads:

These Brooklyn old-law tenements stand empty because the present owner prefers to take a loss on taxes and insurance rather than meet the cost of removing violations. Fire escapes and fire retarding of stair wells are the principal requirements.[54]

The unpublished caption states:

The boarded windows, slate-roofed turret, and medley of posters of 154 Fourth Avenue evoke macabre sensations. Blind eyes, staring but sightless, the windows peer at the passers-by, far more insistent than the raucous signs. Here is a monument of decay, mausoleum of a social era that is ended. The architecture is out-of-date; the building no longer performs needed economic functions. It stands here, waiting for its next phase, as the abandoned mining camps or boom towns of the West stand deserted and ruined. It is a fashionable fallacy to claim that decay is in itself beautiful. Nevertheless the repeated motif of the boards in the windows, the textures of their grain and knotholes, the contrasting textures of brick, mortar and molded cement cornices, combine to make a statement of deep melancholy.[55]

Both captions engage the reader/viewer in social observation. The published one, however, does so in a controlled manner, where the picture's meaning is predetermined to our gaze: if only the landlord would install fire escapes and fire-retard the stairwells, this pictured building, ramshackle and rundown, could return to use. The published text does not antagonize or challenge the image, and as a result the formal horizontal composition, neatly split between an upper and lower half, between boarded windows and printed matter, asserts order over an essentially chaotic situation, where landlords freely choose individual tax relief over social responsibility.

This is not to deny the effectiveness of the published captions altogether; surely, tension exists between the image's static feeling of calm and McCausland's description of social waste and disorder. And ironically, by simplifying McCausland's text, Dutton may have done more to develop a mass audience than if it had allowed McCausland's more erudite, floral caption to reach print. Yet the idea of the "great democratic book"—where the reader/viewer is inserted as an *active* social agent in the communicational circuit—is absent, or at least much more difficult to locate, in the published version. The unpublished caption comments on Abbott's photograph from a position that is more interactive, thoughtful, and expansive in ways that energize and politicize the spaces depicted. As with *"El" Station,* the unpublished text for *Fourth Avenue* introduces a temporal axis ("mausoleum of a social era that is ended"), but here that axis links the building's structure to the viewer's body: the boarded windows are like blind eyes, staring but sightless; the entire edifice, a giant mausoleum. The advertisements and signs plastered below resemble grave markers. A single number, "25" (the charge of admission to the "Midnite Show"), stands out among the words, like a price tag reinforcing the caption's allusion to economic systems and the capriciousness of design: "The architecture is out-of-date; the building no longer performs needed economic functions." The struc-

ture built at 154 Fourth Avenue survives but only as the trace of a past epoch's dream.

By erasing the temporal distance and physical distinction between people and their built environment, McCausland's unpublished text for *Fourth Avenue* transforms Abbott's photograph into a civics lesson. It advises the reader/viewer that decay and melancholy are not inevitable, unalterable, or desirable; moreover, action can reverse feelings of dislocation and alienation. The building, "a monument of decay," exposes the fragility as well as the destructiveness of American modernization in the early twentieth century, thereby contesting the fashionable claim "that decay is in itself beautiful." McCausland, though recognizing the melancholic loveliness of the ruins, challenges the notion that the structure is and forevermore can be nothing but waste, even if turned into aesthetic charm. As a symbol of the past petrified into the present, the text intimates that a history of function and use accompanies the building and that such a history can be regenerative ("It stands here waiting for its next phase").[56] In contrast to the published caption's plainspoken advocacy for urban reforms—the type of reform associated with New Deal liberalism—the unpublished captions express a more biting critique of the processes of capitalist development. They also fit more clearly with Abbott's understanding of a documentary practice based in realism and modernism. The transformation of the body into a phantom and the phantom into air, or of a building into an empty shell and the shell into ruins and the ruins into dust—these processes signify the passing of old social forms that are not tangible or visible in the simple sense that is most often associated with realism in general or Abbott's work in particular. Yet when Abbott's photographs are paired with McCausland's first, unpublished captions, *Changing New York* clearly articulates this trans-

formation. The social relationships that drive change in society's structure are rendered visible in such a way as to show the irrationality of those relations.[57]

The unpublished version, much like the two women's never completed photo-book portrait of the nation, sought to communicate a pattern of change and to generate an invigorated citizenry with a sense of history, not in a romantic sense, as Dutton's advertisement for *Changing New York* suggests, but rather in a way that leads people to feel responsible for and engaged with the world around them. Abbott thus identified photographs like hers as belonging to "civic documentary history,"[58] and she suggested that without such a history new spaces of action made possible by a modernizing world would remain dormant. The promise of her photographic practice—realist, activist, idiosyncratic—was precisely to bring that history to life.

What distinguishes *Changing New York,* as well as Abbott and McCausland's earlier proposed portrait of the nation, from photo-book projects such as Walker Evans's *American Photographs* or Margaret Bourke-White and Erskine Caldwell's *You Have Seen Their Faces* (both of which are examined in this catalogue) is ultimately an idea about the meaning and function of documentary practice and, in tandem, the potential of a realist aesthetics. For Abbott and McCausland, realism consumed the idea of documentary and was conceived of as a position from which one worked. Although Abbott consistently employed various strategies, such as unforgiving light, middle-distance positioning, and temporal tricks, her realist approach—verging on the constructive, the expressive, the allegorical—never signaled any simple style; it was more a mode of operating than a style, a process more than an image. Indeed, Abbott and McCausland practiced a realist model of artistic making that embraced what realists might have been expected to shun: instability, contingency, the indirect, and the un-

representable. But they adopted this position precisely because it allowed them to capture the lived reality of the society they sought to represent, and to do so in a way that both revealed society's openness to change and insisted that the viewer act on that openness. In short, they avoided the danger of traditional conceptions of realism: capturing a world that is completed, static, finished, present in itself, and fully available as a packaged meaning to the viewer. Abbott's approach meant that her images were not as appropriable as those of some of her colleagues to histories of photographic documentary practice, which favored straight, unmanipulated, formally constructed, self-reflexive, self-expressive images. Yet her photo-book projects from the 1930s, designed to strike the viewer/reader and promote a sense of civic duty, evince another way of conceiving of the documentary model beyond the sometimes propagandistic quality of FSA-sponsored imagery, the heightened drama of Bourke-White, and the formalist modernism of Evans. Abbott's photographs make the viewer aware of the processes of representation, but they do so in a manner both reflexive and oriented toward argument and education.

Notes

Much of the material in this essay emerges out of two chapters in my forthcoming book *The Realisms of Berenice Abbott: Documentary Photography and Political Action* (Berkeley: University of California Press, 2011).

1. To name just a few of the photo-books produced during this time: Dorothea Lange and Paul Taylor's *American Exodus: A Record of Human Erosion,* 1939; Margaret Bourke-White and Erskine Caldwell's *You Have Seen Their Faces,* 1937; Walker Evans and Lincoln Kirstein's *American Photographs,* 1938; Archibald MacLeish's *Land of the Free,* 1938; Richard Wright's *12 Million Black Voices,* 1941; and Walker Evans and James Agee's *Let Us Now Praise Famous Men,* 1941.

2. Other examples of picture magazines that solicited work from documentary photographers include *Look* (which began in 1937), *Fortune* (which began in 1930), and *Survey Graphic* (which began in 1921).

3. For instance, in her how-to photography book, Abbott wrote, "Just as the most exciting reading matter is to be found in the daily newspapers, so in photographs we find the pictorial matter most sympathetic to the spirit of our age. This is because photography's direct, realistic nature is closely related to the scientific and technological forces which create the twentieth century's consummate speed and dynamics. . . . Speed of telephone, telegraph, wireless, photoelectric eye, X-ray, TNT, airplane, stratosphere, round-the-world flights, have their visual counterpart in speed of lenses, shutters, films, the stroboscope, high speed flash, electronic radiography" (Berenice Abbott, *A Guide to Better Photography* [New York: Crown Point Press, 1941], 173–74).

4. See *Atget, photographe de Paris* (New York: E. Weyhe, 1930).

5. Among her friends were James and Susan Light, Holger Cahill, Malcolm Cowley, Djuna Barnes, Hippolye Havel, Sadakichi Hartmann, Norma and Edna Millay, Eugene O'Neill, the Baroness Elsa von Freytag-Loringhoven, Man Ray, Marcel Duchamp, and Matthew Josephson.

6. Sarah Carlton, "Berenice Abbott Photographer," *The American Girl* (August 1931), 23, in Abbott Archives, Commerce Graphics (hereafter AACG). Also quoted in Bonnie Yochelson, *Berenice Abbott: Changing New York* (New York: Museum of the City of New York, 1997), 12.

7. Yochelson, *Berenice Abbott,* 14–15.

8. Ibid., 12.

9. Similarly, her earliest New York photographs differ in approach from the more conventional shots of small towns and agricultural settings in the Midwest and Upper South that she

photographed for her and McCausland's planned portrait of the nation project.

10. When the *Republican* closed in 1946 McCausland lost some freedom and financial security, which she never recaptured; without a visible outlet, her reputation also suffered.

11. Elizabeth McCausland, "Plans for Work," application to the John Simon Guggenheim Foundation, 1935, Elizabeth McCausland Papers, Series 7: Other Research and Writing Files: Various Projects, Guggenheim Fellowship Applications, 1935–1942 (Box 24, Folder 12), Archives of American Art (hereafter AAA).

12. Elizabeth McCausland, "The Photography of Berenice Abbott," *Trend* 3, no. 1 (March–April 1935): 8.

13. See, for instance, Tee A. Corrine, "The Lesbian Eye of Berenice Abbott," unpublished paper presented at the College Art Association conference, 1996; Kaucyila Brooke, "roundabout," in *The Passionate Camera: Photography and Bodies of Desire*, ed. Deborah Bright (London: Routledge, 1998). Also see "Paris Portraits," in Weissman, *The Realisms of Berenice Abbott*. Clearly Abbott received enormous and important emotional support from her relationship with McCausland. Indeed, Norma Marin, a friend of Abbott's, and Ronald Kurtz, executor of the Abbott Archives, both mentioned in interviews that Abbott kept a picture of McCausland near her bed after the writer's death as a reminder of the important role her friend had played in her life.

14. For instance, in 1934 McCausland contributed an article, "Stieglitz and the American Tradition," to a collection on Stieglitz edited by Waldo Frank, Lewis Mumford, and others, titled *America and Alfred Stieglitz: A Collective Portrait* (New York: Literary Guild, 1934).

15. Susan Platt, *Art and Politics in the 1930s: Americanism, Marxism, and Modernism* (New York: Mid March Arts Press, 1999), 71.

16. Abbott's 1933 investigation into the work of American Civil War photographer Mathew Brady evidences her interest in history prior to meeting McCausland. After their encounter, however, this interest becomes central.

17. Berenice Abbott, "Plans for Work," application to the Guggenheim Foundation, 1935.

18. The organization was founded in 1936 in response to the call of the Popular Front and the American Communist Party for formations of literary and artistic groups to combat the spread of Fascism. There is no evidence that either Abbott or McCausland ever belonged to the American Communist Party, though they were sympathetic to the same causes, especially during the years leading up to American involvement in World War II.

19. Elizabeth McCausland, letter to Berenice Abbott, November 5, 1934, AACG.

20. Peter Barr, "Becoming Documentary: Berenice Abbott, 1925–1939" (Ph.D. diss., Boston University, 1997), 161–63.

21. Van Wyck Brooks, "On Creating a Usable Past," *Dial*, April 11, 1918, p. 341.

22. Barr, "Becoming Documentary," 154–55.

23. Holger Cahill, "Artists of the People," in *Masters of Popular Painting: Modern Primitives of Europe and America* (New York: Museum of Modern Art, 1938), 103–4. He continued, "From the beginning of the century up to the nineteen-twenties the phrase 'art for the people' seemed to most critics almost a contradiction in terms, and for many it became an expression of contempt. . . . In [these critics'] view[s] the art experience seemed a rarefied activity, limited to a few individuals, the elect of art who are distinguished from the great mass of the non-elect by a special sensitiveness. . . . During the past few years, and especially under the stimulus of their work on the government project, the idea of art for the people has stirred large groups of American artists to enthusiasm."

Abbott also expressed attentiveness to the concept of a usable past through her burgeoning interest in the American Civil War photographer Mathew Brady. With Brady, Abbott begins to construct a usable past lineage specific to photographers—one into which she can insert her own work. This was clearly part of her effort to reclaim an American identity after spending nearly a decade in Paris and promoting the work of Atget.

24. Michael Sundell, "Berenice Abbott's Work in the 1930s," *Prospects: An Annual of American Cultural Studies* 5 (1980): 279.

25. I imagine that McCausland's text would have reinforced Abbott's desire to address issues of race, as questions related to

race relations accompanied almost all of McCausland's writing about their proposed project. She often commented, for instance, on the fact that she and Abbott had grown up in the North and were not familiar with Jim Crow laws. I should also mention the insightful comment made by an anonymous reader that the image has the feel of being taken from a car, which brings up an interesting question of Abbott and McCausland's placement and relationship to their subjects.

26. She voiced this interpretation in Landgren's *Trend* magazine. "The tiny workman," she wrote, "dwarfed by the inhuman steel girder so that he can barely be seen in the photograph, is in itself a devastating criticism" (McCausland, "The Photography of Berenice Abbott," 17).

27. McCausland, "Dusk over America," Reel D368, 7–8, Elizabeth McCausland Papers, AAA.

28. Sundell, "Berenice Abbott's Work in the 1930s," 281.

29. McCausland, "Plans for Work," application to the Guggenheim Foundation, 1935. Norris Dam was the Tennessee Valley Authority's (TVA's) first dam-building project (begun in 1933 and completed in 1936); it therefore generated a great deal of excitement. McCausland positions the dam as a modern manifestation of indigenous architecture, thus connecting its construction to her belief in the usable past.

30. They were rejected both times. After receiving criticism that their first application was deemed unrealistic in scope, they adjusted their second application by stating that they would focus on approximately ten small, rurally located cities rather than all fifty states.

31. Sundell, "Berenice Abbott's Work in the 1930s," 277.

32. McCausland, "Plans for Work," application to the Guggenheim Foundation, 1935. Michael Sundell also quotes at length from this passage in "Berenice Abbott's Work in the 1930s."

33. Sundell, "Berenice Abbott's Work in the 1930s," 279.

34. Elizabeth McCausland, "The Barn Travels West," Reel D369, 1–2, Elizabeth McCausland Papers, AAA.

35. McCausland, "Plans for Work," application to the Guggenheim Foundation, 1935. McCausland's Guggenheim applications, taken in conjunction with her later published essay "Photographic Books," *Complete Photographer,* no. 6 (1943), formulate one of the few attempts ever to codify the photo-book genre. An important recent contribution to this history is Gerry Badger and Martin Parr's *The Photobook: A History* (London: Phaidon Press, 2006), 2 vols.

36. McCausland, "Photographic Books," 2785.

37. McCausland, "Plans for Work," application to the Guggenheim Foundation, 1935.

38. W. J. T. Mitchell, "The Photographic Essay: Four Case Studies," in *Picture Theory* (Chicago: University of Chicago Press, 1994), 288–89.

39. McCausland, "Plans for Work," application to the Guggenheim Foundation, 1935.

40. It is important to note that photographers such as Lange and others associated with the FSA were also committed to working in series. Indeed, *Migrant Mother,* one of the most iconic images from the 1930s, belongs to a series. Lange shot six images of the California woman, not just the one most of us recognize as *Migrant Mother.* Grouped together, however, the series forms more of a lesson in how to conduct a photo-session than it does a broader argument about social and economic circumstance. Maren Stange, in her excellent study *Symbols of Ideal Life: Social Documentary Photography in America 1890–1950* (Cambridge: Cambridge University Press, 1989), 128, also points out that John Fischer, director of the FSA Information Division, sent memos to his regional photographers that emphasized the sequential structuring of information. "The Washington photographic staff will continue to handle most material of national interest, or which covers a number of regions," whenever possible taking not "single, isolated shots," but rather picture sequences, a practice that, as Fischer wrote, "the best picture editors everywhere are developing." While this type of practice appears to be more in keeping with Abbott and McCausland's, the desire of FSA administrators—especially figures such as Stryker—to hone in on the faces of the Depression's most desperate victims indicates an entirely different orientation.

41. McCausland, "Plans for Work," application to the Guggenheim Foundation, 1935.

42. McCausland, "Photographic Books," 2787.

43. Yochelson, *Berenice Abbott,* 21.

44. Berenice Abbott, "Photographic Record of New York City," proposal submitted to the Art Project, Works Division, Emergency Relief Bureau, quoted in Berenice Abbott, "Changing New York," in *Art for the Millions: Essays from the 1930s by Artists and Administrators of the WPA Federal Art Project,* ed. Francis V. O'Connor (Greenwich, CT: New York Graphic Society, 1973), 158–62.

45. For further description of *DePeyster Statue,* see Barr, *Becoming Documentary,* 270; Peter Barr, "Berenice Abbott's *Changing New York* and Urban Planning Debates in the 1930s," in *The Built Surface: Vol. 2: Architecture and the Pictorial Arts from Romanticism to the 21st Century,* ed. Christy Anderson and Karen Koehler (Aldershot, England: Ashgate, 2002), 257–65. Also see John Raeburn, "Culture Morphology and Berenice Abbott's New York," in *A Staggering Revolution: A Cultural History of Thirties Photography* (Urbana: University of Illinois Press, 2006), 119.

46. Fear that the building might collapse became so much a part of the popular imagination that the building acquired the nickname "Burnham's Folly," after its architect, Daniel H. Burnham.

47. See Abigail Solomon-Godeau, "The Armed Vision Disarmed: Radical Formalism from Weapon to Style," in Richard Bolton, ed., *The Contest of Meaning: Critical Histories of Photography* (Cambridge: MIT Press, 1992), 90.

48. Yochelson outlines the changes Dutton made in her introduction to *Berenice Abbott: Changing New York.* For instance, Lincoln Rothschild, director of the New York office of the Index of American Design, oversaw the process of revising the captions, and Audrey McMahon (instead of Lewis Mumford or Russell Hitchcock) wrote a brief foreword.

49. E. P. Dutton & Co. advertisement, clipped by McCausland, Elizabeth McCausland Papers, unnumbered box, AAA.

50. Barr, *Becoming Documentary,* 249. A partial list of these books includes Will Irwin, *Highlights of Manhattan* (New York: D. Appleton Century Co., 1937); *Cecil Beaton's New York* (Philadelphia: J. B. Lippincott Co., 1938); Mario Bucovich, *Manhattan Magic: A Collection of Eighty-Five Photographs* (Philadelphia: Beck Engraving Comp., 1937); *Metropolis: An American City in Photographs,* assembled by Agnes Rogers with running commentary by Fred Lewis Allen (New York: Harper and Brothers, 1934). Moreover, by pointing out that Abbott's choice of subjects neglects many of New York's tourist sites, Barr has convincingly shown that Abbott consciously constructed her book *not* to look like a guidebook. She excludes, for example, landmarks such as Central Park, the Empire State Building, Times Square, the Broadway theater district, etc.

51. Beneath one reproduction in the article's text McCausland writes, "CHANGING NEW YORK. The city tempo is expressed in this photograph of Fifth Avenue and 42nd Street, but the format does not express the same tempo. Side by side, type page and picture page are a duality—the former static, the latter dynamic." Under another image she wrote, "This type of format, taken from Abbott-McCausland's *Changing New York,* is not recommended. . . . [T]he awkwardness of turning a large book (9 × 11½ inches) detracts from the esthetic enjoyment. Moreover, picture and text are not seen as a visual unit" (Elizabeth McCausland, "Photographic Books," *Complete Photographer* 6 [1943]: 2786–87).

52. Elizabeth McCausland, in Berenice Abbott (with captions by Elizabeth McCausland), *Changing New York* (New York: E. P. Dutton, 1939), 164.

53. Original captions are housed in the archives at the Museum of the City of New York. This caption found on page marked 99. Captions are accompanied by an interdepartmental memorandum from Audrey McMahon to Lincoln Rothschild, which states, "This is a complete file of the original captions of the Abbott book."

54. McCausland, *Changing New York,* 188.

55. McCausland, unpublished captions, no. 20.

56. McCausland's history is not always regenerative. The text also reads, "like a mining camp or boom town." These sites are not regenerative, but rather indicative of the transitory and un-

stable nature of a city's built environment and of an economy of planned obsolescence.

57. It could also be said that the unedited version seeks not only to depict vanishing spaces or outmoded buildings as they are replaced by new, "modern" ones, but to render visible that transformation *within photography's very representational structure*. The editorializing of the irrationality of the relations that drive change in society's structure might then also be seen as a specific photographic-textual accomplishment.

58. "Civic Documentary History" was in fact the title of the speech. Berenice Abbott, "Civic Documentary History," *Proceedings of the Conference on Photography: Profession, Adjunct, Recreation* (New London, CT: Institute of Women's Professional Relations, 1943).

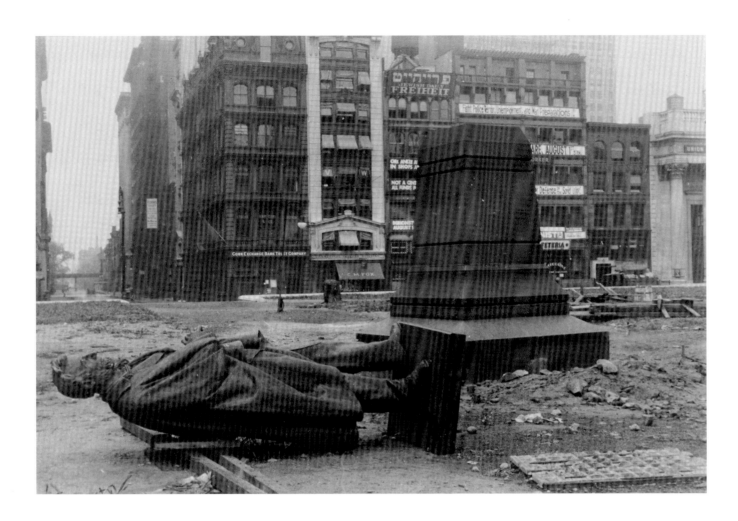

Plate 1. Berenice Abbott, *Union Square: Lincoln Statue*, 1929

Plate 2. Berenice Abbott, *[Early New York Scrapbook]*, 1929–30

Plate 3. Berenice Abbott, *[Early New York Scrapbook]*, 1929–30

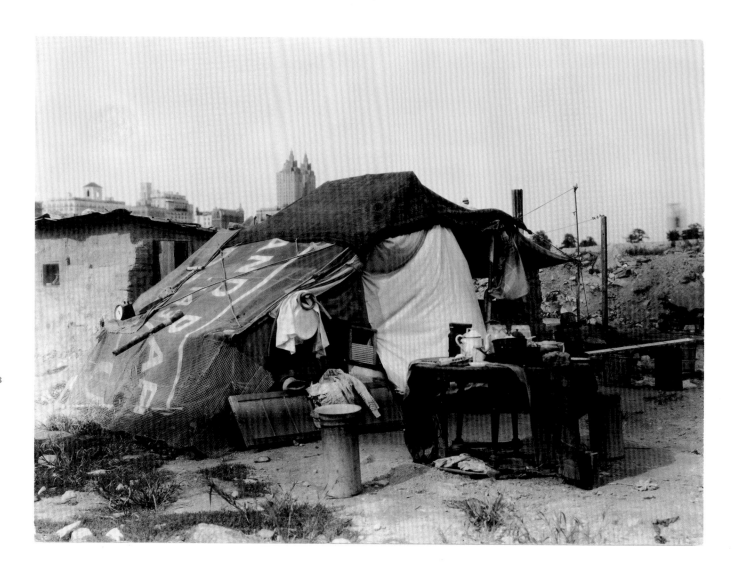

Plate 4. Berenice Abbott, *Hooverville, Central Park*, ca. 1931

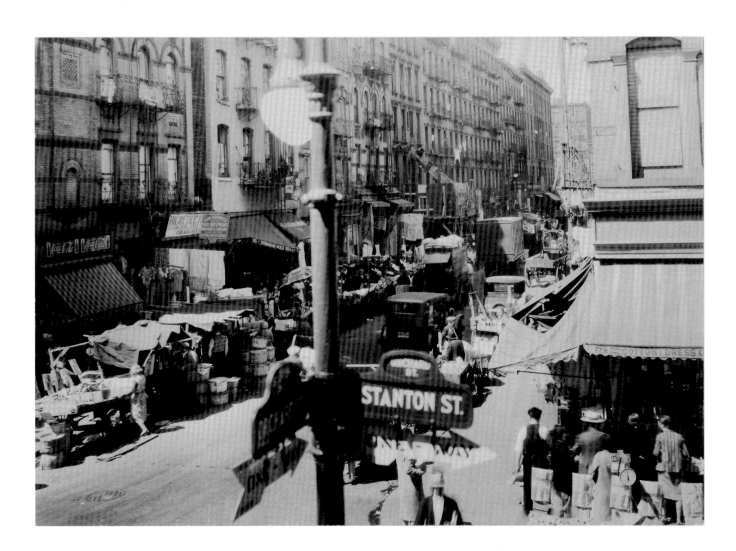

Plate 5. Berenice Abbott, *Lower East Side (Corner Orchard and Stanton)*, ca. 1932

40

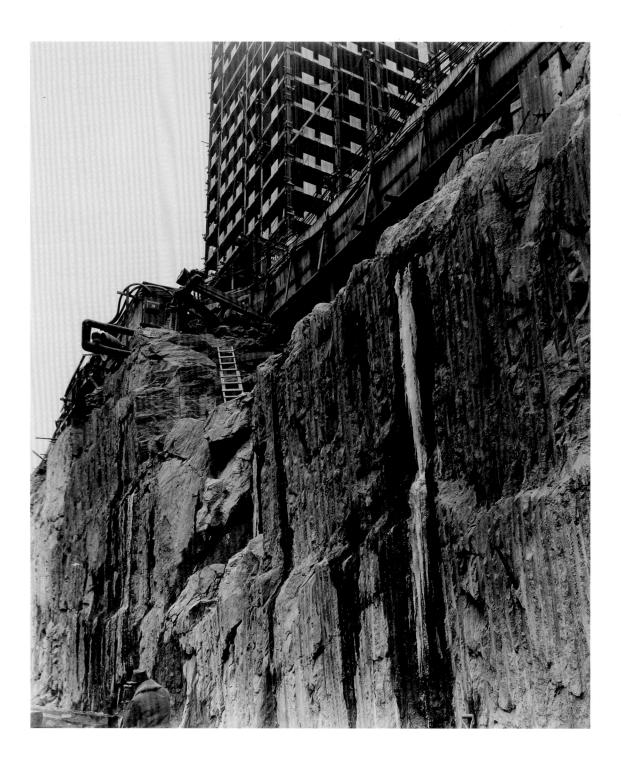

Plate 6.
Berenice Abbott,
Rockefeller Plaza, 1932

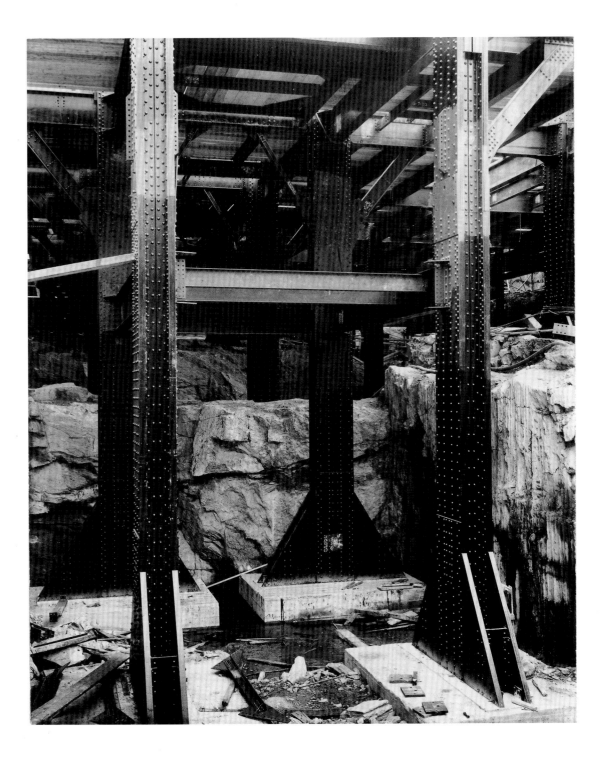

Plate 7.
Berenice Abbott,
Rockefeller Center, ca. 1932

Plate 8. Berenice Abbott, *[Design for Rockefeller Center Mural]*, 1932

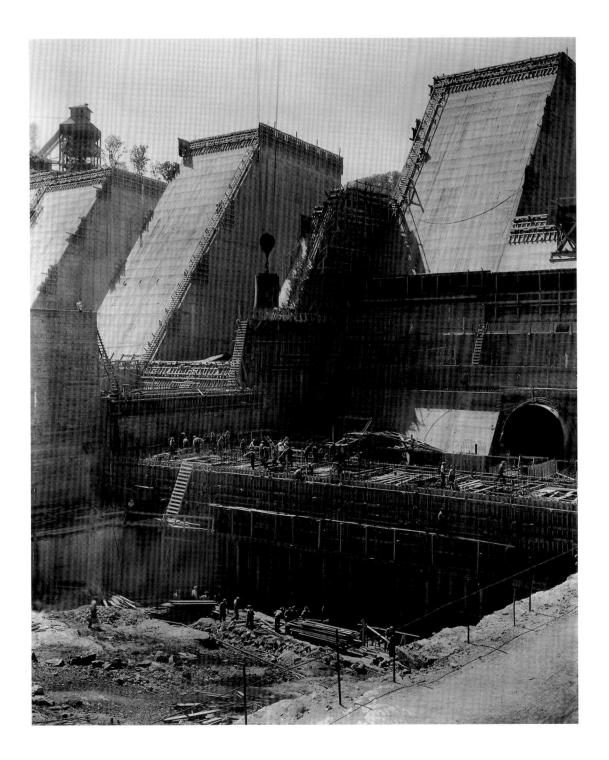

43

Plate 9.
Berenice Abbott,
Norris Dam, Tennessee, 1935

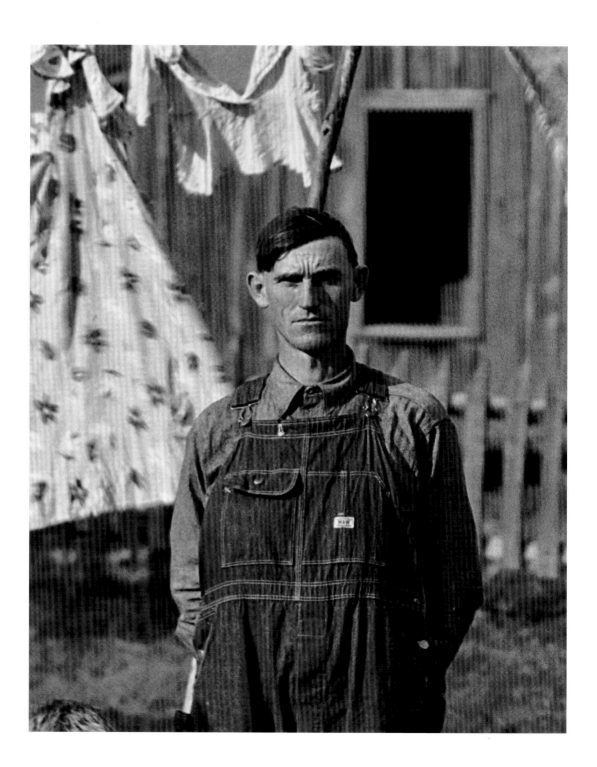

44

Plate 10.
Berenice Abbott,
Portrait of a Miner,
Greenview, West Virginia, 1935

45

Plate 11. Berenice Abbott, *Main Street, Colliersville, TN,* 1935

Plate 12.
Berenice Abbott,
Daily News Building, 1935

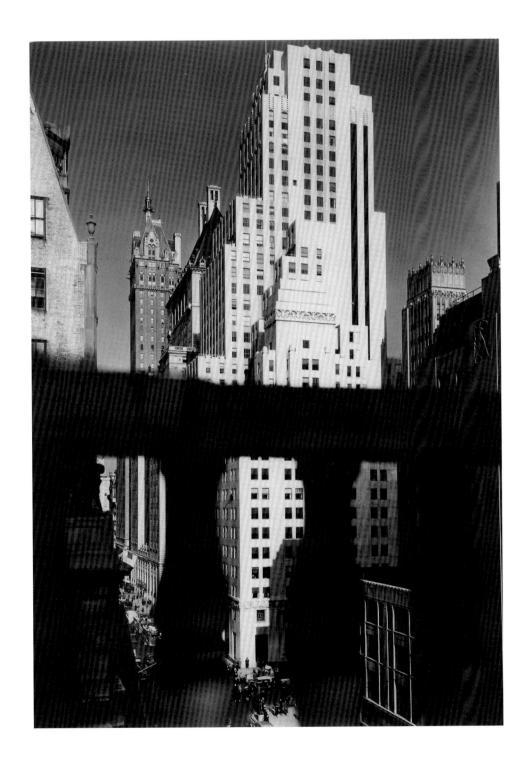

Plate 13.
Berenice Abbott,
Squibb Building with Sherry
Netherland in Background, 1935

Plate 14.
Berenice Abbott,
DePeyster Statue,
Bowling Green, New York, 1936

49

Plate 15.
Berenice Abbott,
Canyon, Broadway and
Exchange Place, 1936

Plate 16. Berenice Abbott, *Herald Square*, 1936

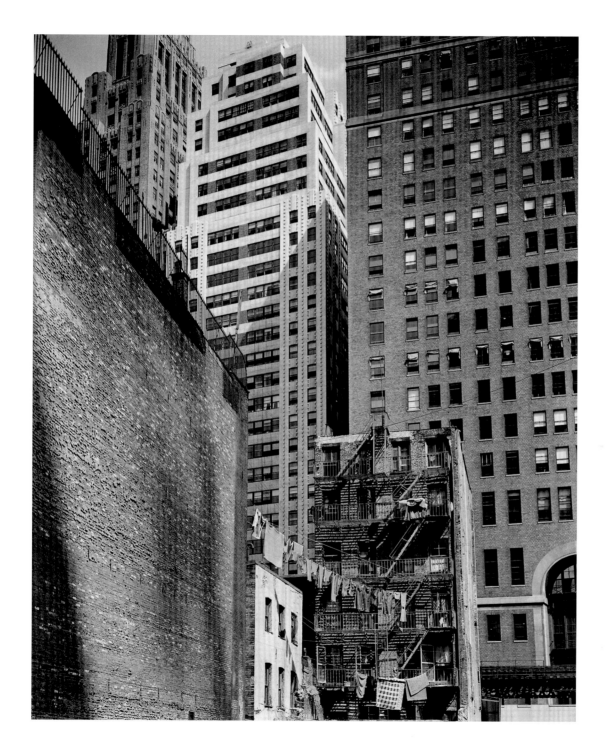

Plate 17.
Berenice Abbott,
Construction Old and New,
1936

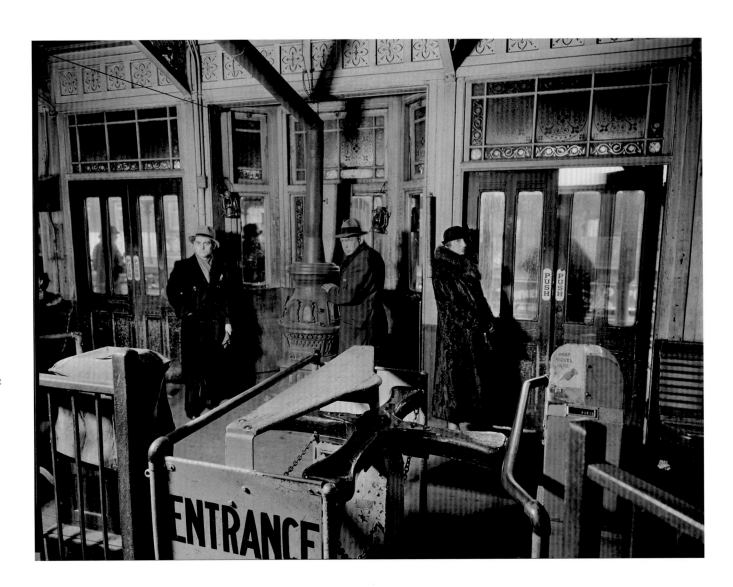

52

Plate 18. Berenice Abbott, "El" Station Interior, Sixth and Ninth Avenue Lines, Downtown Side, 72nd Street and Columbus Avenue, 1936

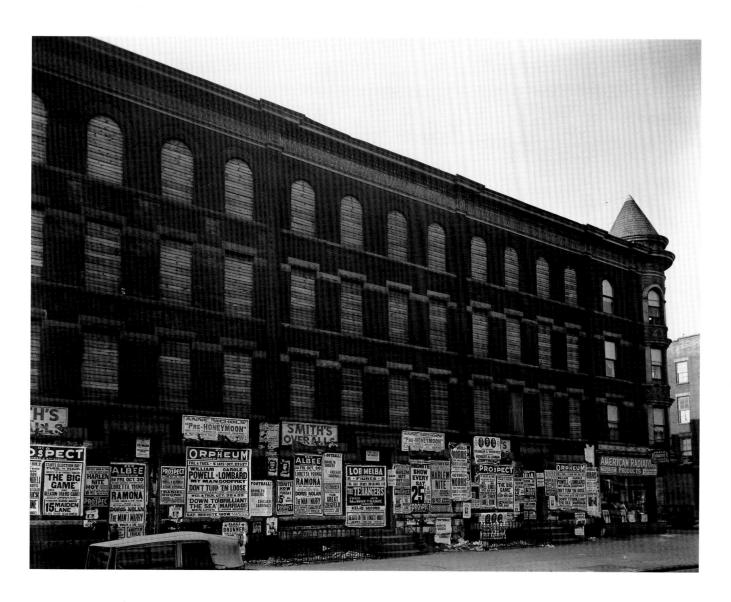

Plate 19. Berenice Abbott, *Fourth Avenue, No. 154*, 1936

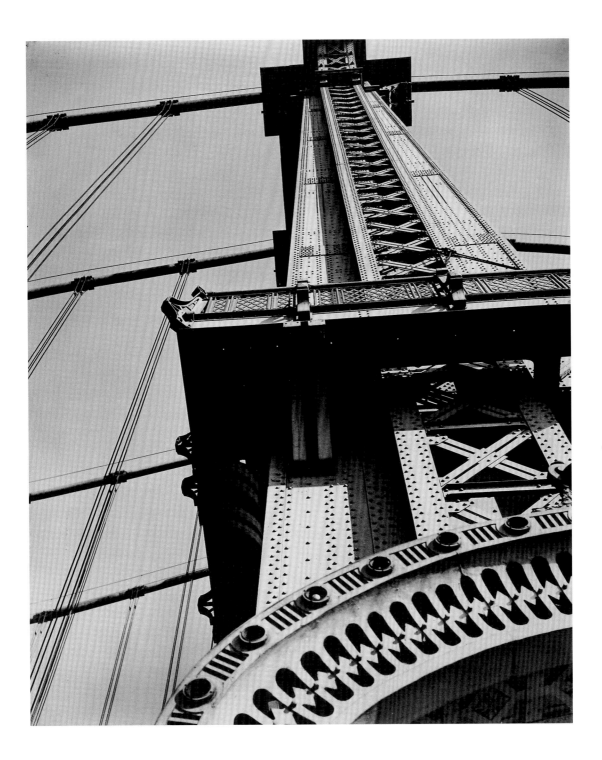

Plate 20.
Berenice Abbott,
*Manhattan Bridge
Looking Up*, 1936

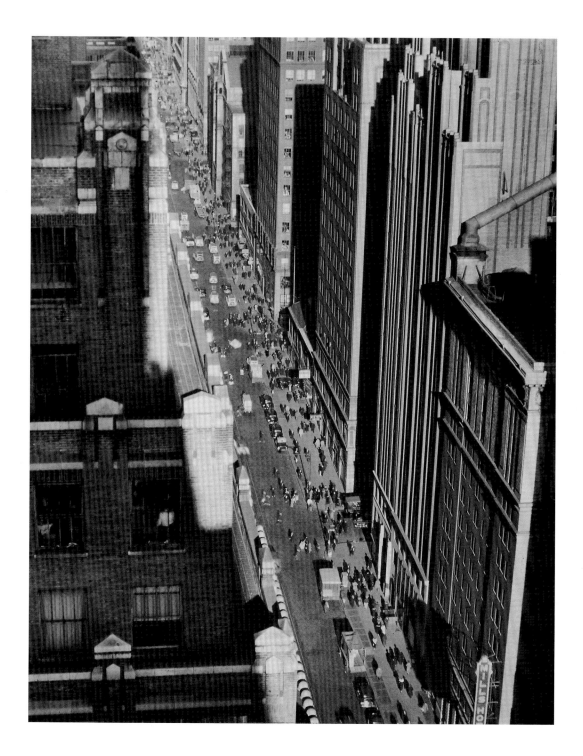

Plate 21.
Berenice Abbott,
*Seventh Avenue Looking North
from 35th Street, New York*, 1936

56

Plate 22. Berenice Abbott, *Stanton Street, Nos. 328–332, Manhattan, 1937*

Plate 23.
Berenice Abbott,
Bread Store,
259 Bleecker Street, 1937

58

Plate 24. Berenice Abbott, *Hell Gate Bridge,* 1937

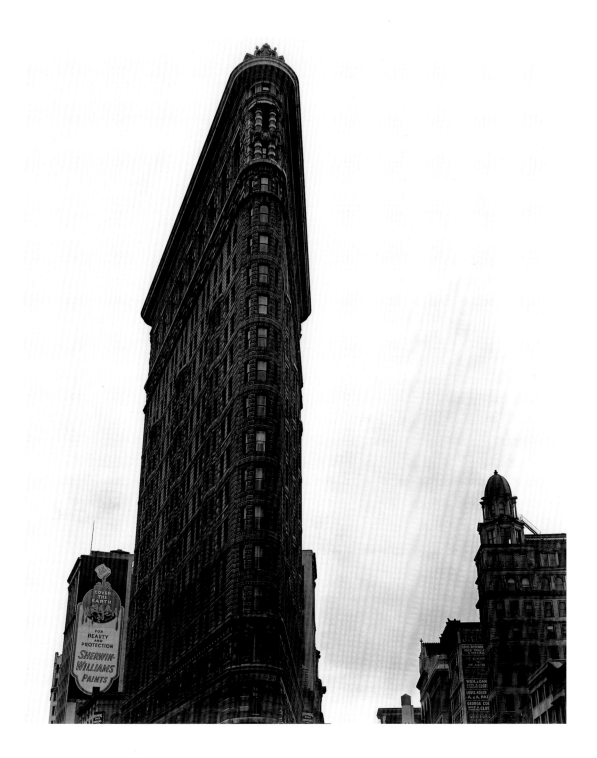

Plate 25.
Berenice Abbott,
Flatiron Building,
Madison Square, 1938

"The Work of an Artist": Walker Evans's *American Photographs*

Concurrent with an expanded presence in magazines and photo-books during the 1930s, documentary photography forged a close new relationship with the art museum. Of particular importance was the relationship between the Museum of Modern Art and Walker Evans, which resulted in Evans's 1938 exhibition, *American Photographs,* and its accompanying catalogue. Late in his life, Evans recalled the show as a sea change that altered the course of his career. Despite the fact that MoMA was a young institution, the distinction of having its first large-scale one-person photography exhibition became, for Evans, his "calling card"—a precise metaphor for the professional transformation afforded the photographer.[1]

Evans's presentation of his work in *American Photographs* amounted to an ambitious declaration of professional identity at a moment when there was no single, defining professional model for the working photographer. The exhibition gave him a forum to announce himself as a modern artist rather than a contract employee, and thus to collapse the distinction in photography between work as a product and work as a process. In Evans's view, the nature of photographic labor, as well as of photography itself, was at issue. Thus the key concepts that Evans put into play within the show intertwined making and the thing itself, so much so that they appeared transparent to one another: the photographer questioned the nature of photographic representation and narrative; proffered the illusion of unfettered movement; and focused on time, repetition, and stasis as subjects unto themselves. It is not surprising that as Evans strove to characterize his own practice with this exhibition, the specific conceptual threads he focused on were shared with other young photographers such as Berenice Abbott and Margaret Bourke-White.

The central argument of this essay is that with this complex toolbox of ideas and values, Evans chose to fashion himself on the model of the modern artist, and that he did so primarily as a means of stabilizing the labor of making photographs. Evans's self-positioning was paradoxical: he relied upon romantic, even chimerical, ideas about the independence and freedom of the modern artist. Simultaneously, however, he forged his understanding of the difference between contract employment and modern art production in stark contrast to many of his peers in the 1930s, who regarded the collapse of a distinction between art-making and other forms of labor with eager anticipation. Further, Evans, like Abbott and Bourke-White, consistently produced work for hire, most prominently as a federal employee with the Resettlement Administration (later, the Farm Security Administration). In fact, Evans achieved the greatest successes of his career while working on assignment. Finally, although Evans

sought to create a narrative of autonomy throughout the exhibition, his actual position within the museum was anything but secure—the photographer frequently worked *for* the museum rather than independently of it.

American Photographs emerged out of this paradoxical framework and bore its traces—Evans's claims were made more fragile by a larger question at that moment about the proper place of photography in public life and the art museum, as well as the relationship between documentary photography and the fine artist. Thus the exhibition itself, with its declarative statement of identity, made an arguable but enduring case for the viability of documentary as an art form. We take its contention—and Evans's perspective on the art-documentary relationship—somewhat for granted now, but in 1938 his position was unusual both in his distinct appreciation for the character of the documentary photograph and in its aggrandizing claim about the nature of *making* photographs. Despite the exhibition's importance, it is somewhat obscure historically, having been long overshadowed in public memory by its catalogue. Although many now know the project by that book, which is considered one of the first great American photo-books, the exhibition also merits critical reflection as a daring and forceful response to two questions: "What makes a photograph?" and "What is the work of the photographer?"

Close examination of the exhibition teaches us much that the catalogue does not, including how multifaceted, experimental, and even bracing Evans's work appeared in 1938 at the relatively new MoMA. As a case study, the show also teaches us how closely intertwined emerging institutions of modern art were in the 1930s with the ambitions of young photographers. Members of the generation that included Evans, Abbott, and Bourke-White were not plucked out of obscurity by curators bent on demonstrating the proper relationship of documentary photography to art. Instead, the photographers danced with museum professionals and patrons throughout the decade, working out their relationships in a fitful but constantly renewed process of negotiation. The contested relationship between art and photography has proved of lasting consequence mostly because the contest itself has radically affected our perception of photography's proper place in public life, juxtaposed with its integral role in the development of modern art.

But an examination of the "dance" in the 1930s reveals different stakes, including the important matter of professional identity. By 1938 Evans saw that to claim the identity of modern artist would enable him, if only rhetorically, to declare freedom from the demands of workaday employment—to claim, essentially, a place outside the prevailing industrial economic order. The responsibility that documentary photography should offer an independent vision, then, was more a product of than a prerequisite for Evans's preferred professional identity. Because independence of vision is the primary narrative of American Photographs, the genesis of that narrative can be traced back to the working life of the photographer.

Ambition

In the fall of 1938, when American Photographs opened at MoMA, Evans had just turned thirty-five and was already regarded by his peers as one of the foremost photographers of his generation. Although Evans was raised in the Midwest (as his early champion and interlocutor, Lincoln Kirstein, repeatedly pointed out), for over ten years he had lived primarily in New York, and his world was thoroughly rooted in that city and its surrounding area. For much of

the 1930s Evans scrambled to gain an economic foothold among the city's young intellectuals and arts professionals. "I know for a fact he is without means," Kirstein wrote in a grant recommendation for Evans in the fall of 1937. "He is not a boy any longer, but he looks five years older than he actually is."[2] Evans tried to sell work to media outlets and gallery patrons, but such sales were irregular, so Evans (like many photographers of his generation) supported himself and furthered his craft via a long sequence of commissions for private individuals, museums like MoMA, and the famous Resettlement Administration, an agency of Roosevelt's New Deal. Together with the photographs of peers such as Dorothea Lange, Arthur Rothstein, and Ben Shahn, Evans's work for the RA is now regarded as a crucial window onto American life during the Great Depression. As a result of his many commissions, by the time Evans and museum officials were planning his exhibition in 1938, the pool of photographs they drew from included much work for hire, including RA material, along with a smattering of independent work.

American Photographs represented an early culmination, rather than the absolute beginning, of Evans's desire to find successful venues in which to show his work. The relationship between photographers and museums began to develop in earnest nearly a decade before Evans's MoMA show, with the establishment of the Harvard Society for Contemporary Art (1928–34). In its roster and program, this organization prefigured the establishment of institutions of modern art in the United States, including MoMA, founded in 1929. In November 1930 the organization expanded its program to encompass photography, mounting an exhibition of established and emerging photographers from the United States and Europe. The show included three young Americans—Evans, Abbott, and Bourke-White—who showed, respectively, signage and

urban scenes, portraits of prominent Parisians, and commissioned scenes of industry. The exhibition was also notable for its diversity: aerial photography, plays of light and shade, architecture, x-rays and astronomical images, portraits and photographs from the picture presses were all represented.

The Harvard Society exhibition announced a new, democratic model of photographic practice, one not bound by hierarchy but open to new processes, new achievements in printing and mass reproduction, new subject matter, and finally, new artists. Lincoln Kirstein, one of the organizers, declared in an unsigned introduction that photography had been transformed in the post–World War I period and the wake of American Pictorialism: "The necessity for simple clarity in documentary form opened the eye of the camera to the approach for which it was originally intended."[3] Kirstein was uninterested in defining *documentary form* as a record of social conditions or inserting it in a tradition of progressive social documentary such as that practiced by Lewis Hine; instead, he used the term in relation to what he saw as an emerging definition of camera work. The term encapsulated contemporary practice that ranged broadly in terms of subject and approach but was also unified as a kind of record-making that isolates a single, transient moment in what Kirstein referred to later in the essay as "the flux of time." Importantly, although the approach was au courant, it gained legitimacy from its backward glance to photography's "original" approach. Kirstein was conspicuously vague about the nature of that approach.

It is not immediately obvious that (or how) Evans's earliest works would have fit Kirstein's model of documentary. We know from the checklist that the works Evans sent to the Harvard Society exhibition included several city signage views and images of New York's East River made

between 1929 and 1930. We do not know exactly which pictures he sent, but *Untitled (Brooklyn Shipyard)* (plate 26) and *S.S. Leviathan, New York City* approximate part of his selection. The photographs are characteristic of Evans's early work: city views that refuse to celebrate the skyline and instead focus downward and across the human-scale sightline. Sewer gratings, the watery edges of the city—including the Brooklyn Bridge—and the crisscrossing lines of electrical signage occupied his interest. These photographs lack a horizon line; they are instead notable for razor-straight perspective and oblique angles. Evans also (mostly) avoided human subjects. Geometry is the core concern of his early urban compositions, and their sturdy lines and blocky shapes spread evenly across the surface of the pictures. Deliberately unromantic in their presentation, they are not indebted to a tradition of social documentary; rather, Evans began his career with a steady, knowing investment in the graphic sensibility of modern art.

It was perhaps Evans's friendship with Kirstein that pushed the young photographer to engage seriously with documentary photography. Evans probably met Kirstein in the winter of 1930, and the friendship that developed between the two men proved as instrumental, in its way, as any later success that Evans enjoyed. Kirstein, a recent Harvard graduate, ran the literary journal *Hound and Horn* (1929–34) and published Evans's early photographs as well as his 1931 critical essay, "The Reappearance of Photography."[4] The "reappearance" of the title was Evans's claim that new photography must reach back in time, past what he called the "misty lanes" of Pictorialism to the directness of early camera work. In the essay Evans dismissively lumped all art photography of the 1890s through the 1920s under the general heading "the middle period" and strongly implied that the defining characteristic of the middle period was its adherents' aggressive use of beauty

Walker Evans, [*S.S. Leviathan, New York City,*] 1930. Film negative. The Metropolitan Museum of Art, Walker Evans Archive, 1994 (1994.251.247).

as the basis of their claims to artistic achievement. Such claims presented a sharp contrast with what Evans described as a nascent third period, "a valid flowering" of clinical, editorial, and impersonal camera work. Evans was no historian, but his hostility toward the middle period was less a function of sloppy scholarship than a deliberate refutation of the most dominant artist photographer in America: Alfred Stieglitz. Evans rejected Stieglitz's authority over American photography and instead praised very early photographic practice as a model of pure ob-

servation. In doing so, he identified his generation's growing perception of the photograph's unique relationship to temporality (its ability to fix a single passing moment out of what Kirstein called "the flux of time"). Both observations led Evans and Kirstein to reframe contemporary photographic practice as documentary. The tradition they identified, however, drew legitimacy not from the daisy chain of social documentary's history but from a model of photography that reached back to the nineteenth century, leapfrogging middle-period art photography. Their ideas about documentary boiled down to several key concepts: first, photographs should fundamentally reflect, even elevate, precise moments pulled out of the current of time; second, rather than presenting posed compositions, moments in time should be captured and registered sharply on film. Importantly, neither man defined documentary a priori in terms of its subject or compositional style; rather, the term seemed to dictate an idealized practice of capturing moments in time.

With so much photographic history on the chopping block, Evans left himself in the months and years after the crash of 1929 with real questions about what to photograph and how to construct a picture. His *[Lunchroom Window, New York City]* (1929, plate 27) suggests one direction that his move toward documentary would take: still urban, still at eye level, the trio of diners forms a group portrait made in passing, of subjects whose awareness and engagement with the photographer seem to flicker with the moment. Evans's subjects, two of them midbite, peer intently past the plate glass window of the Lexington Avenue lunchroom into the spectacle of the street, which is partially visible, reflected on the surface of the window. Their absorption holds them in a suspended moment, and our perception of Evans's movement past the window freezes the photographer as well, placing him in time and space. In its privileging of perception and fleeting temporality, and his pursuit of psychological remoteness in his subjects, *[Lunchroom Window]* and slightly later works, such as his 1933 *People in Downtown Havana* (plate 33), inaugurate Evans's inquiry into photographic portraiture. It is important that Evans developed a repertoire of these unposed portraits at the same time as he produced highly posed portraits like his aptly named *Posed Portraits, New York* (1931, plate 29) and *Coal Dock Workers, Havana* (1933, plate 34). Along with photographs of architecture, portraiture formed the core of his concept of documentary.

Although Evans had already begun to make photographs of architecture, in April 1931 Kirstein hired him to travel through New England with the architectural historian John Brooks Wheelwright and make pictures of nineteenth-century Victorian architecture for a proposed book (the project would go on intermittently for at least another year; the book never materialized). Kirstein's interest from the very start was the photographs more than an architectural history. He repeatedly used the language of photographic temporality in his diary from the trip, describing Evans as "a surgeon on the body of time," and he celebrated the works that were, in his word, "airless," or visually sealed against the modern world.[5] *Gothic Gate near Poughkeepsie, New York* (1931, plate 30), for instance, presents its cottage safely ensconced behind a metal fence and under a graceful tree canopy, removed from the present by its elaborate tracery and distinctly unmodern architectural flourishes.

Despite Kirstein's formulation, many of Evans's photographs from the Victorian architecture project were not at all airless. Works like *Greek House, Dedham, Massachusetts* (1932, plate 31) depict the historical anachronisms that often ensue from the reuse and re-adaption of old buildings, such as the insurance office that occupies part of a

nineteenth-century Dedham home and the accommodation of the streetscape to modern automobiles. Photographs like *Greek House, Dedham,* suggest that a critical gap opened between Evans and Kirstein about the role of temporality in documentary photography. Whereas Kirstein was invested in a passionate defense of the record-making role of photographs as the keepers of remote cultural history, Evans, starting with the Victorian architecture project and increasingly through the 1930s, devoted himself to making photographs that probed the push-and-pull between past and present in the built environment. The idea that the photograph could encapsulate the complicated intersection of time, culture, and architecture was central to Evans's work, as it was to Abbott's, but as early as 1933, with works like *Untitled (Cinema)* (plate 32), Evans had begun to embrace an expanded inquiry into mass culture as well.

In the early 1930s Evans found good venues for exhibiting his work. Catalyzed by the Harvard Society exhibition, new forms of documentary photography appeared regularly in museums and galleries in the early 1930s. Like the Harvard Society show, these exhibitions actively contested older models of photographic privilege by combining fine and commercial camera work; their unifying logic was Kirstein's open-ended definition of documentary. Older, established artist photographers were regularly included in these shows, but the energy and excitement had shifted to a younger generation of photographers, including Abbott, Bourke-White, and Evans, as well as figures like Manuel Álvarez Bravo, Henri Cartier-Bresson, Anton Bruehl, and Lee Miller.[6] Private galleries expanded their repertoire even further than museums: the Julien Levy Gallery, the John Becker Gallery, the Weyhe Gallery, and the Delphic Studios all organized shows of contemporary photography between 1931 and 1933.

By the middle years of the decade the Great Depression had done serious damage to the fledgling market for photographs, and Evans, along with many of his peers, had to retrofit his emerging practice to the demands of contract labor. Just as the turn toward documentary practice had a "changing of the guard" aspect, so too did the embrace of work for hire by young documentary photographers during the 1930s. Bourke-White had long worked primarily for industry and Abbott had done portraits, but all took up piecemeal commissions in the first years of the decade. By 1935 Evans and Abbott had government jobs, working respectively for the Resettlement Administration and the Federal Art Project. Abbott's work provided the funding and clerical support to complete her major documentary project, *Changing New York.* Evans's position with the RA (July 1935–February 1937) afforded him time and resources to make photographs in the American South for the use of the New Deal agency, which was charged with evaluating and modernizing American agriculture.

Evans's work in the South was deep in its reach and varied in its approach, but many of the same concerns that shaped his understanding of documentary photography continued to dominate his practice. For instance, Evans made a suite of photographs that showed men outside of barbershops, including *[Barber Shops, Vicksburg, Mississippi]* (plate 41), during a trip in late February 1936. For this suite he was not walking by, as he had been on Lexington Avenue several years earlier. Instead, Evans set up his camera and tripod across the street. His method suggests that he was bringing his formal explorations of posed and unposed portraiture into line, creating a hybrid form that only became possible as he stood still and let his camera blend into the streetscape. Other photographs from the morning reveal that between exposures the men moved around, not by way of posing for the photographer (al-

Walker Evans, [*Street Scene, Vicksburg, Mississippi*], 1936. Film negative. The Metropolitan Museum of Art, Walker Evans Archive, 1994 (1994.258.324).

though they certainly reveal their awareness of him), but simply following their own paths through the day.[7]

The government job provided Evans with new equipment, including a long lens that allowed him to experiment with spatial compression and pursue new avenues of exploration of the built environment. In *Birmingham Steel Mill and Workers' Houses* (1936, plate 38), he made use of the lens to command a sweeping view of the factory landscape. The lens compressed near and distant space, which allowed Evans to bring the mill and the housing (which was owned and operated by the mill for its workers) into direct comparison; the tight line of front porches echoes the repetitive, orderly row of smokestacks on the mill. *Birmingham Steel Mill and Workers' Houses* is one of Evans's grandest American compositions, with its dirt road approach mimicking a classical allée and a factory that fills

the horizon like a modern monument. One could easily read this photograph as a celebration of the orderliness and monumentality of American industry, particularly at a moment when industry was ailing. Such an impression is aided by the clear reference to Margaret Bourke-White's glamorous photographs of factories, in which repetition is the sign of modernity and a source of excitement and visual energy (plates 53 and 59). But the comparison fails: the flat, gray shape of the factory, the empty space in the composition, and the wobbly, marginal row of workers' housing reveal not a celebration of this landscape or of industrial production but a cooler evaluation of the meagerness of everyday life in the factory's shadow.

In July 1936, as Evans began his second year of work for the Resettlement Administration, he was furloughed by the agency so that he and the writer James Agee could

Walker Evans, "Three Tenant Families" [vol. 1, page 40], 1936. Gelatin silver prints in bound notebook. Library of Congress, Prints and Photographs Division, Lot 991 (OH).

spend time in Hale County, Alabama, to work on a story for *Fortune* magazine's "Life and Circumstances" series, an occasional feature on American workers. The project was not published by *Fortune* but eventually became *Let Us Now Praise Famous Men* (1941), one of the most beloved and studied books in American literary and photographic history. Evans and Agee were interested in tenant farmers.

In Hale County, they met three interconnected families: the Burroughs, the Tingles, and the Fields. The challenge of representing the families as he grew to know them was new to Evans and resulted in a group of portraits that are astonishingly intimate. Among them, Evans's portrait of Allie Mae Burroughs, *Alabama Tenant Farmer Wife* (1936, plate 46), is the most famous and enigmatic. Tight and extremely simple in its composition, the drama of the portrait emerges from the directness of Burroughs's response to the camera, and its visual interest is enlivened by the pattern of her dress, her hair, and the wood grain behind her head.

Evans's arrangement with the RA stipulated that, despite his furlough, he would provide the agency with negatives and prints from the Hale County project. Instead of sending all of the negatives, as had been requested, Evans split his work from the trip, keeping many negatives in his own collection while sending a representative group to his supervisor, Roy Stryker, who headed the RA's historical division and oversaw its photography project. This act of rebellion was not unique; Evans split his negatives throughout his time on the government payroll. Nevertheless, shortly after he left Hale County and turned in his negatives, Evans sent Stryker an intriguing item: a two-volume notebook full of prints from the project arranged in a sequence completely dissimilar to the book that Evans and Agee would later produce. The notebook, titled "Three Tenant Families," offers an alternate presentation of the photographs: Evans ganged several photographs on a page, and the sequence of the Burroughs family (the first) suggests a narrative of approach and movement through the house and farm. Throughout the notebook, Evans used repeating sequences to suggest the families' movement. Beverly Brannan and Judith Keller have convincingly argued that the notebook represented preparatory work for

a film that Evans wanted to make under the aegis of the RA, which fits in with his well-documented desire to make a documentary film.[8] As a collection of still photographs, however, Evans clearly used the notebook to structure a narrative of the dual, nonsynchronous movement of photographer and subject (a movement that comes to a standstill only in portraits such as *Alabama Tenant Farmer Wife*).

Evans's exploration of movement in time would eventually become the core of his exhibition *American Photographs* and his primary visual mechanism for demonstrating his independence of vision, but the exploration itself had roots in his earliest documentary photographs. Still, it was not until he worked for the RA that Evans's movement took on a sustained narrative dimension, as revealed in "Three Tenant Families." With that project, Evans generated a formal means of declaring his independence of vision and expression, thus allaying his fears that his work would be utterly absorbed by the government's voracious appetite for propaganda. Although Evans's arrangement with the RA was generous by contemporary standards, he frequently expressed anxiety about the expectations of his position, writing privately in an undated manuscript:

> When a man working in the field of any kind of "expression" finds himself working for the state he sooner or later discovers that his employer begins to impinge on a certain very important side of his rights: the right to be presented as himself instead of as a sewer of state ideas.[9]

Evans's note of scorn echoes the tenor of his correspondence with Stryker. His tone made Evans an exasperating employee, but the heart of the difficulty lay in redefining himself and his work within the boundaries of workaday employment. Evans perceived and resisted what to him was a nightmare scenario: the loss of authorial control. Although in retrospect it seems perfectly reasonable for the government to insist on creative control over an employee's work, Evans did not conceive of his work within the tradition of social documentary and could not make peace with filling out someone else's storyline.

Evans's anxiety set him apart from his colleagues at the RA, and not in a flattering way. His position can be read as that of a classic prima donna, making unrealistic demands in the name of a highly romantic and historically dubious notion of modern art as a magically independent realm of production. Evans's paradoxical tendency to rely upon commissioned work while resisting the terms of commissions undoubtedly reinforces this damning critique. Yet without denying the legitimacy of this understanding, it is possible to see Evans's resistance and anxiety in a productive light: during the 1930s many artists, especially photographers, worked for commissioning agencies like the RA (or commercial entities), and Evans foresaw how easily their work could be co-opted into broad narratives that far exceeded the artists' own interests. Further, while Evans clearly appreciated his own need to make a living, he was aware that photography was a medium that was answerable to too many masters, and thus he resisted the wholesale incorporation of photographic practice into an exclusive model of salaried labor. In other words, Evans regarded resistance to his own employee status as completely necessary, which won him few friends in the RA hierarchy.

Stryker had *his* final say in the fall of 1937, when Evans asked him to write a letter of recommendation for a Guggenheim fellowship, then as now a prestigious and coveted award for artists and scholars. Evans had already left the RA, so the award would have provided funds for a completely independent project. Evans suggested in his application that the award would probably result in either a study of New York or the completion of the Hale County

project but was deliberately evasive about his intentions, writing, "The nature of the work is not readily describable in words, and the direction it may take is unpredictable."[10] It is hard to tell what was more damaging to his application: his own statement of purpose or Stryker's devastating letter. While the administrator agreed with the other referees about the high quality and great interest of Evans's photographs, he warned the committee that Evans worked hardest and best when his assignment was clearly articulated and the parameters of a project were defined in advance. He also strongly implied that the parameters were best set by someone else. In an extraordinary irony, he cited the success of the Hale County project as an example of Evans's "work under pressure."

By directly casting doubt on the feasibility of Evans's proposed project, Stryker may have in part been expressing his own long-standing hostility toward Evans for what he perceived as his employee's foot-dragging when given too much freedom in the field. Yet Stryker also seems to have genuinely felt that the structure, time frame, and collaborative nature of the *Fortune* project were the magical combination that yielded the finest photographs of the young artist's life. In other words, as difficult an employee as Evans was, to Stryker his best work was that produced for hire.

In the final paragraph of his long letter, Stryker put his cards on the table and clearly expressed the rupture that underlay contemporary photography:

Mr. Evans suffers a great deal from a feeling that he is misunderstood and that he is not recognized as the artist he feels he is. This of course ties in to the controversy of which you are more conscious than I—"photography as art." I think he would be much better off if he [recognized] that he is one of the few who are competent to make a great contribution in the documentary field, and forget about this controversy. It is perhaps this conflict which is accountable for a trait which some of us have regretted in Evans—a seeming inertia and a slowness in "getting going."[11]

Stryker named Evans's ambitions, denying them completely, but he was pointedly unkind and inaccurate about the reality of Evans's work life and overly polarizing about a gap between art and documentary, over which, during the 1930s, there were many bridges. Stryker, however, had a great deal to gain in his own professional life from the irresolution of the art/not-art dichotomy and here brought up the long-standing debate to put Evans in his place as an employee. For Stryker, the continued viability and stability of the concept of documentary, independent of modern art, were important for reasons both philosophical and professional. As a progressivist, Stryker believed in the independent role of photography in education; as a bureaucrat, he was defensive of the need for continued budget appropriations. But Evans's perspective was radically different: he and his peers traversed the line between employment and independence during the 1930s because they had to. Evans, no longer a boy, needed the money.

The Museum's Documentary

Over the course of the 1930s, as the Museum of Modern Art took shape as a major cultural institution, Evans's steady relationship with the museum promised an avenue for establishing creative control over his work. This connection arose through his friendship with Kirstein and other former alums of the *Hound and Horn* and the Harvard Society for Contemporary Art, including Thomas Mabry, the museum's executive director from 1935 through 1939 (he served as the administrative counterpart to Alfred Barr, the director). Mabry kept Evans informed about what

was going on at the museum, and during its turbulent first decade he protected Evans's interests by shuttling messages between Evans, Barr, and the trustees, extending Evans's deadlines, and offering him commissions. The distinction of Evans's association with the museum was undoubtedly beneficial, but it often forced the photographer to wear two hats: he was both a collection artist and a contract employee. Paradoxically, Evans's status as a worker for both the RA and MoMA eventually brought him into view as an artist.

Evans's projects at MoMA between 1933 and 1938 suggest that he switched roles fluidly and regularly. In his first show there, in 1933, the museum hung photographs from the Victorian architecture project as a complement to its Edward Hopper retrospective. Evans's work was also included in the museum's *Fantastic Art, Surrealism and Dada* (1936) and in Beaumont Newhall's omnibus *Photography 1839–1937,* although Evans preferred to be represented in Newhall's show by his prints of Mathew Brady negatives rather than with his own work.[12] (This plan did not work out: Evans failed to gain access to the Brady negatives, and Newhall eventually borrowed prints of Evans's work from museum staff and friends, including Barr, a trespass Evans never fully forgave.) In the summer of 1935, Mabry hired Evans to take photographs of objects in the museum's *African Negro Art* exhibition and print them in five series for African American colleges. The following year, Mabry again struck a deal with Evans to produce a collection of photographs suitable for making into postcards to sell in the museum's shop.

The postcard project is particularly interesting in light of an inquiry into photographic labor. Evans and Mabry corresponded in 1936 about the possibility of Evans producing a series of postcards for the museum gift shop, but the plan failed in 1937 because Evans, Mabry, and the chair of the board of trustees, A. Conger Goodyear, could not come to an agreement about the terms by which the postcards would be produced. Evans was interested in the smallness, portability, and relative anonymity of the postcard, and he had a large collection of his own.[13] When Mabry secured funds for the project, Evans began producing unique prints of his large-format negatives on postcard stock. Interestingly, he did not miniaturize the full exposure to accommodate the severe horizontal template of the postcard. Instead, he printed sections of larger negatives, effectively retrofitting their compositions. For instance, a postcard (plate 42) made from the same Vicksburg barbershop negative as his *[Barber Shops, Vicksburg, Mississippi]* (plate 41), isolates the man on the left as its sole subject and turns a horizontal composition into a vertical. A similar movement is afoot in a postcard based on Evans's *Penny Picture Display, Savannah.* The completed grid of penny portraits in the full-scale photograph, *Penny Picture Display, Savannah* (plate 45), is transformed in the postcard into an abstract vignette. Although Evans was interested and enthusiastic about photographs that seemed anonymous through their openness and simplicity, his postcards are notably particular and individualized, as well as compositionally independent. Postcard stock is not a valuable printing material, so Evans clearly enjoyed the prospect of mixing genres: each photograph was printed individually on paper meant for mass distribution. Although there were certainly administrative differences between Evans and Goodyear, the project failed because Evans could not make the postcard project successful on a large scale; he could not resolve the tension between anonymity as a pictorial principle and the uniqueness, or individual authority, of each print. The promised postcard templates simply did not materialize within the allotted time frame.

Walker Evans, [Detail of *Penny Picture Display, Savannah*], 1936. Gelatin silver print on postcard stock. The Metropolitan Museum of Art, Purchase, The Horace W. Goldsmith Foundation Gift, through Joyce and Robert Menschel, 1996 (1996.165.1).

Evans's many roles at the museum during the 1930s partly reflect the manifold function of photography in society, but they also demonstrate an institutional openness to the shifting function of photography within an art museum and to the shifting roles of the photographer. There was from the start an acknowledgment of Evans's place within the museum's exhibition schedule, but his work also had a utilitarian role, and sometimes the two got mixed up. The museum's flexibility derived from the technology's adaptability, but it was also a reflection of the museum's initial approach to American modernism. Although the history of the museum is well documented, many historians addressing its early years have taken for granted that modernism was fully understood by the museum's early administrators and trustees, and that there was consensus within their ranks. This is only partially true. Barr focused on clarifying the genealogy of modern European painting and sculpture, and the first trustees' collections were similarly concentrated. But the museum showed ambivalence about contemporary American art. As a result, its first truly successful exhibitions of American art reached back in time: in 1930 the museum exhibited *Homer, Ryder, Eakins;* in 1933 it opened *American Folk Art* (curated by Holger Cahill, acting director of the museum while Barr took a yearlong leave of absence) and *American Sources of Modern Art*.[14] Eventually, museum curator Dorothy Miller worked out a semiformalized system with Barr whereby contemporary painting and sculpture by American artists would be de-emphasized but American production in other areas, such as photography, film, design, and architecture, would be permanent aspects of the museum's curatorial mission.

Multiple factors were at play in this schism, echoing administrative prerogatives and also illuminating broader

aspects of modernism's reception in the United States, including in particular the interests of Barr and the founders. Further, while modern American painters found successful exhibition contexts at institutions such as the Whitney Museum of American Art (founded 1931) during the early 1930s, MoMA's institutional strategy was to seek out American objects that reflected either on the relationship of modernization to everyday life, as in design exhibitions, or on native vernacular aesthetic traditions, as in Cahill's folk art exhibit. Thus the instrumental and the decorative, the historical and the contemporary, along with all the points of intersection between them, were commingled throughout the museum's presentation of American objects.

As the 1930s wore on, it became more and more difficult to mount all-European loan exhibitions because of increasing tensions and then war in Europe. This did not immediately prevent the museum from offering its audiences—which by the mid-1930s were quite large due to an elaborate touring-exhibition program—a steady diet of modern European painted masterpieces, such as its enormously popular 1936 Vincent van Gogh tour.[15] But it did force the museum to seek out American artistic production to fill out its exhibition calendar. The emphasis continued to be American material and technological culture, including photographs, rather than American painting and sculpture, but the museum actively cultivated a dialogue between contemporary forms of production and much older American artistic traditions. This kind of dialogue has long been understood as part of a search for what the critic Van Wyck Brooks first described as the "usable past" in 1918. Brooks's exhortation to mine the past was originally geared toward writers, but by the 1930s the concept had assumed a broad artistic and institutional appeal.[16] The quintessential example of this type of exhi-

bition was Evans's Victorian architecture show, in which the photographs straddled the divide between being a frictionless means for representing historical American architecture (they were, after all, exhibited in the museum's architecture gallery) and functioning independently as contemporary objects of visual interest.

Given his history with MoMA and the RA, and given the museum's approach to American modernism, it is not surprising that when Evans and museum officials agreed to initiate *American Photographs,* he pushed for an exhibition that would declare the independence of his practice, remind viewers of the eye and will of the photographer, and open up photographic representation as an ontological question rather than an epistemological given.

Opportunity

Although *American Photographs* is central to Evans's career and the history of American photography, there are many mysteries about its exact nature. The exhibition is somewhat invisible in the public record of Evans's career, especially in comparison to the catalogue, because archival material relating to the exhibition, including checklists and press information, touring schedule, hanging instructions, and photographs of the New York installation, has never been analyzed for its overall effect. This exhibition blindness is not unusual: we know even less about Evans's exhibitions earlier in the decade, and checklists and other information are often sketchy for museum and gallery exhibitions in the 1930s. We know that they happened and often what was included in them, but rarely do we know much about how they looked to their audiences. This gap is regrettable, as the hang was an important issue in the 1930s.

As a result of his friendship with Mabry, Evans had real authority over the *American Photographs* project, but there were still compromises to be made. The catalogue has traditionally received more scholarly scrutiny than the exhibition, but it required more concessions to institutional prerogatives, probably because it was a more expensive undertaking. Those concessions ranged from the compact size of the book (its literal proportions were a subject of correspondence between Evans and Frances Collins, the museum's director of publications) to the choice—likely dictated by the need for economy—not to bleed images and even to the arrangement and sequence of pictures.[17] In the introductory statement Evans claimed total control of the sequence, but multiple friends—including Collins, Kirstein, Mabry, and even the young Helen Levitt—remember helping with it.[18]

The catalogue, because of its collaborative nature, was substantially different from the exhibition: the book contained eighty-seven images, mostly uniform in size and scale, each picture separated from its peers by subject matter, white margins, and a blank facing page. It was discrete and elegant, and it looked like art. In contrast, the hundred photographs in the exhibition often repeated one another to some extent and were presented in a variety of formats—some were outsized while others were so tiny that at one venue they were displayed in glass cases.[19] Through their variation, the images jostled one another. Further, the presentation was unusual. Elodie Courter, an administrator at the museum, described the overall effect to a colleague at Smith College:

When we showed the photographs here they were mounted directly on white walls and since Mr. Evans did not want the photographs to be shown under glass or in mats we had to find another way to mount them. They are mounted with a very strong adhesive paste to Masonite. . . . Then the edges of the Masonite have been taped with a black linen tape which comes already varnished. The surfaces of the photographs are quite unprotected and the gloss is Mr. Evans' own finish.[20]

Courter's letter gives the best extant sense of what the photographs looked like: glossy, unencumbered by frame or mount (and therefore probably scuffed), slightly apart from the wall. The support of the Masonite backing changes the dynamic of looking at a paper print into the experience of looking at a thing: the photograph has weight and stands rigidly away from the wall.

In undated notes that relate to the planning of the exhibition, Evans made the following list: "Show Ideas: small defined sections, people, faces, architecture, repetition, small pictures, large pictures."[21] The list suggests that the exhibition promised an opportunity to demonstrate a range of photographic possibilities and to structure an experience of repetition and variation that would directly challenge the idea of a unified and orderly march of pictures by theme. The word *repetition,* in particular, indicates that Evans wanted viewers to experience seeing the same thing again and again, each time under a slightly different guise. Not coincidentally, then, this is the effect that Evans's installation shots bear out. The experimental, and *experiential,* qualities of the exhibition suggest Evans's efforts to find an adequate pictorial strategy for representing the complex American landscape. The small sections, jumps in scale, and repeating motifs suggest a fundamentally new story about making photographs in America.

We know from Courter's documentation, as well as Evans's photographs of the hang, that the photographer made good on his plan to present the works in small clusters: throughout the show, groups of five to six photographs demarcated themes—architecture and the built

Attributed to Walker Evans, installation view of *Walker Evans: American Photographs* at the Museum of Modern Art, New York City, 1938. Film negatives. The Metropolitan Museum of Art, Walker Evans Archive, 1994 (1994.254.626–627).

environment, signage, contextual portraits, and interiors.[22] The show started with a series of photographs of architecture—first, two typological studies of wooden housing, including *Frame Houses in Virginia* (1936, plate 39), then three broader views of small towns with rows of look-alike houses spread over the landscape. Two installation shots reveal that the next sequence was a group of crumbling signs, followed by groups that combined views of buildings with identifying signage, such as *Penny Picture Display, Savannah* (plate 45). At the center of the exhibition were series of interiors and portraits, some from Hale County and other small towns.

Throughout the exhibition, Evans demonstrated that he could exert narrative control via the typological, even clinical, photographic means that he described in *Hound and Horn*. The narrative of the show, which viewers would have reenacted as they moved through the galleries, was the photographer's own movement through the landscape.[23] That physical movement fostered comparisons over space and time, prompting the observation of subtly repeating clues in the visual environment and steadily building into the argument that the nation's culture was experiencing a historic transformation from local to national. The description of America that Evans offered,

then, was not a direct transcription but an accumulated impression that relied on the viewer's experience of seeing the same thing over and over again, as well as illustrative clues to suggest patterns of repetition in the landscape. Evans depicted the breakdown of the regional economy and its replacement by a national economy of brands, logos, and the movement of capital, but this depiction was fully premised by its author's independence of observation and movement.

Was the story new because no one else was telling it or because it presented documentary photography in a different guise than viewers expected? The answer was perhaps a combination of the two. Many viewers experienced that newness as a function of the subject matter: they wondered how representative the project was, asking themselves, "Is this America?" In private letters to Evans and museum officials, and in public reviews (often of the catalogue), critics openly questioned the accuracy of the photographs, indicating that documentary photographs should be transparently representative of the nation they purported to describe rather than so thickly layered with the perspective of the photographer. Some critics were upset that the exhibition afforded poverty and degradation an entrée into the museum. The pictures were exhib-

ited with a minimum of text, they seemed to repeat one another, and their presentation emphasized their thingness rather than their transparency to the everyday world. For these reasons, the exhibition was difficult for visitors to assimilate into historical or contemporary models of documentary practice, which Americans saw everywhere in newly published photo-books, large-scale exhibitions of RA work, and magazines that ranged from the politically progressive *Survey Graphic* to the massively popular *Life*.

If a number of Evans's presentation choices announced to viewers that this documentary was something new, the photographs that depicted signs and signage suggested that the nature of representation itself was at issue. Throughout the exhibition, Evans used photographs of signs to announce the show as a set of signs in itself. The installation shots pictured here reveal an entire wall occupied with images of vernacular signage, graffiti, movie posters, and racially charged revues, including an alternate version of *Minstrel Showbill* (1936, plate 44). Evans juxtaposed a large photograph of a decaying show bill (on the left) with a movie poster photograph whose dimensions are more traditionally photographic, closer to the size of a sheet of film negatives.[24] The effect is twofold. First, we are reminded that transformation of scale is a crucial aspect of photography. Although we usually associate photography with the power to miniaturize, here *all* sense of scale is altered. Second, in the larger, perhaps poster-sized print (although posters in public places were not generally made via photographic processes until later), Evans forced viewers to read this object simultaneously as a show bill and a photograph and thus brought these two terms into an explicit relationship with one another. The photograph flips back and forth between seeming more like a picture and more like a thing. Thus, even before one registers the electrifying content of this suite of

pictures, the group provides a meditation on the properties of still photography and its place within the hierarchy of visual representations in the public sphere.

The sign photographs were taken throughout the Northeast and the South, but they share a common visual language in that many look handmade. They also share the impression that regardless of geography, they have been transformed by time and the elements—including humans. Careful viewers would have noticed that all the signs were in some stage of decay and that in *Minstrel Showbill* the decay was hastened by vandalism. Small holes are visible throughout the advertisement for the Sunny South Minstrel Show, in particular through the eyes of the caricatured mother figure. Although there is no visible vandalism in the other posters along the wall, the deterioration in each is apparent—signs fall apart. In this light, it is interesting to compare the Sunny South show bill with the advertisement for Silas Green's New Orleans–based all-Black revue. The startling difference between the two representations of African Americans had to do with the nature of the posters themselves: in one, an ad for Green's revue, the figures dance in finery, a visual reference not to racial stereotypes but to the standards of bourgeois entertainment. The ad for J. C. Lincoln's Sunny South Minstrel Show, by contrast, offers crude caricatures of the standard Black antebellum figures. The proximity of these two photographs reinforces the sense of a national identity that is constructed through a web of signs: like photographs, which function as signs, and the signs that dot the American landscape, racial identity in the United States is informed and reinforced by signs and symbolism.

It is not incidental that the entertainment advertisements traveled, in the sense that they advertised traveling shows and that the same bills appeared in different towns

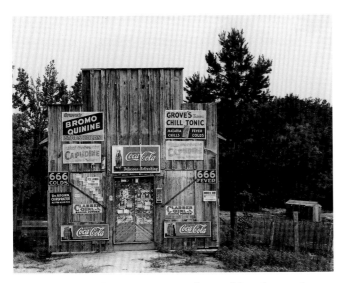

Walker Evans, *Roadside Store Between Tuscaloosa and Greensboro,* 1936.
Film negative. Library of Congress, Prints and Photographs Division,
LC-USF342-008282-A.

Evans visited, largely on RA assignment on 1936. These advertisements were juxtaposed in the show with photographs of other kinds of public signage: decorative architectural elements. Photographs of decidedly immobile pressed metal ornamentation, the tin relics, are stacked on the right edge of the wall. The tin relics' immobility brings the wall's central photograph, a vernacular hand-painted butcher sign, into focus. These photographs, more abstruse yet regionally specific, contrast with the show bills, explicitly evoking the relationship of sign to architecture. Because architecture, in Evans's lexicon, recalls both regionalism and history, the ephemeral, transitional, and placeless nature of the advertisements is again brought into unsteady and uneven comparison, as well as competition, with these localized forms of symbolism.

The wall of minstrelsy and movies introduced the theme of signage and media, but other signs reappeared throughout the exhibition, most notably cheap paper bills adver-

tising products like Coca-Cola, Nehi soda, and 666 Cold and Fever Medicine. Throughout the exhibition, Evans included photographs of public spaces in the South covered with these signs and others that advertised prepackaged, nationally distributed products. In *Roadside Store Between Tuscaloosa and Greensboro* (1936), a photograph of a nondescript building with signs instead of windows, the collection of signs has its own aesthetic order: they are arranged on the façade of the building in a pattern that is precisely mirrored on either side of the door. In another case, *West Virginia Living Room* (1935, plate 37), the Coca-Cola ads are hung inside the house like wallpaper. So out of place as to be purposeless for actually soliciting customers, the paper ads instead pulsed through the exhibition as indicators of detritus that had become a national aesthetic staple in both urban and rural areas. One had to wonder: are we a country united by poverty and a shared appreciation for the satisfying swirl of the Coca-Cola logo?

Evans's exhibition, with its association of portraits, signage, the built environment, and the experience of repetition, identified both the gap and the points of contact between the local and the national. Further, *American Photographs* revealed that the regions Evans visited were under pressure from a host of nationally scaled social and economic forces—forces like the movies and Coca-Cola. Although the pressure was not new, Evans's photographs reveal that its symbolism was still bluntly integrated into public culture, particularly in small southern towns. The signage representing increasingly standardized products formed a kind of repeating hum through the diverse regions that appeared in the exhibition, which was then amplified by similarly standardized buildings. The hum of recurrent likeness ensured that as viewers moved through the galleries they again and again confronted signs of both regional and national culture. The sheer

number of repeating terms forced the national and the regional to occasionally flip positions, so that what was common, like Coca-Cola, became particular; and what was particular, like "Gas A," was integrated into the shared pool of abandoned visual detritus. By more or less literally making his photographs over into freestanding signs, Evans acknowledged that by nature signs circulate; they are not bound by locality but instead are mobile and disrespectful of the invisible boundaries between the local and the national (boundaries that were actively being reorganized by the New Deal government).

The photographs of signs in the exhibition brought questions about representation to the surface, but other aspects of the show mined the same territory. Evans included various forms of repetition, so that often viewers had the experience of seeing the same thing over and over. Repetition structured individual photographs, some of which, like the *Birmingham Steel Mill and Workers' Houses* (plate 38), were constructed around the repetition of architectural elements. Repetition also connected photographs to one another: viewers saw the same signs reappear in different photographs. Twice Evans directly repeated himself in multiple photographs. In one case, a row of balloon-frame wooden houses, shown in profile in *Frame Houses in Virginia* (1936, plate 39), literally reappears in a frontal study with the same title (1936, plate 40).[25]

In addition, Evans included a number of photographs in which the buildings look so much alike as to create confusion between buildings that actually repeat and buildings that appear to repeat. The two Virginia photographs were not adjacent in the exhibition, so one wonders how many viewers would have noticed that the photographs depicted the same site. Yet they do attest to Evans's effort to produce the illusion of sameness in the visual environment. If viewers weren't expected to recognize these houses as repeating, they were at least meant to recognize them as in conversation with one another: this is what frame houses look like in Virginia. As in the photographs of signs, Evans was suggesting that pictures function as a kind of sign system, picking up repetition and similarity in the landscape. As viewers walked through the exhibition, the relationship between the particularity of a single location—a single viewpoint—and *how things look* in a more general sense would have dominated their experience. Repetition and variation are the clues to Evans's experimentation with representing ubiquity in the visual environment.

American Photographs was rich in portraiture, which complicated and deepened Evans's use of repetition. Evans exhibited on uniformly sized mats a pair of portraits of the Fields family from Hale County, Alabama, in their bedroom (1936, plates 47 and 48). The two portraits, made during Evans and Agee's time together in Alabama, constituted one of the stranger contrasts of the exhibition. One photograph offers a seemingly traditional family portrait, but the other includes at its center a woman whose head is cropped by the upper edge of the frame. It appears at first glance that the second photograph represents the family assembling for or dispersing after their group portrait and thus records a passage of time between one exposure and the next. Such a reading would support the idea that Evans is here denaturalizing the act of posing, as if we were able to watch the family adjusting to Evans's camera. This play on the family portrait undermines the iconic presentation of the sharecropper's family and prioritizes contingency, chance, and specificity over iconicity and timelessness as pictorial values. Further, the narrative implied in such a comparison synthesizes the qualities of remoteness and temporal distance of the men on the street in Vicksburg within the imme-

diacy and intensity of a portrait like that of Allie Mae Burroughs.

This initial reading depends upon our ability to read the absence of the older woman's head in the second photograph as a residue of motion—as though she were moving into place. The photograph does not wholly support this reading, however; the woman, the mother of Lily Rogers Fields, is posed facing the camera and evidently unaware of her exclusion. When he took the picture, Evans slightly lowered the camera to crop her face out of the composition. The effect is of someone posing, engaged with the camera in expectant anticipation and yet rejected by it. The camera operator made a decisive cut, without the knowing participation of his subject. The effect is to draw attention back to the photographer and his decisions.

The repetition of the Fields family pictures has no a definite or complete meaning. As with the entire group of photographs that Evans made in Hale County, including portraits of the Burroughs and Tingle families and especially that of Allie Mae Burroughs, these portraits seem to be as much about portraiture as they are about their subjects, and the repetition draws us back to the moment of their making and the editorial work of the maker, although here in a particularly unkind way. (A more generous reading might acknowledge that Evans used his brutal editing to demonstrate that all subjects, even people, are subject to the camera.) The double portrait of the Fields family reinforces the impression that Evans pushed his audience to see photographic portraiture as a convention of representation.

Finally, *American Photographs* presented a "new story" about both America and photographs through its relationship to language. The twinning of social documentary photography and descriptive language, which reinforced the genre's usefulness and perceived veracity, was no-

where to be found in Evans's exhibition, where the photographs were presented unencumbered by captions or even titles (wall labels are not visible in the photographs of the hang, and no documentary evidence suggests a list of titles that viewers could use while they were in the galleries, although such a list may have existed). The photographs were about words, about identification and representation, but Evans refused the identification between pictures and words that typically attended documentary and trade photography. His friend, the critic Stark Young, reviewed the show and struggled to describe the relationship between the pictures, "hang[ing] there on the walls as clean as light and sand," and his desire as a writer to give them an anecdotal voice: "Some of them [are] so beautiful and right that you want to hit people over the head with words."[26] Evans's refusal to provide words pushed viewers to experience the space of the exhibition, not as a bundle of social or geographic information, but as a journey. The viewer's mobility through the galleries provided a constant reminder of the photographer's mobility through the country.

In its many references to the photographer's freedom of movement, *American Photographs* was frankly self-referential, which further inverted the rule that documentary photography should have a clear relationship to the everyday world; as an artistic project, it articulated Evans's increasingly sure-footed argument that making photographs was independent work that required total freedom from the constraints of the workaday world. Evans claimed in the exhibition that his role was to create (and print, sequence, and hang) representations rather than just collect pictures and information. In a charged letter to Roy Stryker that effectively cut him out of the exhibition planning process, Evans defensively clarified his role at the museum:

I think you know well enough what I am about to say, but let us not take any chances: this is a book about and by me, and the number of Resettlement pictures I have decided to reproduce . . . has been determined solely on the grounds of my opinion of their worth as pictures. They form a part of my work, all of which is to be represented. The museum understands it this way, is bringing the thing out as an example of the work of an artist, is not interested in this respect in whom he has worked for or with.[27]

Evans's rhetoric suggests that he may have taken the concept of the "work of an artist" more seriously than did the museum's administrators because of the great flexibility in the photographer's role at the museum. One can only imagine the annoyance Stryker must have felt at receiving such a letter. Yet more than setting up a legitimate distinction between a hallowed realm of art and a debased realm of documentary, Evans's letter reveals his frank ambitiousness regarding a privileged form of labor that he identified with art production. The letter grows out of his desire to distance himself from the terms of his employment, which in his view required a loss of authorial control. Instead, Evans idealized the labor of art as a fully independent means of production—without backing, without compromise, without someone else's directives, and without any of the other hallmarks of contract or wage labor. Full independence was the exhibition's fiction: Evans used repetition, variation in scale, and juxtaposition to create the illusion of a mobile and unencumbered artist-eye in the American landscape.

From a contemporary perspective, Evans's professional ambitiousness is more easily disparaged than understood, particularly because his photographs so often examine poverty and crisis, a subject (then as now) that is ethically charged to begin with. What value did he place on independence and mobility, aside from his own comfort or preening sense of distinction? One answer is certainly the expansion of the intellectual respectability of photography. Evans did not conceive of photography as an art within the "middle-period" model of the beautiful print, but instead saw it as a fundamentally new form of art, one perhaps more closely aligned with the intellectual fervor of the modern avant-garde. In many ways, this position proved ironic: Evans's aggressive rejection of the terms of his own production made him adopt essentially the same posture as the art photographers of the middle period that he mocked, including Stieglitz. Yet another—more politically nuanced—possibility for how to read Evans's aggressive ambition exists: he believed that photography as a medium provided a technology for understanding the undercurrents of social transformation, of which the economic shift to national markets and mass media was central during the Depression, and he believed that story had to be told outside the confines of the employment model of industrial capital. In other words, he understood that photographic narratives were highly vulnerable to being co-opted by discrete interests, and he actively sought to control the narratives of his own photographs, even to the point of creating anti-narratives. The model of the working modern artist, self-conscious and deliberate in his or her mode of production, provided a desirable (if fictive) alternative to the model that actually dictated most of his working life.

Evans's show did not present a utopia of the past or the future; nor did it present a comprehensive and politically consistent study of the Depression, of American agriculture, workers, or architecture. Instead, its view of the present was wavering, unsteady, and noninstitutional; its relationship to social documentary was simultaneously central and completely ancillary. For Evans, the ultimate answer to questions about the work of the artist and the nature of

the photograph involved winding the two questions together, making the one unthinkable without the other. *American Photographs*, so central to the institutional history

of art photography, made equally powerful cases about the nature of the work and the nature of the picture.

Notes

I am grateful to Jeff L. Rosenheim for his extraordinary care and custodianship of the Walker Evans Archive at the Metropolitan Museum of Art (WEA/MMA) and for the generosity that he has shown me in unearthing its many riches.

1. Paul Cummings, "Interview with Walker Evans," Archives of American Art, Smithsonian Institution (1971). Quoted by Alan Trachtenberg, *Reading American Photographs* (New York: Hill and Wang, 1989), 238.

2. Lincoln Kirstein, confidential letter of recommendation for Walker Evans to John Simon Guggenheim Memorial Foundation, received Nov. 13, 1937. Letter in author's files, courtesy of the foundation.

3. Unsigned introductory text for Harvard Society photographs exhibition, Nov. 7–29, 1930, WEA/MMA 1994.250.87.

4. *Hound & Horn* 5, no. 1 (Oct.–Dec. 1931): 125–28. Evans reviewed recent volumes by Eugène Atget, Edward Steichen, Albert Renger-Patzsch, Franz Roh, and August Sander.

5. For the "surgeon" reference, see Kirstein, "Diary" (1931), 264. Lincoln Kirstein Papers, New York Public Library Performing Arts Division. Reprinted in James R. Mellow, *Walker Evans* (New York: Basic Books, 1999), 137. For the "airless" reference, see Kirstein, "Walker Evans' Photographs of Victorian Architecture," *Bulletin of the Museum of Modern Art* 1, no. 4 (Dec. 1933): n.p.

6. For an incisive summary of the marginalization of Alfred Stieglitz in particular, see John Raeburn, *A Staggering Revolution* (Urbana: University of Illinois Press, 2006), 19–29.

7. My assertion that the Vicksburg photographs are largely if not completely unposed puts my argument here at odds with that of James Curtis, whose chapter on Evans in *Mind's Eye, Mind's Truth: FSA Photography Reconsidered* (Philadelphia: Temple University Press, 1989), 21–44, makes the opposite claim. My reading of the sequence of negative records and published photographs reveals not a coordinated photo shoot but instead the requisite period of time in which a large-format camera and its operator disappear into the streetscape and are basically forgotten by passersby. See WEA/MMA 1994.257.91, 1994.258.112, 1994.258.122, and 1994.258.318–25.

8. Beverly Brannan and Judith Keller, "Walker Evans: Two Albums in the Library of Congress," *History of Photography* 19, no. 1 (Spring 1995): 60–66. For an account of Evans's interest in film, see Jenna Webster, "Ben Shahn and the Master Medium," in Deborah Martin Kao, Laura Katzman, and Jenna Webster, *Ben Shahn's New York: The Photography of Modern Times,* exh. cat. (Cambridge, Mass.: Harvard University Art Museums, 2000), 75–95.

9. WEA/MMA 1994.250.7, file 16, undated fragment.

10. See Walker Evans, Fellowship Application for 1938, John Simon Guggenheim Memorial Foundation, New York. Photocopy of the application in author's personal files, courtesy of the foundation.

11. Ibid.

12. The narrative is recounted by Mellow, *Walker Evans,* 351–55.

13. See Jeff L. Rosenheim, "'The Cruel Radiance of What Is': Walker Evans and the South," in Rosenheim et al., *Walker Evans,* exh. cat. (New York: Metropolitan Museum of Art, 1999), 85. Evans's collection eventually numbered around 9,000. The collection is now part of his archive at the Metropolitan Museum of Art, New York, WEA/MMA 1994.264.1–111. See also Rosenheim, *Walker Evans and the Picture Postcard* (Göttingen: Steidl, 2009). For the correspondence with Mabry, see WEA/MMA 1994.250.72.

14. Attendance figures and an official recitation of the relative merits of the museum's early exhibitions are provided by the first

chairman of MoMA's board of trustees, A. Conger Goodyear. See Goodyear, *Museum of Modern Art: The First Ten Years* (New York: Museum of Modern Art, 1943), Appendix H.

15. On the museum's van Gogh show and its possible resonance in Evans's work, see Steve Spence, "Van Gogh in Alabama," *Representations* 75 (Summer 2001): 33–60.

16. Van Wyck Brooks, "On Creating a Usable Past," *Dial* 64 (April 11, 1918): 337–41. Joan Saab's *For the Millions: American Art and Culture between the Wars* (Philadelphia: University of Pennsylvania Press, 2004) effectively and efficiently discusses American modernism at MoMA, the museum's design exhibitions, and the concept of the usable past as it operated in the 1930s.

17. Collins to Evans, May 4, 1938, in WEA/MMA, quoted in Mellow, *Walker Evans,* 371.

18. In addition to Alan Trachtenberg's major essay on *American Photographs,* "A Book Nearly Anonymous," in *Reading American Photographs,* 231–85, two important essays deal with this project specifically: Lew Andrews, "Walker Evans' *American Photographs:* The Sequential Arrangement" *History of Photography* 18, no. 3 (Autumn 1994): 264–71; and Douglas R. Nickel, "*American Photographs* Revisited," *American Art* 6, no. 2 (Spring 1992): 79–97. All three texts address the project exclusively on the basis of its catalogue. Helen Levitt's *New York Times* obituary refers to her role in the preparation of prints for both the catalogue and the exhibition (see Margaret Loke, "Helen Levitt, Who Froze New York Street Life on Film, Is Dead at 95," *New York Times,* March 31, 2009, A27).

19. Elizabeth Payne to Elodie Courter, Feb. 28, 1939, "Walker Evans's American Photographs, 1939" file, Smith College Museum of Art Archives.

20. Courter to Payne, Feb. 23, 1939, "Walker Evans's American Photographs, 1939" file, Smith College Museum of Art Archives.

Some of the installation photographs appear to reveal either white mats behind photographs or white blocks of paint against a darker wall.

21. "Show Ideas," WEA/MMA 1994.250.57, file 5.

22. See the entire sequence of exhibition prints in Gilles Mora and John T. Hill, *Walker Evans: The Hungry Eye* (New York: Abrams, 1993), 162–97, or in the original negatives (which preserve a better sense of the relative scale of the works), WEA/MMA 1994.250.623–52. For alternate installation information, see Courter to Payne, Jan. 27, 1939, "Walker Evans's American Photographs, 1939" file, Smith College Museum of Art Archives.

23. My argument here is indebted to Alan Trachtenberg's essay on *American Photographs,* in which he argues that the innovation of Evans's work was his discovery of photographic point of view as the crucial determination of narrative. However, I date Evans's innovation to the 1936 "Three Tenant Families" project, and the thrust of my argument differs from Trachtenberg's in its emphasis on the claim to photography's relationship to labor and in its examination of the exhibition rather than the catalogue. See "A Book Nearly Anonymous," in *Reading American Photographs,* 231–85.

24. The 1930s were a period of expanded use of the photographic enlarger, so it makes sense that Evans would have used the enlarger to create a contrast with older "contact print" sized prints.

25. Jeff L. Rosenheim originally noticed this peculiar detail in the book and very generously pointed it out to me.

26. Stark Young, untitled review from *New Republic,* Oct. 19, 1938, n.p., clipping in WEA/MMA 1994.250.57, file 23.

27. Typed letter, Evans to Stryker, July 16, 1938, WEA/MMA 1994.250.57, file 57.

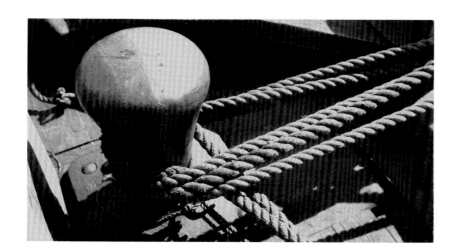

Plate 26. Walker Evans, *Untitled (Brooklyn Shipyard)*, 1928–29

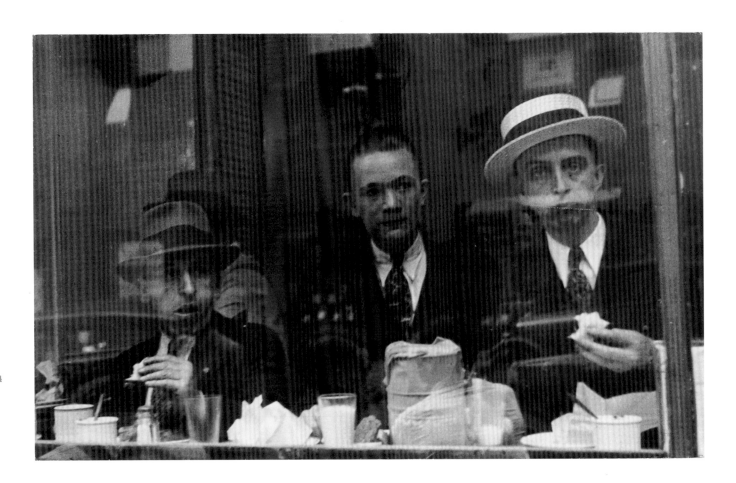

Plate 27. Walker Evans, *[Lunchroom Window, New York City]*, 1929

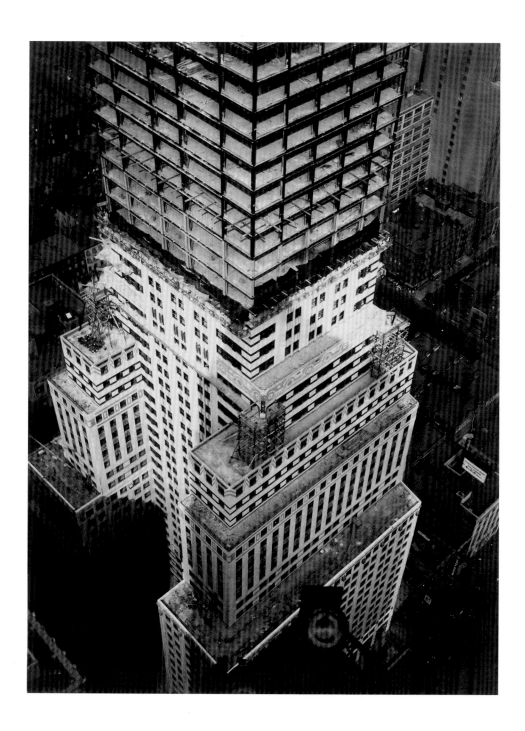

Plate 28.
Walker Evans,
[Chrysler Building Construction,
New York], 1930

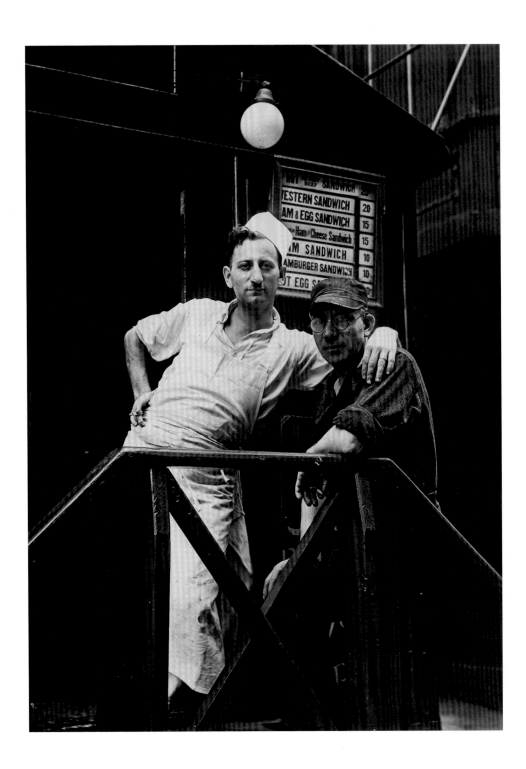

86

Plate 29.
Walker Evans,
Posed Portraits, New York, 1931

Plate 30. Walker Evans, *Gothic Gate near Poughkeepsie, New York*, 1931

Plate 31. Walker Evans, *Greek House, Dedham, Massachusetts, 1932*

89

Plate 32. Walker Evans, *Untitled (Cinema)*, 1933

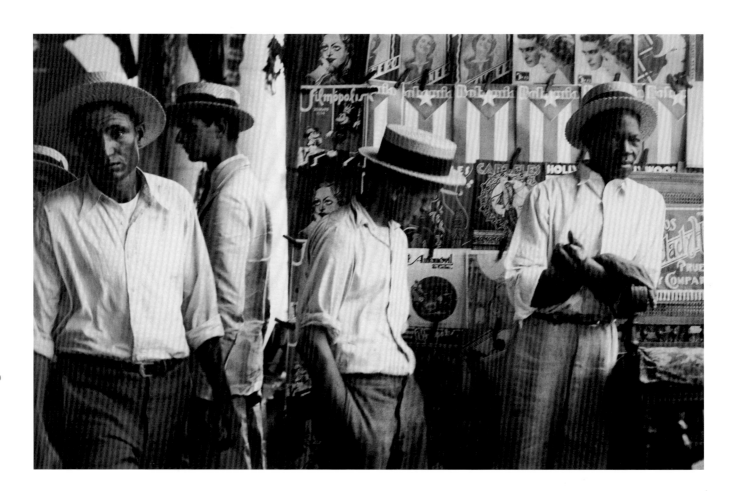

Plate 33. Walker Evans, *People in Downtown Havana, 1933*

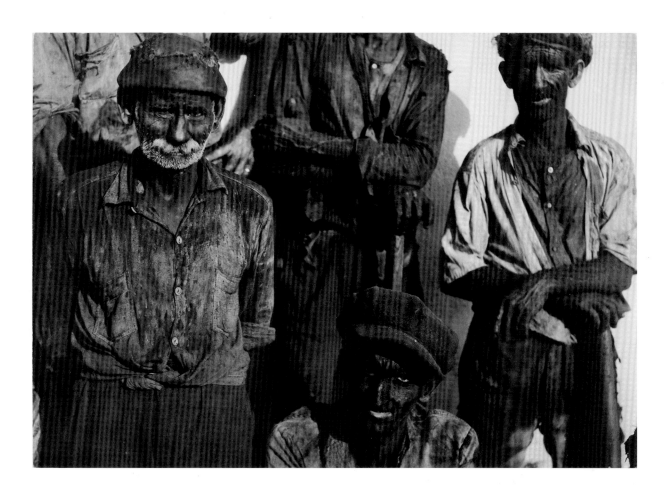

Plate 34. Walker Evans, *Coal Dock Workers, Havana*, 1933

Plate 35. Walker Evans, *Demonstration and Picketing Organized by Communists, NYC Waterfront, 1934*

93

Plate 36. Walker Evans, *Breakfast Room, Belle Grove Plantation, White Chapel, Louisiana, 1935*

94

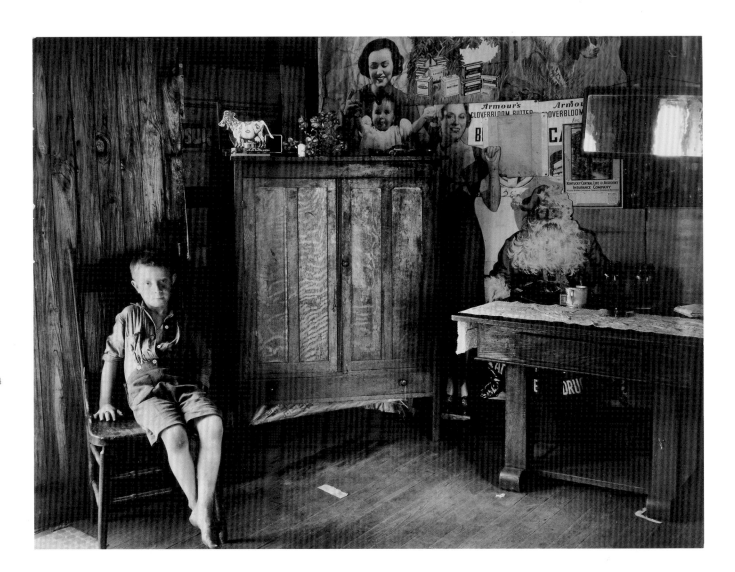

Plate 37. Walker Evans, *West Virginia Living Room*, 1935

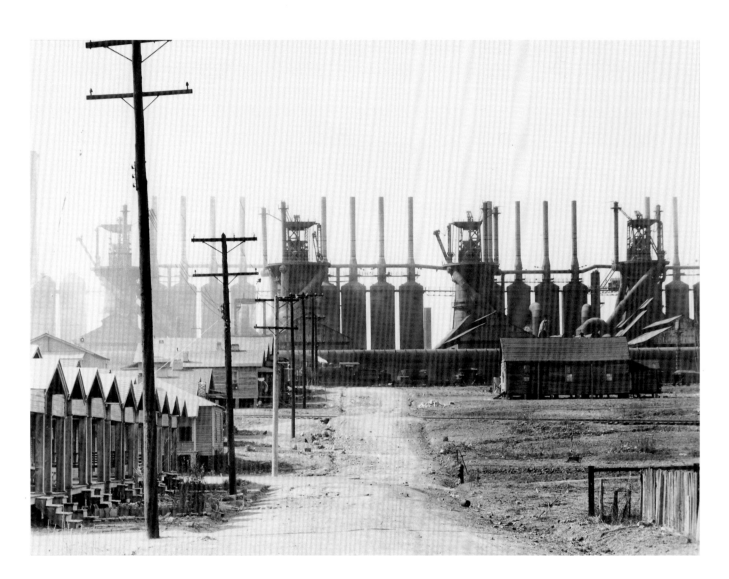

Plate 38. Walker Evans, *Birmingham Steel Mill and Workers' Houses, 1936*

96

Plate 39. Walker Evans, *Frame Houses in Virginia*, 1936

Plate 40. Walker Evans, *Frame Houses in Virginia*, 1936

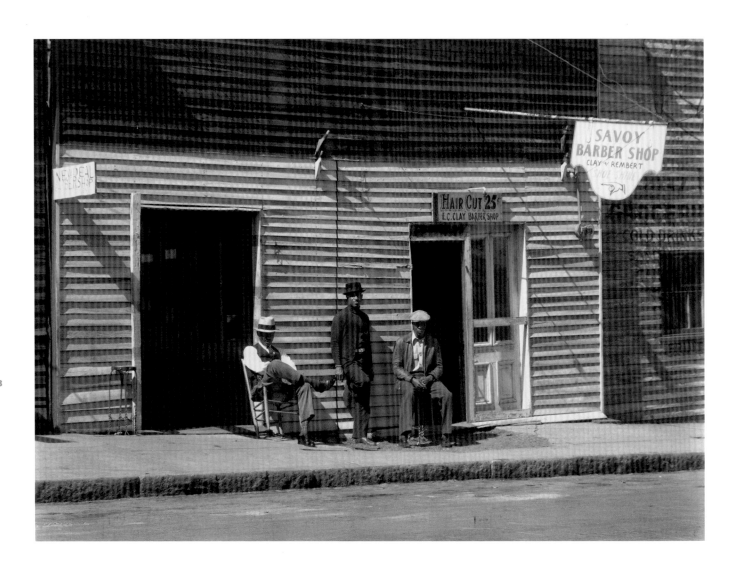

98

Plate 41. Walker Evans, *[Barber Shops, Vicksburg, Mississippi]*, 1936

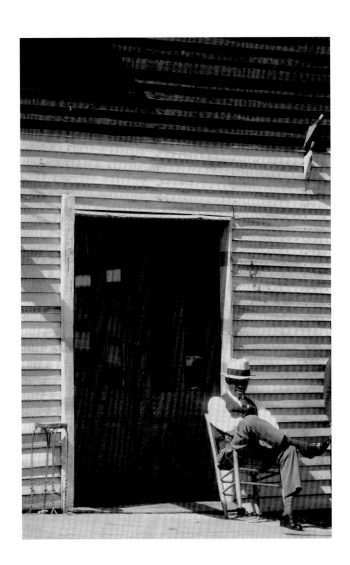

99

Plate 42.
Walker Evans,
[Barbershop Façade,
Vicksburg, Mississippi], 1936

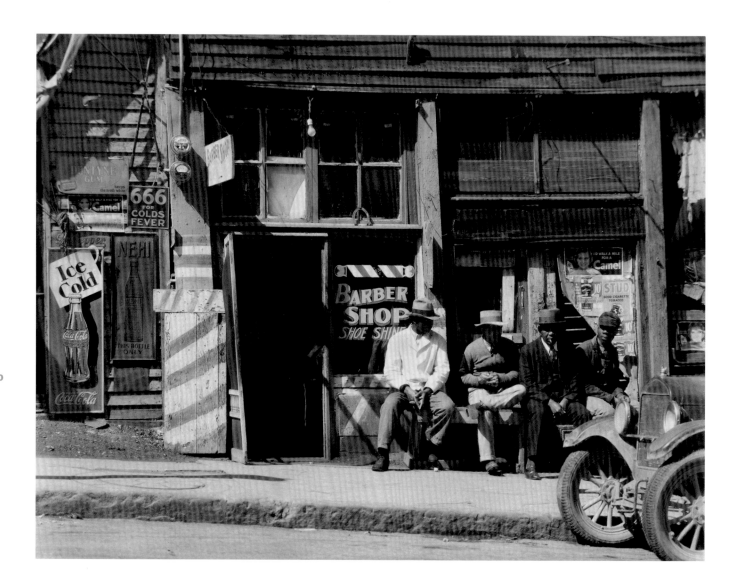

Plate 43. Walker Evans, *[Barbershop, Mississippi]*, 1936

Plate 44.
Walker Evans,
Minstrel Showbill,
1936

Plate 45.
Walker Evans,
Penny Picture Display,
Savannah, 1936

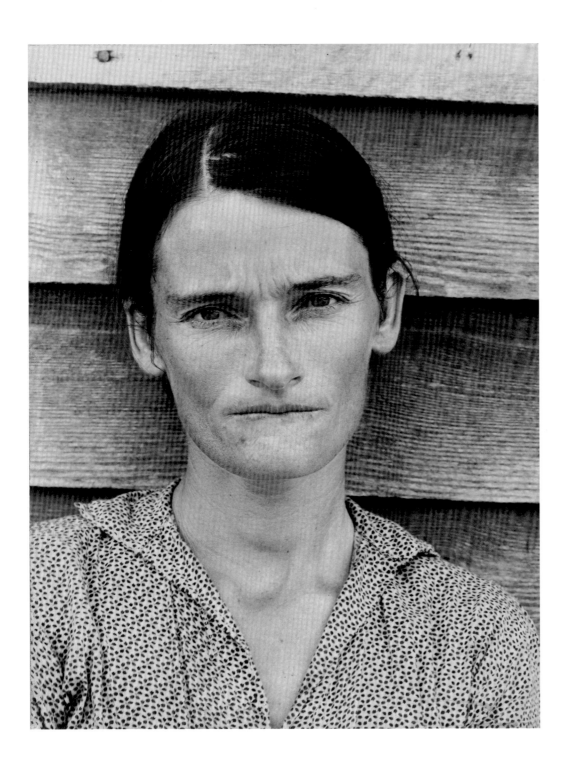

Plate 46.
Walker Evans,
Alabama Tenant Farmer Wife
[Allie Mae Burroughs], 1936

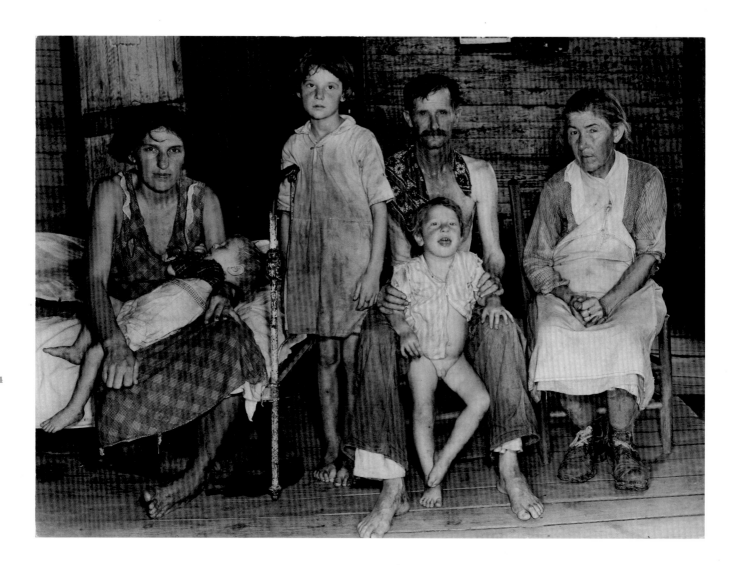

104

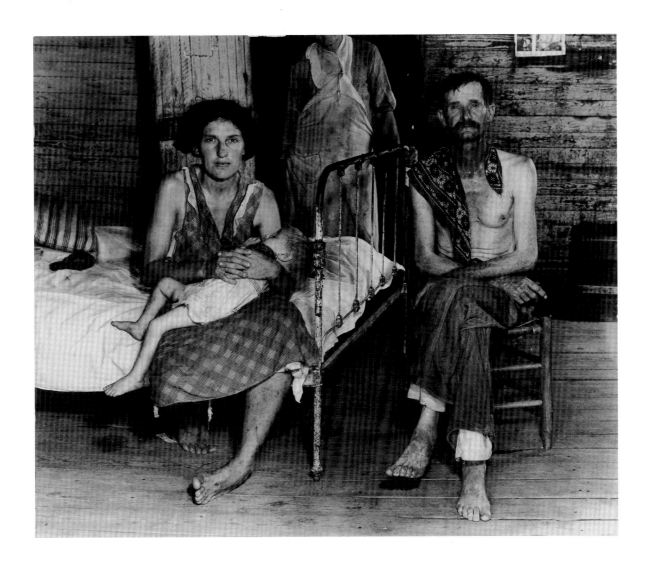

105

Plate 48. Walker Evans, *Bud Fields and His Family*, 1936

106

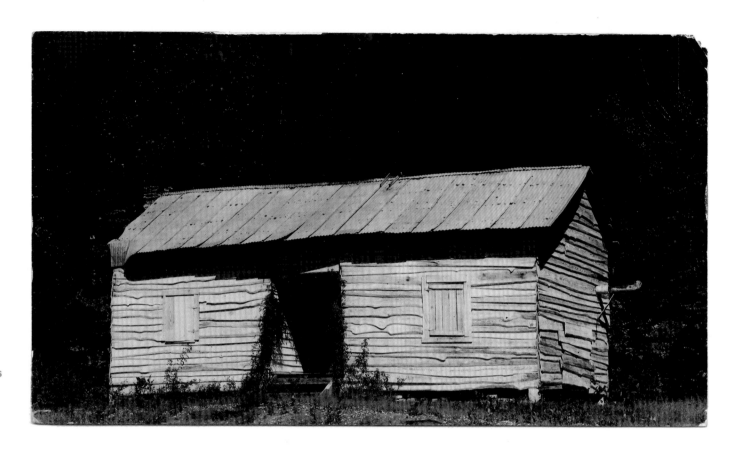

Plate 49. Walker Evans, *Negro Sharecropper's Cabin*, 1936

11, 1936

Plate 50. Walker Evans, *View of Railroad Station, Edwards, Mississippi,* 1936

Constructed Documentary:
Margaret Bourke-White from the Steel Mill to the South

Margaret Bourke-White began her photographic career in the late 1920s documenting the machines, factories, and commodities of the industrial age, working on her first important commissions for corporate patrons at precisely the moment when the great financial collapses that ended the decade began to alter profoundly the American economic and political landscape. As a consequence, during the 1930s she began to turn her focus away from these symbols of industry toward the human subjects on whom the devastating effects of the Depression were taking their greatest toll. In contrast to Berenice Abbott and Walker Evans, who often struggled to find financial support for their photographic work, Bourke-White was a highly successful commercial photographer, and her documentary practice was forged in close relation with the demands and opportunities presented by mass media. The photographs she took for the newly formed picture magazines *Fortune* and *Life,* her primary employers throughout the 1930s, serve both as photojournalistic records of the power and beauty of American industry and as documentary expressions of the social hardships and labor challenges facing America during the Depression. Indeed, it is often in these moments of tension—between aggrandizing representations of factories and machines and the socioeconomic consequences of America's industrial and agricultural decline—that the photographer reveals her most cogent expressions of social documentary.

After only a few years as a successful commercial photographer, by the early to mid-1930s, Bourke-White had begun to question the role of the photograph in an age marked by widespread suffering, and she struggled to reconcile her images of industrial America with the position of the human subject in the modern world. While her early industrial images answered the visual demands of America's big business, her photographs are not without conflict or ambiguity in their depictions of the increasingly imperiled subjects of corporate America. The effects of the Depression, while not explicitly featured in her industrial photographs, are visible nonetheless, and nowhere more so than in her depictions of labor. While Bourke-White's early photographs offer glorified views of the machine and the factory, the status of the worker, threatened both physically and symbolically in the machine age, emerges as an essential theme in her work from this period, and the social concerns that would come to dominate her later documentary photographs are subtly prefigured in even her earliest industrial images of factories and workers.

The Great Depression—a time when the promises of the machine were yielding to ineluctable human failures—

provided the historical setting for her shift in focus from factories and machines to more explicitly social concerns, and her photographs provide a vivid expression of the toll that industrial capitalism's collapse would have on American lives. Bourke-White's photographs give visible form to the contingent status of Depression-era labor through the marginalized and diminutive bodies found in her images. The physically awkward (generally read as overly posed) depictions of people in her work similarly serve to express the indeterminate status of these working subjects within her representations of the modern factory. Bourke-White's photographs from this era thus engage directly the question of what the representational status of the human subject was to be in the mass industrialized world, and it is this question that is at the crux of her early experiments in social documentary photography.

Mass Production and Mass Media

Bourke-White was quick to grasp the commercial promise of photography, and throughout her career she maintained a more professionally successful relationship to the mass media than either Abbott, who never fully sought out commercial work in the thirties, or Evans, who sought to distance himself from his commissioned employment.[1] Her training at the Clarence White School of Photography in 1922, taken as part of her coursework at Columbia University's Teachers College, introduced Bourke-White to photography's commercial potential. White, whose students included Anton Bruehl, Paul Outerbridge, and Ralph Steiner (whom Bourke-White befriended at the school), taught a modernist aesthetic that was particularly well suited to advertising photography.[2] After her studies at the White School, Bourke-White spent the next few years

taking college courses at the University of Michigan, Purdue University, and Case Western Reserve; she ultimately received her degree from Cornell University in 1927.[3]

That same year Bourke-White departed for Cleveland, where she would take up her first commercial work, photographing the city's bridges and skyscrapers and the estates of its business elite. It did not take long, however, for her to turn her camera to the surrounding factories, and during the winter of 1927–28 she photographed smokestacks, ore piles, and blast furnace interiors at the Otis Steel mill. Drawn to the monumental subjects of the factory, Bourke-White embarked on this project of her own accord, and she appears to have been given relatively unrestricted access to take her photographs. She made hundreds of exposures, many of them failures in her mind, and in the early spring she sold eight prints to the president of Otis Steel, E.J. Kulas, for one hundred dollars apiece.[4] Kulas quickly understood the potential of Bourke-White's photographs as a sophisticated public relations device, and he used them in a limited-edition, leather-bound book, *The Otis Steel Company—Pioneer,* which he sent to Otis stockholders in 1929.[5] Only a few months earlier, the Precisionist painter and photographer Charles Sheeler had photographed Ford Motor Company's famous River Rouge Plant for the advertising firm N. W. Ayer and Son.[6] While Sheeler's Ford images are technically and compositionally more sophisticated than Bourke-White's early experiments at Otis, both artists grasped early on the commercial and aesthetic promise of industrial photography. Appearing in trade literature and business magazines, Sheeler and Bourke-White's photographs of industry functioned as visual advertisements for corporate America in the late 1920s and 1930s.

With the Otis photographs, Bourke-White proposed a type of industrial photography in which factory and ma-

chine could be made to represent the drama and power of modern America; her photographs not only represented the institutions of capitalism but could also communicate its values. As the photographer quickly discovered, she could make images that in their adherence to a formal logic of economy, repetition, and standardization took in and reflected back the terms of mass production. In short, the qualities that characterize Bourke-White's photography made it an amenable and desirable vehicle for the visual demands of industrial capitalism, and it was at Otis Steel that she began to establish her own distinct style. As she would recollect, this effort was profoundly important to her artistic evolution: "I feel that my experimental work at Otis Steel was more important to me [than] any other one single thing in my photographic development."[7]

Her work at Otis was "experimental" in terms of not only subject matter but also technique. Bourke-White had yet to perfect her formula for photographing industrial sites, and the mills proved to be a fertile testing ground for her new methods. She worked mostly at night, and the darkness of the factory interiors was extremely challenging: sufficient illumination proved to be one of her greatest obstacles. She "made loads of mistakes," as she recounts, and for every photograph she kept, she claims to have thrown away hundreds.[8] As she quickly learned, molten metal gives off very little illumination, and her interior scenes had to be artificially lit.[9]

Bourke-White found the solution to her lighting challenge in the tools and trade of modern cinema, through the assistance of a traveling salesman who was on his way to Hollywood to sell magnesium flares to the movie industry. Those flares, which burned for thirty seconds, provided Bourke-White with the illumination she needed.[10] It is fitting that the look of her photographs, with their high drama and theatricality, was partially indebted to the technologies of the cinema; and it was at Otis that she began to explore aspects of the cinematic style that would become one of the hallmarks of her photography.

This stylistic exploration reveals how her work at Otis was more than technically challenging. The young photographer was also, as she recalls, grappling with a challenging subject: "The theme itself was colossal. Despite my enthusiasm I needed orientation. I needed to go through a kind of digestive process before I could even choose viewpoints on my subjects."[11] The Otis photographs reflect Bourke-White's growing confidence in her choice of subject matter and offer a glimpse of the beginnings of the stylistic and thematic devices that would come to characterize her industrial photographs—namely, her focus on the aesthetic potential of machine subjects, the repetition of identical forms, and the inclusion of a diminutive figure or figures against the colossal backdrop of the industrial age.

Bourke-White's exterior views of the Otis Steel mill are often partially obscured by clouds of smoke and steam, and her photographs of the mill's interiors are mostly shrouded in darkness and haze, with the exception of cinematic punctuations of light that dramatically highlight the factory scenes (plate 52). In her exterior landscapes, the gray sky, the covering of snow, and the clouds of smoke all contribute to an intensely bleak vision: the bite of the air is almost palpable, just as the thick soot-filled air is nearly tangible in her factory interiors. In addition to documenting the extreme conditions at the mill in the dead of winter, her Otis photographs capture the aesthetic potential of the factory: its framework of steel girders flattens into an abstract composition of form and line (plate 53)—a formal exploration that she would take up again in 1933 in her great photographic abstraction of the NBC sending tower (plate 61).

It did not take long for Bourke-White's photography to assimilate the languages of mass production: the precision and formal economy of the machine, the standardization of the factory, and the seemingly infinite reproducibility of the commodity were values her artistic vocabulary quickly expanded to convey. A number of Bourke-White's exterior shots of the Otis plant, for example, emphasize the eight massive smokestacks that rise from the factory's snow-covered ground (plate 51). In their repetition of a standardized type, the verticals of the smokestacks symbolize the dominant expression of the factory in the mass industrial age: the assembly line.

Repetition, standardization, precision: these were the terms through which capitalism spoke, and what better way to represent itself—and sell itself—than through a visual language that could give these ideals form? It is not surprising, therefore, that Bourke-White became a successful, if not always contented, commercial photographer. Like the Otis smokestacks, much of her subsequent commercial imagery employs as its leitmotif the tightly framed repetition of identical objects, often viewed across a diagonally receding line with no discernible termination. This compositional motif provided Bourke-White with a kind of visual template onto which she could insert a range of subjects: Delman women's dress shoes (plate 62), International Silver spoons (plate 63), generators in an electrical plant, or even unemployed men sitting on a sidewalk curb in St. Louis (plate 66). With their repetition of standardized types, these images reiterate the visual terms of the assembly line.

Bourke-White's industrial photographs picture, in other words, not only the subjects (or products) of mass production but also its systems and values. In her photograph for International Silver, Bourke-White tightly framed the spoons so that they appear to be part of a never-ending

Margaret Bourke-White, *Generators in Electric Plant*, 1937. Gelatin silver print. Gary Davis Collection.

sea of silverware, as if caught in an infinite regression—an image of capitalist abundance. The fact that reiteration became a favored stylistic device in the 1930s is not insignificant. In the context of the Depression, such images of capitalist fecundity may be seen as hyperbolic attempts to shore up the power of the commodity in the face of continuing economic deterioration. With their manic repeating of forms, Bourke-White's photographs of standardized commodities and machines suggest a consumerist desire (albeit often unfulfilled) for an unwavering stream of mass-produced goods; they advertised the promise of capitalist production, through which endless, bountiful, and unmediated objects seem to be on offer. In this sense, Bourke-White's commercial photographs participate in the formal logic of capitalism, in which the commodity image is made to mimic the structures of mass production and mass consumption. For the cultural historian Lewis Mumford, the repetitive nature of modernity was readily apparent in the industrialized world. Writing in 1934, Mumford urged his reader to

stand in a warehouse and observe a row of bathtubs, a row of siphons, a row of bottles, each of identical size, shape, color, stretching away for a quarter of a mile: the special visual effect of a repeating pattern, exhibited once in great temples or massed armies, is now a commonplace of the mechanical environment. There is an esthetic of units and series, as well as an esthetic of the unique and the non-repeatable.[12]

Bourke-White was well versed in this "special visual effect of a repeating pattern," this "esthetic of units and series." She often spoke of her "pattern pictures" of industry and continually employed repetitive devices in her imagery.[13] She was by no means alone in making pictures of this type: repetitive subjects across a dramatic diagonal composition constituted a formal trope in Soviet avantgarde film and still photography, and her photographs of commodities and machines exhibit strong visual affinities with, for example, scenes from Dziga Vertov's groundbreaking 1929 silent film *Man with a Movie Camera*, in which Vertov frames a row of identical nursery cribs along an oblique line, as well as photographs like Boris Ignatovich's *Dynamo* from 1930.[14] Repetition was also a part of the languages of modern consumer culture, and examples are ubiquitous in the pages of magazines and newspapers from this period in pictures of anything from lightbulbs to top hats in endless lines, such as in the advertisement by Anton Bruehl for Weber and Heilbroner (ca. 1929).[15]

The image of the infinitely abundant commodity takes on a different tone, however, when examined in light of contemporaneous critiques of capitalism. For the social theorist George Soule, writing in the *New Republic* during the initial stages of the Depression, the principal problem affecting American capitalism was the inability of consumer spending to keep pace with production; the result was warehouses packed with goods that Americans could

Boris Ignatovich, *Dynamo*, 1930. Gelatin silver print. Spencer Art Museum, Gift of David Tate Peters, 2004.0203.12. © Estate of Boris Ignatovich/RAO, Moscow/Licensed by VAGA, New York, NY.

no longer afford to purchase.[16] Bourke-White's photographs of seemingly limitless silver spoons or designer shoes, from this perspective, are as much images of commodity surplus and the shortcomings of capitalism as they are images of industrial wealth and capitalist potency.

As consumption was increasingly challenged and pro-

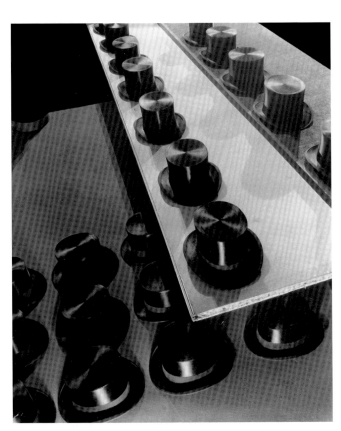

Anton Bruehl, *Top Hats*, ca. 1929. Gelatin silver print. George Eastman House, Courtesy of George Eastman House, International Museum of Photography and Film. © Estate of Anton Bruehl.

duction stagnated during the Depression, the commodity took on a particularly anxious appeal, becoming more tantalizing and powerful as it became less attainable. In this light, Bourke-White's photographs of commodities display a certain magical aura of desire and fascination, radiating an energy that suggests their imperviousness to—or ignorance of—the economic forces that are working to inhibit their consumption. Each of the seemingly innumerable spoons in the International Silver image appears to generate its own light in the reflections of Bourke-

White's studio lights, which pool in the shallow bowls. Her use of cropping makes identical units sem to push against and exceed the rectangular frame of the photograph, creating an aesthetic image of dynamism. The combination of a close-up view and an often elusive ground-plane gives her photographs of repeated and standardized objects a distinctly animate quality: her Delman shoes, for example, appear ready to march out of the image. In short, Bourke-White's photographs capture the vibrant, transformative potential of the commodity—a potential that was all the more provocative considering the increasing unattainability of goods during the Depression years.

This same tantalizing vibrancy permeates Bourke-White's photograph of the bank vault at the First National Bank of Boston, an early commercial assignment (1929, plate 54). The strongly lit scene glimmers with an alchemical aura, and the reflection of her lights on the vault's polished steel surfaces gives the scene a fantastic quality, as if in crossing this threshold one might be transported to some other, imaginary realm. The reflection in the center of the open vault door, seemingly emanating from its own source, further establishes this effect. The photograph gains added meaning from the fact that it was taken on the evening of October 24, 1929—the day of the initial stock market collapse. As the bottom was falling out of the national stock market, Bourke-White recorded an image that captures the mythic potential of the capitalist dream, at once beckoning the viewer with its magical promise and intimidating with its allusion to an unknown realm that lies on its other side. This photograph, like her images of marching shoes and glowing spoons, resonates with the inherent fascination and appeal of movies and the cinema, which show their audiences the recognizable and the everyday but also invoke, sometimes simultaneously, the larger-than-life and the imaginary.

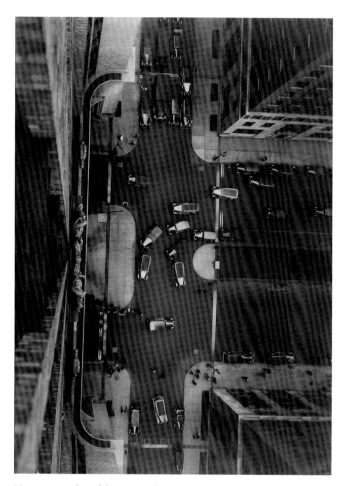

Margaret Bourke-White, *New York City*, ca. 1933. Gelatin silver print.
Margaret Bourke-White Collection, Special Collections Research Center,
Syracuse University Library.

In like fashion, Bourke-White's photographs of New York City convey a fantastic, ethereal quality, one that is similarly indebted to the conventions of modern film. The photographer, for instance, made sunlight perform cinematically in her high-contrast images, such as the 1933 aerial photograph of a New York City street scene (plate 60), taken for a Goodyear Tire account, in which bright sunlight rakes through Park Avenue traffic and highlights the street scene with the shiny illumination of a film. Her signature diagonal composition gives further dramatic emphasis to the scene. She rotates the composition of Park Avenue obliquely to the right of the frame while also sloping the plane of the avenue downward to the right. This visual effect—one that would have been appropriate in an advertisement promoting automotive tire safety—tilts the city at a vertiginous angle, leaving its cars and buildings in danger of slipping off the picture plane. Soviet photography again offers important visual predecessors; for example, Aleksandr Rodchenko's photographs from the late 1920s and early 1930s display the oblique angles and dizzying perspectives that would come to characterize Bourke-White's photographs (as in the one to the left).

Compared with Abbott's images of New York City, with their cavernous abstractions (plate 15) and everyday street corners (plate 19), Bourke-White's city is one of movement and high drama. Her photograph of the spire of the Chrysler Building (ca. 1930–31, plate 57), tilting to the left at a precipitous upward angle and with polished steel sparkling in the sun, exemplifies the glamour and theatricality that characterize her depictions of New York City. By contrast, when Evans had photographed the Chrysler Building under construction approximately one year earlier (plate 28), he pictured it from the opposite angle, looking downward on the skyscraper's blocky masses—a formal study in the rectangular structures that make up the city.

Bourke-White's New York City images enjoyed broad distribution through mass media outlets. Many of her commercial photographs, like the Goodyear Tire advertisement, circulated in several popular magazines of the day, but it was in the pages of Henry Luce's *Fortune* and then *Life* that she found her most productive media relationship. At the onset of the Great Depression, Luce intro-

duced a new type of magazine to the American public. *Fortune,* its inaugural issue released in late January 1930, was the first magazine of its kind: a visual, even artistic, proposition. According to Luce, it was to be "the most beautiful magazine yet attempted in this country—so strikingly illustrated that nearly every page will be a work of art."[17] Like its sister magazine, *Life,* which debuted six years later, *Fortune* was a magazine of pictures as much as text. Such a venture provided fertile ground for the joining of American industry and modern photography, and Luce was one of the pioneering forces in harnessing what he characterized as "the tremendous unrealized power of pictures."[18]

Bourke-White's Otis Steel photographs had brought her instant recognition; they were reproduced in newspapers around the Midwest and quickly acknowledged by institutions of fine art. Her photograph of a two-hundred-ton ladle was awarded a first prize at the Cleveland Museum of Art in May 1928, and it did not take long for Luce to take note of Bourke-White's talent.[19] In the spring of 1929 the young publishing magnate telegraphed the photographer, requesting a meeting with her in New York. Bourke-White was immediately impressed by Luce's proposition: "I could see that this whole concept would give photography greater opportunities than it had ever had before."[20] She moved to New York to join *Fortune* eight months before its first issue, and she was the magazine's first and only staff photographer during its initial year. For Bourke-White, "it seemed like a marriage made in heaven," and she remained on staff until 1936, when she went to work for *Life.*[21] Bringing together Bourke-White and *Fortune* made perfect sense: the magazine required sophisticated imagery though which to tell its stories of corporate America, while Bourke-White needed financial support for her photography. Her work for *Fortune* allowed her to pursue projects that her rigidly circumscribed advertising assignments rarely provided. It was in the pages of *Fortune* that she continued to refine her documentary practice and began to explore the narrative potential of photographs grouped together in the service of a story.[22]

With its pictures of industry and manufacture, *Fortune* proposed an image of modern America—ordered, productive, and visually seductive—that big business needed in the midst of the economic impotence and chaos of the Depression. And Bourke-White's photographs, with their glossy dynamos and standardized forms, are the very picture of industrial might and efficiency. Yet the *Fortune* images also reveal a more complex reality as Bourke-White sharpens her focus on the status of the worker at this moment, both in the mechanized factory and as a subject in representation. Her work for the magazine thus offers a glimpse into the social and formal concerns that would come to dominate her photographs as she negotiated the demands of her explicitly commercial work alongside her emerging practice of documentary photography.

Picturing Labor

Bourke-White's photographs of industry are often discussed, sometimes in comparison to those of her peer Charles Sheeler, as showing little to no interest in the laboring body.[23] Even Bourke-White herself downplayed the role of the worker in her images. It was machines, not the people using them, that apparently interested her; she writes in her autobiographical notes, "As for my work, I think the important thing is that what I was interested in was the pattern of industrial subjects. I hadn't even noticed there was a man behind the machine unless I put

one in for scale."[24] Yet her photographs tell a different story. She could be quite attentive to the presence of workers—even, at times, to the point of directing their participation in her scenes. Not only was Bourke-White selective in her choice of "models," wanting just the right "cast of features" (her words) for her pictures, but she also posed workers, acknowledging, for example, changing the tilt of one woman's head and shifting the position of her arm.[25] She even wrote of the difficulty she experienced posing American workers, whom she found to be to be overly affected, unlike the Russian workers she had photographed during her first visit in 1930:

Posing American workmen for photographs is often very difficult. Usually I go many times through the factory, studying their attitudes as they work and memorizing every detail of the position, so that I will be able to reconstruct it correctly when I come to take my picture. The minute an American worker sees a camera he becomes self-conscious. Often I have to work over every detail of his posture, changing the slope of his back, the attitude of his head, the position of every finger, until movement will be suggested by his attitude in the photograph, even though he must be photographed standing still.[26]

Importantly, then, Bourke-White's photographs of workers are reconstructions of their labor. Unlike Evans, whose photographs suggest, as Jessica May argues in the preceding essay, the passage of time between moments of action and the exposure in Evans's camera, Bourke-White produced photographs that mark a stoppage or suspension of time. The mannered pose of a Chrysler worker (plate 59), arrested in place as he poses stiffly beneath the massive gears of the stamping press with his left arm fully extended and a rigid facial expression, typifies the photographer's practice of halting the act of labor to take her photographs. For Bourke-White, work had to be suspended to be represented, and her images depict stoppage and inactivity rather than productivity and work's flow. This was, of course, the precise circumstance in which workers in general found themselves during the Depression, as much of the American workforce was forced into a crippling standstill.

Bourke-White's staging of her subjects was not unusual. Photographers had been posing workers since the early days of the medium—Nadar's images of "workers" in the Paris catacombs (1861–65) are one such example. Due to poor lighting conditions and rudimentary photographic technologies, Nadar's photographs often required exposures for as long as eighteen minutes, a significant amount of time for any person to remain immobile.[27] Thus, rather than using live workers who might move and blur, Nadar employed mannequins—dummies that served as surrogate laborers whom he could pose for extended periods of time. Bourke-White's exposures, although shorter than Nadar's, required her subjects to pose with little movement: "The two women whom I was photographing continued to slip their lace over the racks as I set up my lights, and when I was ready to take the picture, I stopped them in position."[28] In her Swift and Company photographs for *Fortune*,[29] she asked a worker to stand still with his shovel for as long as fifteen minutes while she photographed him in a pose of labor (1929, plate 55).[30] The effect was to create a narrative of manual labor in which the Swift worker performs a fictional account of his duty. As a result of Bourke-White's long exposure, the figure takes on the appearance of a posed model, with a stiffness much like Nadar's mannequins. While it is possible to discern his overalls, work boots, and hat, any distinguishing facial characteristics are wholly obscured by the blur of the exposure.

Of course, when Bourke-White entered a factory it was

nearly impossible for her to remain unnoticed. Encumbered by a large-format camera and its attendant equipment, she had very little chance of taking the sort of covert snapshot that Evans so purposefully strove to achieve. Bourke-White recalls the difficulty she encountered in this regard during her work in Russia:

I set up my tripods, mounted the lamps, adjusted the camera, and we threw on the current. All the workers on the floor left their machines and came running in astonishment to look at the great blaze of light. It was with difficulty that I got these people back to their jobs again. I wanted to be able to study them doing their work and not watching mine.[31]

In such scenarios, workers were unavoidably aware of the presence of a photographer—particularly a woman photographer—in the factory. As a consequence, they also became aware of their roles as photographic subjects, posing—or even acting—for the camera.

As a result of this give-and-take between the photographer's direction and the workers' actions, laboring figures became crucial, rather than unintentional or extraneous, to many of Bourke-White's images. Indeed, an examination of these early photographs reveals how important the human figure, most often that of a worker, was to her photographic practice even in its nascence, years before she turned to the explicitly social concerns of the Depression-era Dust Bowl and the sharecropper South. Yet this is not to say that working subjects dominate her early compositions—on the contrary, many of the people are positioned at the margins of Bourke-White's pictures. But no matter how small or marginal, these figures of workers are essential to the thematic weight and overall formal organization of her images. Bourke-White may have had a straightforward goal in including laborers in her earliest photographs—they

were often included for scale—but these figures also play a significant and previously unacknowledged role within her representations of industry. The status of laborers vis-à-vis the subjects of industrial capitalism was an inherently charged one given the circumstances of the day, and the position of the worker in the modern factory became increasingly important to Bourke-White's work over the course of the 1930s. Recognizing the significance of the workers' presence in her industrial photographs is necessary to understand the influence of these early images on her subsequent documentary work.

It began in the Otis pictures. For example, in an exterior view of the Otis mill, two workers are located at the bottom edge of the photograph (plate 51). Their diminutive stature is compounded by the angle from which Bourke-White photographed them, looking down rather than across at ground level. In 1931 she constructed a similar image, this time on level footing with the figures, at the Rosenbaum Grain Corporation, where she pictured two workers standing beneath the towering rows of grain elevators (plate 58). And again in 1936, for the inaugural cover of *Life* magazine, Bourke-White photographed two workers at the base of the gigantic pillars of the Fort Peck Dam (plate 64). Scale, of course, is at issue here: the pairs of miniature figures provide a striking contrast to the massive architecture of industrial America—its smokestacks, silos, and pylons. In both the Otis photograph and the *Life* cover the workers are pushed to the margins of the image, overpowered by the monumental backdrop. The juxtaposition cuts both ways, however. While the diminutive workers serve to aggrandize the factory, the oversized setting in which they are represented also points to the increasingly tenuous position of labor during the Depression.

As in a number of the early images discussed here, Bourke-White's attention to these figures was in dialogue with the stylistic and narrative conventions of modern cinema. She was a frequent and passionate moviegoer and was well versed in both Hollywood and avant-garde film, even briefly experimenting in documentary filmmaking while in Russia.[32] Her archived papers include movie bills from countless films as well as a personal letter from a Mr. Ginsberg of the Little Carnegie Theater, recommending films that she should see.[33] Among those he listed is German director Walther Ruttmann's 1927 silent film *Berlin: Symphony of a Great City,* which captures the bustling activity of Berlin's streets and factories through the course of a single day. Not only does the film picture many of the same subjects as Bourke-White's photographs—smokestacks, machine gears, steel production—but filmmaker and photographer share a common visual language of dramatic angles, repetition, abstraction, and monumental scale.

The resonance between Bourke-White's images and iconic scenes created by Vertov and Ruttmann as well as by other contemporary filmmakers, such as Fritz Lang and Charlie Chaplin, does not seem accidental. The photographer's attention to lighting and the careful posing of her figures, dismissed by some critics as staged or forced, was a compositional style highly evocative of the film still. As a cinema aficionado, Bourke-White certainly must have recognized the power of movies as a popular mass medium, and the formal similarities to be found in her images strongly suggest that she appreciated the ability of movies, like picture magazines, to reach a wide audience. Moreover, much of the power of films to capture the imagination of their audience lay in the ability to simultaneously represent the familiar and make it feel larger than life, a dynamic that Bourke-White also nurtured in much of the early work that made her commercially successful.

The exaggeration of scale was one of the most powerful special effects filmmakers had in the 1920s and 1930s, probably nowhere more effectively used than in Lang's seminal 1927 film *Metropolis.*[34] Lang's oversized sets—the monumental stadium, twenty-foot doors, colossal machines, and towering skyscrapers—contrast with the diminutive and ultimately threatened status of the human subject (for Lang, too, a worker) in the modern industrialized world. Bourke-White takes up this thematic trope, perhaps most powerfully in her 1932 photograph at the Chrysler Corporation (plate 59), in which she depicts a worker dwarfed beneath the huge gears of the stamping press, his hands hidden and his lower body truncated at the right edge of the image. His presence is assimilated into the surrounding industrial scene, and he almost becomes a mere appendage to the press. Yet, significantly, this figure is also afforded a certain strength as his body anchors the image at one bottom corner of the composition. He has been carefully posed by the photographer, and he ultimately serves as the fulcrum of the picture. Furthermore, Bourke-White's lighting dramatically highlights him, and his presence seems to contain or limit the force of the machine by returning the image to the world of the real and the bodily. Without the workman, the photograph would be a formal exploration of gears and belts, with a certain beauty to be found in the repetition of the three circular gears that overlap each other in rhythmical succession. But by including this person, Bourke-White added a visual expression of the disparity of power between worker and machine in the modern factory. The soft body of the workman stands in counterpoint to the steel armature and massive jaws of the press into which he leans, the contrast making evident the vulnerability of the human body vis-à-vis the machine.

Bourke-White would revisit this visual motif of the body

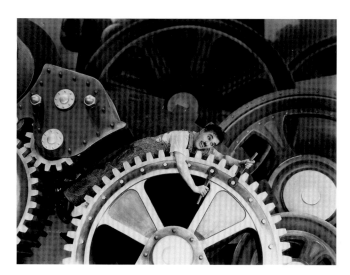

Charlie Chaplin, *Modern Times*, 1936. Film still. © Roy Export, S.A.S.

It has economized human energy and it has misdirected it. It has created a wide framework of order and it has produced muddle and chaos. It has nobly served human purposes and it has distorted and denied them.[35]

Others were even less sure of the liberating potential of the machine. In *Modern Times*, Chaplin depicts a body (his own) inexorably seized by the demands of the machine. It twitches and jerks with the repetitive motions of the assembly line and is ultimately consumed by the machine's rotating gears.

Two years prior to her Chrysler assignment, on a commission from N.W. Ayer and Son, Bourke-White visited Ford Motor Company's River Rouge plant, where she also included workers in her photographs. At the Rouge plant, she primarily photographed Ford's steel mill; the assembly line and Ford's automobiles and parts were apparently off-limits to her camera.[36] Nonetheless, the interior of the open-hearth mill provided Bourke-White with numerous subjects. One of her photographs inside the mill (plate 56) depicts, with high contrast achieved through dramatic lighting, a foreman and crane against the illuminated backdrop of the factory. Worker and machine appear to be made of the same material; they form one coterminous silhouette. In the photograph, Bourke-White foregrounds the relationship between the machine and the worker; the crane and the foreman (his fedora suggests his rank) face each other with only a thin sheet of metal separating them. The foreman's supplicatory gesture—head bowed and hand to the brim of his hat—intimates the dynamic of this relationship. With the image's highly cinematic contrasts of white-hot steel, illuminated metal, and pitch-black machine forms, Bourke-White conveys the intensity and drama of the scene and the contingent status of the worker, both in the context of an industrialized America and in representation itself.

of the worker seemingly caught in the monumental gears of the machine—a theme that Chaplin also explored in his 1936 classic film *Modern Times*—when she photographed the construction of a wind tunnel at Fort Peck Dam, Montana, for *Life* that same year (plate 65). Her Fort Peck Dam photograph, like the Chrysler image, exposes the reduced and vulnerable position of the worker in the modern industrial landscape as his small body crouches in the tunnel and seems caught amid the radiating, visually overlapping steel rods in the wind tunnel.

Bourke-White's representation of laboring bodies as peripheral, sometimes uncertain figures served as a powerful metaphor for the socioeconomic status of the worker threatened by both the rationalized factory's mechanization of work and the Depression-era realities of mass unemployment. Around this time, Mumford was expressing his own feelings of uncertainty toward the machine:

One is confronted, then, by the fact that the machine is ambivalent. It is both an instrument of liberation and one of repression.

Like her early image of the Swift laborer, the photograph offers very little visual information about this worker as an individual. Partly as a result of the figure's lack of specificity, the image proved to be highly malleable, and its capacity to stand as a generic image of labor and industry is evident in the many different commercial and journalistic uses to which it was put. In June 1930, for instance, the image was used as a cover for *Trade Winds,* the magazine of the Union Trust Company of Cleveland.[37] In 1932, it was reproduced in an article on Ford in the *New York Times Magazine* above the caption "Mass Production and the Man—A Scene at the Ford Plant."[38] (As the caption makes clear, the *Times* clearly grasped the metaphoric weight of Bourke-White's image of machine and worker.) And in November 1934 it was used on the cover of *Scientific American* with the subheading "Where Stainless Steel Is Born."[39] That the image could be made to stand for so many different examples of American business and industry speaks to the multiple and capacious roles that Bourke-White's photographs could be called on to play in the mass media.

Yet despite the interpretive malleability of many of her photographs, the expectations of her corporate and commercial patrons nonetheless required her to adhere to a strictly conscribed (if often implicit) set of rules governing the representation of labor. As an artist she could visualize variegated relationships between bodies and machines, yet the legibility of the working body in a given image ultimately depended upon its commercial application. For corporate clients, it seems that the visibility of the machine was contingent upon the relative invisibility of the worker. Workers could be made visible, but only in ways that did little to undermine the power and authority of the machine and the corporation. She was at one point chided by a *Fortune* editor for overemphasizing labor at the expense of industrial process: "Your pictures weren't good enough. At Armour you got too interested in the people and neglected the processes."[40] Her move toward a more explicit form of social documentary photography in the mid-1930s was thus, in part, a reaction to the demands being placed upon her by her commercial patrons and her editors at *Fortune.* Her independent project to photograph the rural South, initiated with Erskine Caldwell in 1936, would allow Bourke-White a level of photographic freedom that she had not experienced before and provide a formative opportunity to expand her work within the documentary mode.

You Have Seen Their Faces

The transition from the commercially driven production of Bourke-White's advertising work and her mass-media-driven assignments for *Fortune* to a more recognizable expression of documentary photography began to take root in Russia, which she first visited in 1930, returning again in 1931 and 1932. Her initial visit followed a *Fortune* assignment that took her to Germany to photograph industrial sites in the summer of 1930. Her *Fortune* editors were skeptical that she would be granted access to the Soviet Union and refused to sponsor the trip, so Bourke-White secured her own visa and covered her own expenses.[41] The Soviet Union, it would seem, not only offered Bourke-White access to industrial subjects that fit her aesthetic but also spoke to the photographer's increasing awareness of the role of human subjects in her photographic work. The appeal was initially aesthetic, however; as Bourke-White herself admitted, her politics as an artist had yet to be fully formed: "No one could have known less about Russia politically than I knew—or cared less. To me,

politics was colorless beside the drama of the machine."[42] Yet as she photographed the subjects of the Soviet Five-Year Plan, Bourke-White began to turn the focus of her camera on the workers and peasants who populated the Soviet industrial and agricultural landscape. Her photographs—forty of them published in her 1931 book *Eyes on Russia*—feature not only the great dams and expansive fields of Soviet Russia but also portraits of the people who puddled steel and plowed fields.

Bourke-White continued to develop her interest in human subjects with her coverage of the Great Drought for Henry Luce. In 1934 *Fortune* sent Bourke-White to the Dust Bowl, where she documented the struggling farmers and barren landscape of the American Midwest. James Agee (two years prior to his collaboration with Evans on what would become *Let Us Now Praise Famous Men*) wrote the accompanying article for the magazine; it focused on the devastating conditions of the drought. "The earth turns before its sun like a hog on a spit," wrote Agee.[43] For Bourke-White, the assignment marked a conscious shift in her work, one characterized by an increasing awareness of the Depression's human toll. As she would later explain in her autobiography:

I was deeply moved by the suffering I saw and touched particularly by the bewilderment of the farmers. I think this was the beginning of my awareness of people in a human, sympathetic sense as subjects for the camera and photographed against a wider canvas than I had perceived before. During the rapturous period when I was discovering the beauty of industrial shapes, people were only incidental to me, and in retrospect I believe I had not much feeling for them in my earlier work. But suddenly it was the people who counted. Here in the Dakotas with these farmers, I saw everything in a new light. How could I tell it all in pictures? Here were faces engraved with the very paralysis of despair. These were faces I could not pass by.[44]

Bourke-White's experience photographing the Great Drought had a strong and sustained impact on her approach toward her subjects, and a year later she wrote to the art director at *Fortune* of her "growing interest in the lives of workmen. It seems to me that while it is very important to get a striking picture of a line of smoke stacks or a row of dynamos, it is becoming more and more important to reflect the life that goes on behind these photographs."[45] Her political convictions were simultaneously taking root; by the mid-1930s, she was subscribing to the Communist-run newspaper the *Daily Worker* and supporting Communist front organizations.[46] She also, like Abbott, joined the American Artists' Congress, which promoted an anti-Fascist agenda, at its founding in 1936 and was elected vice-chairwoman in 1938.[47] In an article for the *Nation* in 1936, Bourke-White expands on the inequity of power she perceived between industry and the worker in an emerging political voice:

It is possible for hydraulic presses to rear their giant forms majestically in automobile factories, and for the workers who place and replace the metal sheets beneath the stamping block to be underpaid [a possible reference to her Chrysler worker?]. It is possible for cranes to etch their delicate tracery against the sky, and for the iron miners to look from the front doors of their company houses across the deep-tiered stripping and see the derricks, exquisite but idle. It is possible for glistening saws to whir their way, halos of living steel, and for the mill hands to watch those saws slow down into stillness, knowing this betokens another stretch of unemployment.[48]

Her political awakening brought a new sense of possibility for her photographs as an impetus for social change; in 1934 she offered her drought photographs, perhaps her most socially conscious to date, to the left-wing journal *New Masses*.[49]

By July 1936, when Bourke-White headed south with novelist Erskine Caldwell to photograph the effects of the Depression on southern sharecroppers, she had already begun to revise her aims for her photographic practice: "It was not the cross section of industry I wanted. Nor was it the sharp drama of agricultural crisis. It was less the magazine approach and more the book approach that I was after. It was based on a great need to understand my fellow Americans better."[50] Bourke-White was beginning to see the formal character of her photographs in light of her more political concerns as an image-maker and reporter of social circumstance. Yet even as she sharpened her attention to her human subjects, the unique style that she had developed in her industrial photographs and the early influences from which she had drawn inspiration—the formal language of the industrialized factory and the visual and narrative drama of modern film—continued to inform her compositional style and the manner in which she represented the social and economic conditions of tenant farmers in the American South.

Bourke-White met Caldwell in Augusta, Georgia, on July 18. It was the start of a collaboration (and later a marriage from 1939 to 1942) that would result in *You Have Seen Their Faces,* the 1937 illustrated book on the rural South.[51] For two months, Bourke-White and Caldwell traveled across Georgia, Alabama, Arkansas, Mississippi, Louisiana, South Carolina, and Tennessee, speaking with and photographing the people they met. They returned to the South in March 1937 to complete the project. *You Have Seen Their Faces,* with photographs by Bourke-White and text by Caldwell, was published that November to great critical acclaim. In many ways, it succeeded as "the great democratic book" to which Abbott and Elizabeth McCausland had aspired.[52] Just one month after Viking Press released the hardcover edition, a Modern Age Books paperback edition was issued at the significantly reduced price of seventy-five cents (the hardcover sold for five dollars), making clear that a wide reach was anticipated for the book and enabled by its publishers.[53] Expectations of mass consumption were made explicit in editorials in the *New York Post* and in the *Philadelphia Record,* where it was proclaimed that "*You Have Seen Their Faces* deserves the audience of another *Uncle Tom's Cabin*"—the most widely sold book in the world, second only to the Bible, in the nineteenth century.[54] While Abbott and McCausland were never able to publish the photo-book they proposed as a portrait of the nation, and Evans and Agee were forced to delay publication of *Let Us Now Praise Famous Men* (in part because of the competition provided by Bourke-White and Caldwell's book), *You Have Seen Their Faces* quickly achieved widespread commercial success.[55]

The "democratic" appeal of *You Have Seen Their Faces* and its enthusiastic public reception owed as much to Bourke-White's particular version of documentary as it did to a well-executed distribution. It was not just that the book reached a great number of readers, but also that Bourke-White's photographs for *You Have Seen Their Faces* presented a type of image that was highly legible to a great cross-section of the American public. Though she worked within a documentary style that would later be read by critics and scholars as overly staged and exploitative,[56] at the time her distinctive version of documentary photography seemed to fit perfectly within the visual culture of the day. She framed her images of the rural poor with the same exaggerated scale, strong diagonals, repetition of visual motifs, and dramatic lighting that characterized both commercially successful mass media images (her own industrial photographs included) and the popular cinematic conventions of the era. Her vision of the American South and its inhabitants employed a visual language

and sentimental narrative (albeit one that often reflected contemporary stereotypes of race and class) that were recognizable to the viewers of her time and thereby rendered accessible and compelling a new and challenging artistic medium—documentary photography—as well as a new and challenging socioeconomic reality.

In 1936, during the same summer months when Bourke-White and Caldwell traveled through the South, Evans and Agee were on assignment from *Fortune* as part of its new series "Life and Circumstances," which focused on the lives of working families.[57] *Fortune* ultimately decided not to publish their work from that summer, and Evans and Agee struggled to find a publisher until 1941, when the now iconic *Let Us Now Praise Famous Men* was finally released.[58] The subjects photographed by Bourke-White and Evans in the South are, for the most part, uncannily similar: southern architecture, domestic interiors, prison gangs, rural sharecroppers, posters, and signs. Yet the two photographers approached their subjects in fundamentally different ways. Whereas Evans employed his characteristic straight-on shot, which became one of the defining stylistic devices of documentary photography (e.g., plates 46–47), Bourke-White employed the diagonal compositions that had structured her earlier work. She rarely photographed her subjects straight on, always preferring the dynamism and drama that the oblique shot could achieve. She shows homes from their corners (plate 68); signs tilting on a sloped horizon line (plate 70); workers, prisoners, families, buildings—all are depicted at a receding, diagonal angle, offering a familiar sense of movement and drama (recall, for example, her photograph of Delman shoes) as well as a suggestion of narrative.

Both photographers were drawn to the signs that covered the landscapes of the South. But whereas Evans was interested in signage as a formal device through which to

Margaret Bourke-White, *Scorched Earth,* 1934. Gelatin silver print. Margaret Bourke-White Collection, Special Collections Research Center, Syracuse University Library.

emphasize the modernist flatness of the photograph (e.g., plates 44–45), Bourke-White used posters and signs in her photographs as a kind of caption—one contained within the photograph itself that offered a metanarrative of the scene. It mattered to Bourke-White, in other words, what these signs said, not just what they looked like or how they could be made to behave in representation. Her photograph of scorched land for the 1934 *Fortune* story on the Dust Bowl captures the makeshift sign that reads, "You gave us beer, now give us water," a desperate cry for relief from the conditions of the drought. Similarly, throughout her work for *You Have Seen Their Faces,* she was drawn to evangelical roadside signs: "Look 'Now is the day of salvation,'" "The Lord Jesus is Coming, perhaps today. Are you ready," and "To Heaven or Hell—which?" (plate 70). These signs offered the photographer another voice through which to convey the narrative of doom and salvation that characterized the religious lives—and popular representations—of many in the Pentecostal South.

As before, Bourke-White approached her scenes like a filmmaker—posing her subjects, adjusting lighting, scripting visual narratives. "She was very adept at being able to direct people," Caldwell observed. "She was almost like a motion picture director."[59] She also lit her subjects as if on a movie set, relying on multiple light sources rather than a single flash bulb attached to her camera. She would sometimes distribute as many as six flash bulbs throughout a room to achieve the effect she wanted.[60] Her first experiments with cinematic lighting, begun at Otis Steel, provided the technical and stylistic foundation that she continued to build on and refine.

The interior scenes she photographed for *You Have Seen Their Faces* are lit to dramatically highlight her subjects against their domestic settings, as in a photograph of a mother and her two young children in Clinch County, Georgia, near the Okefenokee Swamp (plate 67). She photographed this family on July 21, 1936, only three days into her travels with Caldwell.[61] Bourke-White would often photograph her subjects in a variety of poses and settings, and she did so in Clinch County. Two other photographs of this family are included in *You Have Seen Their Faces:* in one instance the family gathers for a modest meal, and in the other the mother nurses her infant. Some details about the family are known from a journal that Bourke-White kept during her travels that summer. The mother is Lizzie Steedley, a widow with two children, ages three and one, who are also pictured. She was unable to find work or a place to live and therefore lived in the house of another widowed woman, Mrs. Knight, and her twelve-year-old son. The Steedleys received support from the county in the sum of five dollars a month.[62]

In the technical notes on the photographs that Bourke-White included as an appendix to *You Have Seen Their Faces,* she explains that she wished "to avoid the flat lighting that results from the usual synchronizing device in which the reflector is attached directly to the camera."[63] Instead, she built a lighting system with numerous extensions, adopting the cinematic practice of composing her images with multiple light sources. Bourke-White lit the scene dramatically from the left, casting mother and children in bright light—their gazes turned downward—while hiding the area behind the bed frame in shadow. Bourke-White's use of harsh contrasts highlights the starkness of her subjects' social conditions. Signs of poverty fill the domestic space: bed ticking stuffed above makeshift roof purlins hangs over the family, and flattened cardboard boxes insulate the wall. An exposed mattress and ramshackle bed frame slant diagonally across the composition at an angle that appears to tilt Lizzie Steedley and her children, especially the fussing infant, into the lower left corner of the photograph. Despite the intimate space, this is not a picture of domestic security. The photographer conveys the tenuous nature of the family's circumstances through the instability of their shelter, constructing a narrative of poverty and struggle in the face of the Depression.

Bourke-White's images thus differ dramatically from Abbott's realism or Evans's formalism in the documentary practices outlined by Weissman and May, respectively, in the preceding essays. For Bourke-White, documentary photography was a highly constructed practice dominated by artificial lights, directed and performed poses, dramatic angles, and sentimental narratives. This reading, however, is not meant to minimize the role that Bourke-White hoped her photography could play as an agent for social change. In fact, by creating dramatic fictions with her subjects, Bourke-White ensured that there was little ambiguity regarding the social issues she wished to foreground in her documentary work. Moreover, her visual

language, in dialogue as it was with mass media conventions—particularly those of cinema—was a style her viewers were adept at reading. Early reviews seemed to confirm the success of her photographs in issuing a call for social action. As one critic put it in a 1937 review: "If all the talk of the sharecropper's plight is ever translated into action it will be largely because of this book. One may be indifferent to the sufferings of others when running across stray articles in the newspapers, but it is impossible not to be deeply moved by what is shown here."[64]

Bourke-White knew how to tell a story through images, and she seemed to perceive her subjects through a cinematic lens, even recognizing them as already existing within the visual language of film. In her autobiography, she recalls the sight of a prisoner work detail as if it were a movie set: "They were chained man to man, each with his soup spoon tucked in his iron ankle cuff. The sudden sight was almost too theatrical to believe. They looked as though they had strayed from an M-G-M group on location."[65] The popular Hollywood film *I Am a Fugitive from a Chain Gang*, released in 1932, may very well have been on Bourke-White's mind. When she photographed the chain gang, she emphasized the cinematic quality of the scene through the repetition of the prisoners, identically clad in striped prison garb, and the massive body of the guard, who towers over his charges (as well as photographer and viewer) with a rifle slung over his shoulder, adding to the scene's dramatic effect (plate 71).

At times, Bourke-White appears to appropriate film scenes directly. The composition of her photograph from Iron Mountain, Tennessee (plate 72)—the steep hill of the landscape pictured as a diagonal horizon line against the sweeping sky—is strikingly similar to the opening scenes from Alexander Dovzhenko's 1930 Soviet silent film, *Earth* (also translated *Soil*), which pictures an open field and

Alexander Dovzhenko, *Earth*, 1930. Film still.

equally dramatic horizon line tilting beneath the expansive sky.[66] Yet while the landscape in Dovzhenko's film is depicted with lush waves of grass, the soil of Iron Mountain has yet to yield its crop. Further pointing to the agricultural and economic challenges facing poor southern farmers, Bourke-White includes a horse-drawn plow at the furthermost right edge of the picture (another worker at the margins), poised at the bottom of the hill's steep incline. While it seems clear that Bourke-White knew Dovzhenko's film (a copy of a program for it is in her papers), its influence may have been less a conscious and explicit reference for the photographer, working in the rural South some six years later, than a formal lesson she learned and then put to use in her own work.

The narrative conventions of film also influenced how Bourke-White envisioned her photographs operating within *You Have Seen Their Faces*. The idea of building a narrative from a purposeful grouping of photographs guided her work with Caldwell from the beginning. She describes her process on the trip: "I like to have the feeling

125

of architecture while I work—of shaping up a group of photographs so that they form a meaningful whole."[67] This method had its origins in the photojournalistic stories that she made for *Fortune,* in which a series of photographs would function in dialogue with each other to tell a story. In *You Have Seen Their Faces,* she took this narrative device one step further by showing her subjects only moments apart in time, like frames on a filmstrip, to suggest movement as well as the passage of time.

Bourke-White included four such narrative sequences in the book: a child eating watermelon, a politician giving a speech, a preacher dancing behind the pulpit, and women in a church congregation testifying their faith. In each case, she records the passage of time and the movement of subjects through a tight sequence of photographs, tracing the unfolding of an event in the way that narrative action unfolds in film from moment to moment: a young child digs out the flesh of a watermelon in the first frame, lifts the fruit to her mouth in the second, and finally lifts the entire melon to her mouth in the last frame. Bourke-White, in fact, planned these narrative sequences like storyboards for a film. In preparation for the layout of the book, she mounted the photographs on mat board as a way of scripting her stories.[68] This cinematic approach allowed the photographer to tell stories about her subjects that a single photograph could not fully convey. In another striking instance, Bourke-White presents three photographs that capture the rhetorical gesticulations of an Arkansas politician, Neil C. Marsh, only moments apart as he delivers a speech: he presents a piece of paper with his right hand in the first frame, extends both hands in an emphatic gesture in the next frame, and lifts his left hand in the final frame as if to further emphasize his point (plate 69).[69] The manner in which Bourke-White arranges the three photographs, in a vertical sequence from the top

of the page to the bottom, essentially directs the viewer to read the images as a strip of film.

Bourke-White also gravitated toward subjects that could express the scale and drama of the cinema. She was drawn to antebellum architecture as she had been to industrial landscapes, and she photographed southern houses, with their Greek Revival columns, as she did the smokestacks of Cleveland factories. In her picture of a façade in Clinton, Louisiana (plate 73), the diagonal composition of the colonnade echoes the row of smokestacks she shot at Otis Steel some nine years earlier (plate 51).[70] Also drawing from her previous techniques, she included figures as a way to point to the scale of her architectural subjects and the uncertain position of the human figure in these settings. The mother and daughter in the Clinton photograph, like the two figures at the foot of the Otis smokestacks or the two workers at the base of the grain elevators at Rosenbaum Grain in Chicago, are diminutive figures against the massive columns behind them, evoking the now-familiar metaphor in her work of the powerlessness of the Depression-era human subject. Yet while the mother and child are overpowered in scale, they are not marginalized in the same way as her earlier industrial workers. Instead, they are central to the image both formally, in that they are at the center of the composition, and symbolically, in that they can stand for the human consequences of the collapsed economy, inviting the viewer to imagine a story of loss and despair in which mother and daughter sit amid this crumbling setting while gazing grimly into the distance. By the middle of the decade, the deterioration consequent to the Depression was everywhere. Bourke-White's Clinton photograph captures the entropic effects of time and disuse on this once-grand mansion from an earlier era (which had become, according to Bourke-White's notes, a three-family tenement) through the erosion of the col-

umns and stairs and the broken wheel of a silenced plantation bell at the far left foreground of the image.[71]

Bourke-White's work for *You Have Seen Their Faces* has been criticized as displaying an exploitive disregard for her subjects' personal lives and histories.[72] However, meticulous notes survive in her papers from her two months with Caldwell in 1936 and their return trip in the spring of 1937, establishing that Bourke-White engaged with and knew her subjects. She knew their names, their personal health histories, their incomes, their crop yields, their employment status, and she jotted down these details with the care of a reporter. Sometimes she also noted her subjects' reactions to being photographed. Some refused to pose, one wanted to show off a new hat, another mentioned that she had not been photographed since 1883.[73] They were, like her posed industrial workers, participants in the construction of their images, and they were certainly conscious of their role as photographic subjects.

Mostly Bourke-White's notes record the economic and employment conditions of her subjects. The four men she photographed in Natchez, Mississippi, worked in a box factory and did odd jobs (plate 74). They could make $1.50 a day when they worked, which sometimes they were able to do two or three days a week.[74] She goes into careful detail describing the "Caravan Family from Florida," whom she photographed on March 23, 1937, on the outskirts of Ringgold, Georgia, near Chattanooga (plate 75). She describes their journey from the Florida Keys to Lawrence, Kansas: their attempts to peddle painted doorstops, their constant hunger, and their rate of progress of fifteen to twenty miles a day except when it rained. She then notes the family members: "C. E. Reed, 35, father; Juanita, 28, pregnant mother; children: Ernestine, 12; Elberta Jane, 9; Elmer, 6; [and] Charles Edward Jr., 3."[75]

Bourke-White's detailed accounts are not reflected in the captions or Caldwell's extended text for *You Have Seen Their Faces*. Instead, the book offers generalizations and contrived sentimentality both textually and visually. The caption for the box-factory workers in Natchez reads, "Just sitting in the sun watching the Mississippi go by"—a narrative of leisure that belies the economic circumstances of the time. Bourke-White pictures this same sentiment in her photograph of the Natchez men in a state of carefree repose—a fiction that is sustained until one notices the tattered shoes of the foreground figure. The Ringgold, Georgia, caption does not identify the Reed family by name but simply reads, "Those poor people walking all the way from Florida looking for a job, and hungry every step. It's a shame they have to walk so far, but they've got to go somewhere—they can't stay here."[76] Similarly, Bourke-White emphasizes the drama of this family's plight and the uncertain nature of their journey through her oblique composition, which tilts the road upon which they travel at a precarious downward angle.

Bourke-White assumed partial credit for the captions—or "legends," as they were termed in the book—explaining that she and Caldwell would arrange a selection of pictures on the floor, step back, and separately compose their attempts; the resulting caption might be a combination of both of their efforts.[77] Either way, they wrote their captions by largely, if not wholly, decontextualizing the photographs from Bourke-White's careful notes. They created their own fictions for these subjects and were harshly judged in the critical literature for doing so, despite the disclaimer that opens the book: "The legends under the pictures are intended to express the authors' own conceptions of the sentiments of the individuals portrayed; they do not pretend to reproduce the actual sentiments of these persons."[78] Bourke-White and Caldwell could not have been more explicit that they were constructing their own

fictional accounts. Indeed it was this fact that some found most offensive; for example, when Dorothea Lange and Paul Taylor published their photo-book *An American Exodus* in 1939, they were careful to note (in an almost direct rebuttal to Bourke-White and Caldwell's opening statement): "Quotations which accompany the photographs report what the persons photographed said, not what we think might be their unspoken thoughts."[79]

The fact that the journalistic substance of Bourke-White's notes did not make it into *You Have Seen Their Faces* speaks in part to the direction and influence of Caldwell's text for the book as well as to Bourke-White's own narrative impulses for its photographs. As a dramatic recasting of southern life, the final product was very much in keeping with fictional narratives Caldwell had created in previous work, such as his 1932 novel, *Tobacco Road,* which became a hugely successful Broadway play in 1933. The lengthy text that Caldwell wrote to accompany the images often reads like an extended caption, sometimes employing the same device of first-person narrative that they had used in the photograph captions. At the same time, Bourke-White employs visual and narrative tropes that would have been legible to viewers well versed in the languages of popular culture (including Caldwell's) and mass media (including her own). Thus while it remains unclear what role, if any, Bourke-White intended her notes to play in the book, detailed reportage was a part of Bourke-White's practice of social documentary photography much earlier than has been generally recognized; her working method

for *You Have Seen Their Faces* stands as an important progenitor for her move to more explicitly photojournalistic photography in her coverage of world events for *Life* during the 1940s.

As Bourke-White moved through the first decade of her practice as a photographer, from the commercial commissions of her early career through the photojournalistic stories for *Fortune* and then *Life* to the explorations of the social conditions of the American Depression in *You Have Seen Their Faces,* the artistic practice that emerged to connect her work was her ability to effectively draw on and redeploy the visual and narrative conventions of both mass production and mass media that were so familiar to her audience. Building up a visual language for her work that took its lessons from the popular and accessible cultural mediums of advertising, picture magazines, and film, she established a mode of documentary photography that was highly legible to its viewers. In the course of a decade she went from creating some of the most iconic photographs of the American machine age to powerfully representing the social struggles of the workers and families who had once been at the margins of her gaze. The tensions she confronted and explored during this transition led to some of her most evocative images of America in the 1930s; in effect she traveled the same path as her subjects, as she documented a changing American landscape in which the power and promise of industry had collided with the new realities of pain and suffering ushered in by the Depression.

Notes

1. See Weisman and May, respectively, this volume.

2. See Bonnie Yochelson, "Clarence H. White Peaceful Warrior," in *Pictorialism into Modernism: The Clarence White School of Photography*, ed. Marianne Fulton (New York: Rizzoli, 1996), 96–98.

3. Bourke-White's itinerant education was partially the result of her first marriage to Everett "Chappie" Chapman, whose employment moved them from the University of Michigan, where he was an engineering student, to a teaching job at Purdue University, and finally to Cleveland. Bourke-White ended her marriage in 1926 and enrolled at Cornell University that fall. For a useful chronology of these years, see Stephen Bennett Phillips, "A Chronology: Margaret Bourke-White's Life and Times," in *Margaret Bourke-White: The Photography of Design 1927–1936* (New York: Rizzoli, 2003), 172–74.

4. According to Bourke-White, Kulas selected eight out of the twelve photographs that she presented to him and commissioned another eight. See Margaret Bourke-White, *Portrait of Myself* (New York: Simon and Schuster, 1963), 59–60; and see "Margaret Bourke-White Photographs the Machine Age," report, 1932, 5–6, in Biographical Materials, Box 1, Margaret Bourke-White Collection, George Arents Research Library, Syracuse University (hereafter MBW Collection). Bourke-White's Otis photographs were not, however, her first corporate job. Beginning in November 1927, the Union Trust Company bank used her pictures of bridges, railroads, and factories as the covers and frontispieces for its monthly magazine, *Trade Winds*. Between 1927 and 1932, approximately thirty of Bourke-White's photographs were used by the company in this manner. See Suzanne Ringer Jones and Marjorie Talalay, "The Cleveland Years," in *Margaret Bourke-White: The Cleveland Years 1927–1930* (Cleveland: New Gallery of Contemporary Art, 1976), n.p.

5. Nine of Bourke-White's Otis photographs were used in this publication. See *The Otis Steel Company—Pioneer, Cleveland, Ohio* (Cambridge, Mass.: Riverside Press, 1929). See also "Margaret Bourke-White Photographs the Machine Age," report, 1932, 6, in Biographical Materials, Box 1, MBW Collection. In 1942 Otis Steel was acquired by Jones and Laughlin Steel, which is now part of LTV Steel Company, Cleveland.

6. Sheeler spent six weeks at the River Rouge in October and November 1927.

7. Bourke-White, letter to Elroy John Kulas dated November 28, 1934, Correspondence, Box 34, MBW Collection.

8. Bourke-White, lecture ca. 1932, Writings, Box 67, MBW Collection.

9. See Bourke-White, *Portrait of Myself*, 51.

10. See ibid., 52–53.

11. Ibid., 50.

12. Lewis Mumford, *Technics and Civilization* (New York: Harcourt, Brace, 1934), 334.

13. Bourke-White, *Portrait of Myself*, 70.

14. Bourke-White apparently frequented screenings of Soviet films in New York, including "The History of Russian Film," a program by the Workers Film and Photo League in 1931, and she saw numerous films at the Acme Theatre, self-promoted as "the only Soviet Kino in America" (see movie bills in her archived papers, Box 105, MBW Collection). Moreover, she was introduced to the internationally renowned Soviet director Sergei Eisenstein in 1930 and famously photographed him receiving a shave on the balcony of her Chrysler Building studio. Bourke-White recounts that Eisenstein offered to write letters of introduction for her to artists in Paris, Berlin, and Moscow for the trip that she was to make in the summer of that year. She does not mention, however, whether these meetings actually took place (see Bourke-White, *Eyes on Russia* [New York: Simon and Schuster, 1931], 25–26).

15. Like Bourke-White, Bruehl studied with Clarence White, whose teachings helped to establish the principles of design that would influence this generation of commercial photographers. For more on the Clarence White School, see *Pictorialism into Modernism: The Clarence White School of Photography*, ed. Marianne Fulton (New York: Rizzoli, 1996).

16. See George Soule, "Will Prosperity Return?" *New Republic*, May 21, 1930, 4–5; and George Soule, "Gold and the Industrial De-

pression," *New Republic*, November 12, 1930, 343, quoted in Richard Pells, *Radical Visions and American Dreams: Culture and Social Thought in the Depression Years* (New York: Harper & Row, 1973), 47. On Soule and his critique of capitalism, see Pells, *Radical Visions*, 47–48.

17. Henry Luce, "*Fortune* Prospectus," 1929, Time Inc. Archives.

18. Henry Luce, letter to Subscribers, dated September 8, 1936, Correspondence, Box 49, MBW Collection.

19. See Vicki Goldberg, *Margaret Bourke-White: A Biography* (New York: Harper & Row, 1986), 87.

20. Bourke-White, *Portrait of Myself*, 64.

21. Bourke-White, "Calendar" (1927–1954), Biographical Materials, Box 1, MBW Collection.

22. In addition to her editorial assignments for *Fortune*, Bourke-White also took on advertising jobs. Her biggest accounts were Buick and Goodyear, but she would photograph everything from Wrigley's Doublemint chewing gum to Flinkote roofing finish.

23. According to Vicki Goldberg, "Both [Charles] Sheeler's work and Bourke-White's celebrate the force and the splendid design of technology without paying any attention to the worker" (Goldberg, *Bourke-White*, 88). Similarly, Terry Smith claims that Bourke-White's "is the same procedure as Sheeler's: modernism aestheticizes by stilling motion, banishing productive labor, excluding the human, implying an autonomy to the mechanical, then seeking a beauty of repetition, simplicity, regularity of rhythm, clarity of surface" (Terry Smith, *Making the Modern: Industry, Art, and Design in America* [Chicago: University of Chicago Press, 1993], 194).

24. Bourke-White, "Calendar, 1928," 2, Biographical Materials, Box 1, MBW Collection.

25. See Bourke-White, *Eyes on Russia*, 55.

26. Ibid., 56.

27. See Allan Sekula, "Photography between Labor and Capital," in *Mining Photographs and Other Pictures 1948–1968*, ed. Benjamin H. D. Buchloh and Robert Wilkie (Halifax: The Press and the Nova Scotia College of Art and Design and the University College of Cape Breton Press, 1983), 225.

28. Bourke-White, *Eyes on Russia*, 58.

29. "Hogs," *Fortune* 1, no. 1 (February 1930): 55–61.

30. See undated *Time* Office Memorandum, Biographical Materials, Box 1, MBW Collection.

31. Bourke-White, *Eyes on Russia*, 54.

32. While in Russia in 1932, Bourke-White made her first and only attempt at shooting a movie. She struggled to find distribution for the resulting films, *Eyes on Russia* and *Red Republic;* they were ultimately released by the Van Beuren Corporation in 1934. While her photographs succeed in large part due to their formal debt to cinematic conventions, her brief foray into filmmaking did not benefit from the reciprocal influence of her still photography, and her films display little of the visual drama that characterizes her photographs. In *Eyes on Russia*, however, Bourke-White offers a direct quote from Vertov's *Man with a Movie Camera,* which pictures a cameraman at work throughout the film: her film, similarly, has multiple shots of Bourke-White herself behind a movie camera.

33. Letter dated March 25, 1933, Box 105, MBW Collection.

34. I am grateful to Uri Lessing for his observation regarding the use of scale as a special effect and for his invaluable assistance in identifying and locating films from this era.

35. Mumford, *Technics and Civilization*, 283.

36. In a letter dated May 20, 1930, to Rudolph H. Wurlitzer, Bourke-White recounts her work for Ayer at the Ford plant (Box 55, MBW Collection). Charles Sheeler's work at Ford's plant in 1927 was also commissioned by Ayer.

37. See *Trade Winds* 9, no. 6 (June 1930).

38. See Anne O'Hare McCormick, "The Future of the Ford Idea," *New York Times Magazine*, May 22, 1932, section 5, pp. 1–2.

39. *Scientific American* 151, no. 5 (November 1934).

40. Letter to Margaret Bourke-White from *Fortune* Editorial Offices, dated April 25, 1934, Correspondence, Box 49, MBW Collection.

41. See Goldberg, *Bourke-White*, 125.

42. Bourke-White, *Portrait of Myself*, 91–92.

43. "The Drought," *Fortune*, 10, no. 4 (October 1934): 77. Laurence Bergreen's biography of Agee characterizes the writer as dismayed that the *Fortune* article was illustrated by Bourke-White's

photographs. See Laurence Bergreen, *James Agee: A Life* (New York: E. P. Dutton, 1984), 145.

44. Bourke-White, *Portrait of Myself*, 110.

45. Bourke-White, quoted in Goldberg, *Bourke-White*, 149.

46. See Goldberg, *Bourke-White*, 158.

47. Ibid., 157–58.

48. Bourke-White, "Photographing This World," *Nation*, February 19, 1936, 217.

49. Letter to Mr. Joseph North, *New Masses*, December 5, 1934, Box 33, MBW Collection.

50. Bourke-White, *Portrait of Myself*, 113.

51. Bourke-White's journal from this trip begins on July 19, 1936, with an entry from the House of Prayer in Dearing, McDuffie County, Georgia (Box 70, MBW Collection). *You Have Seen Their Faces* was the first of Bourke-White's three book collaborations with Caldwell, which also include the less critically and commercially successful *North of the Danube* (1939) and *Say, Is This the U.S.A?* (1941).

52. *You Have Seen Their Faces* also differs from the idea of the "democratic book" that Weissman proposes for Abbott and McCausland in that it does not present an equity of images (the lack of a single iconic photograph). Multiple photographs from *You Have Seen Their Faces* have risen to iconic status.

53. See *The Book Review Digest, 1937* (New York: H. W. Wilson, 1938), 158.

54. Insert in frontispiece of Library of Congress copy of *You Have Seen Their Faces* (New York: Modern Age Books, Gold Seal Books), 1937.

55. When Abbott and McCausland's *Changing New York* was published in the spring of 1939, Bourke-White wrote to Abbott, wishing her "great success" on the book and suggesting that they exchange autographed copies of each other's books (Bourke-White to Berenice Abbott, April 13, 1939, Box 4, MBW Collection).

56. William Stott offers an early expression of this critique in his *Documentary Expression and Thirties America* (Chicago: University of Chicago Press, 1973), 220. John Raeburn traces other expres-
sions of this criticism in *A Staggering Revolution: A Cultural History of Thirties Photography* (Urbana: University of Illinois Press, 2006), 213–14, 345n38.

57. See Belinda Rathbone, *Walker Evans: A Biography* (Boston: Houghton Mifflin, 1995), 119–20.

58. One publisher at the time declined Evans and Agee's project in the wake of the success of *You Have Seen Their Faces*, declaring that "competition would be ruinous" (see Sean Calahan, *The Photographs of Margaret Bourke-White* [Boston: Little Brown, 1998], 16). When the book was finally released in 1941, it included in the appendix a condescending review from the *New York Post* of *You Have Seen Their Faces*. The review focuses on Bourke-White's glamorous lifestyle and her "years traveling the back roads of the deep south bribing, cajoling, and sometimes browbeating her way in to photograph Negros, share-croppers and tenant farmers in their own environments" (see James Agee and Walker Evans, *Let Us Now Praise Famous Men* [Boston: Houghton Mifflin, 1941], 450–54).

59. Quoted in Goldberg, *Bourke-White*, 168.

60. In a letter to Beaumont Newhall at the Museum of Modern Art, Bourke-White explains her techniques as follows: "I am deeply impressed with the possibilities of flash bulbs distributed through the room instead of using one attached to the camera in the usual way. I work mine with extension cords from a synchronizer attached directly to the shutter but always use two sources of light and sometimes three or four or even six distributed around the room" (Bourke-White to Beaumount Newhall, June 28, 1937, Box 31, MBW Collection).

61. Typewritten notes from 1936 travels, Box 70, MBW Collection.

62. Ibid.

63. Bourke-White, "Notes on Photography," in *You Have Seen Their Faces*, 51.

64. N. B. Cousins, quoted in *The Book Review Digest, 1937* (New York: H. W. Wilson, 1938), 158.

65. Bourke-White, *Portrait of Myself*, 132.

66. The movie bill from *Earth* is in Bourke-White's papers (Box 105, MBW Collection).

67. Bourke-White, *Portrait of Myself*, 124.

68. In the artist's archive, each of the four narrative sequences in *You Have Seen Their Faces* is mounted on mat board in the order in which they appear in the book (Box 86A, MBW Collection).

69. Typewritten notes from 1936 travels, Box 70, MBW Collection. The location of this photograph was changed to Caxton, Mississippi, in the book even though an early draft of the captions by Caldwell still maintained the site as Eudora, Arkansas (Box 8, Erskine Caldwell Papers, George Arents Research Library, Syracuse University).

70. This iconic image ultimately served as the cover for the 1937 Gold Seal paperback edition of the book.

71. See Bourke-White, handwritten notes in small bound notebook, Box 70, MBW Collection. I am indebted to Jessica May for finding this notebook in the Bourke-White Collection.

72. For more on the critical reception of *You Have Seen their Faces* and an excellent comparative analysis with *Let Us Now Praise Famous Men,* see John Stromberg, "A Genealogy of Orthodox Documentary," in *Beautiful Suffering: Photography and the Traffic in Pain,* ed. Mark Reinhardt, Holly Edwards, and Erina Duganne (Williamston, Mass.: Williams College Museum of Art, 2007), 43–56.

73. Bourke-White, handwritten notes in small bound notebook, Box 70, MBW Collection.

74. Ibid.

75. Ibid.

76. *You Have Seen Their Faces,* n.p.

77. See *Portrait of Myself,* 137.

78. *You Have Seen Their Faces,* front pages. For an example of criticism of the book, see Stott, *Documentary Expression and Thirties America,* 220–23.

79. Dorothea Lange and Paul Schuster Taylor, "Foreword," *An American Exodus: A Record of Human Erosion* (New York: Reynal and Hitchcock, 1939), 6. Others, such as Gordon Parks (who would join Bourke-White as a staff photographer at *Life* in 1948), were less critical and embraced the book's potential to enact social change. Years later, Parks recalled the influence of *You Have Seen Their Faces* on his own approach to photography: "I was very much in search of some way to express my own feelings about the situation in America as concerned race, discrimination, and minority groups, especially black people, since I was black. *You Have Seen Their Faces,* along with some FSA photos, opened my eyes to the possibility of using my camera as an instrument or a weapon against this sort of thing. For me, that book was a pretty important step" (Gordon Parks, quoted in Goldberg, *Bourke-White,* 193).

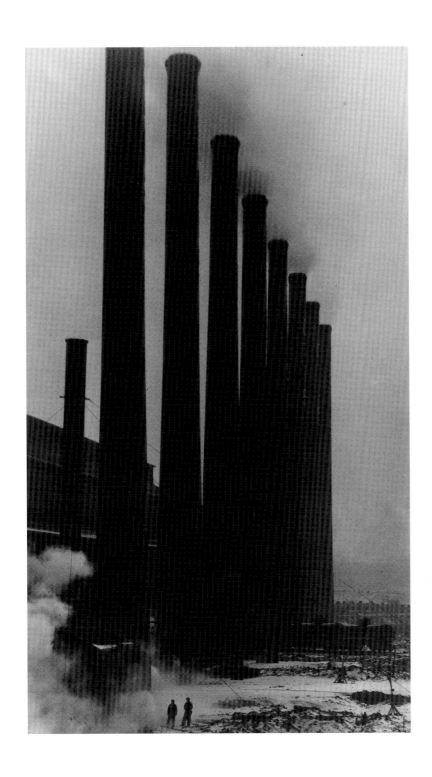

Plate 51.
Margaret Bourke-White,
*The Towering Smokestacks of
the Otis Steel Co., Cleveland,*
1927–28

134

Plate 52.
Margaret Bourke-White,
*Pouring Metal, Otis Steel
Company, 1927–28*

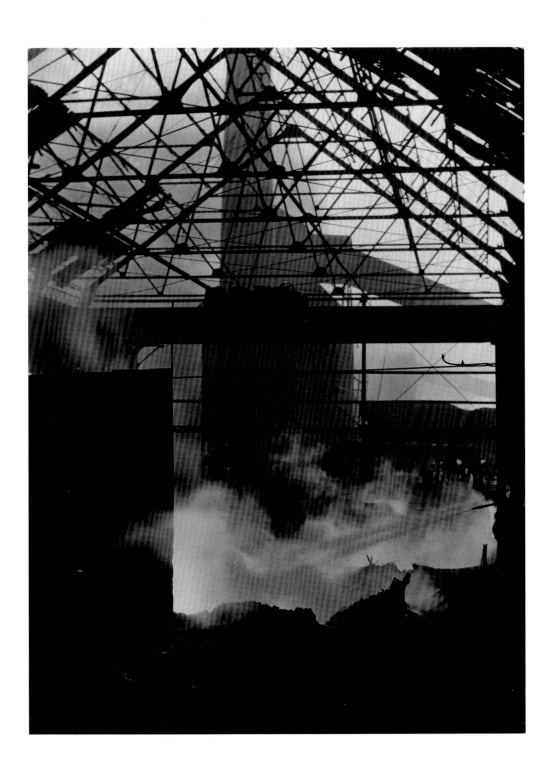

Plate 53.
Margaret Bourke-White,
*Mountains of Ore, Otis Steel
Company*, 1927–28

136

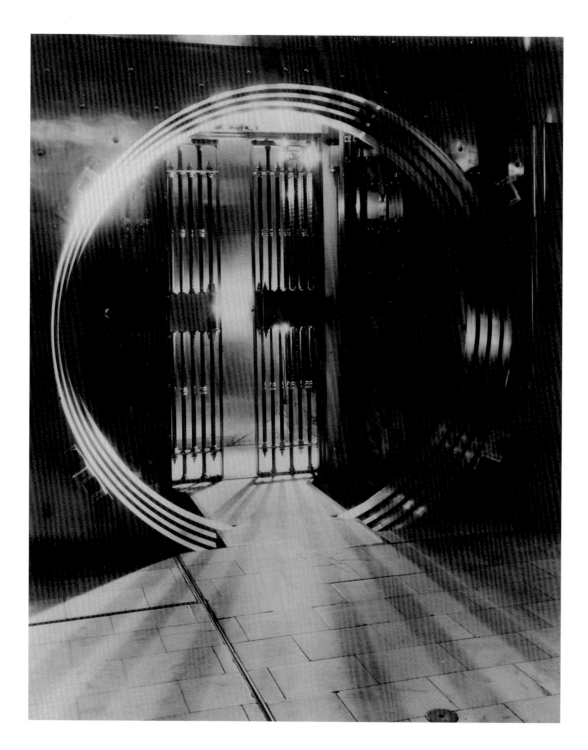

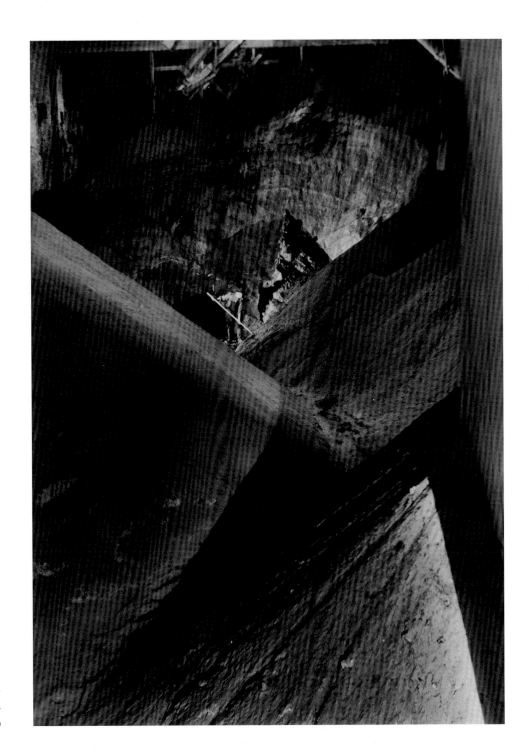

137

Plate 55.
Margaret Bourke-White,
Swift, 1929

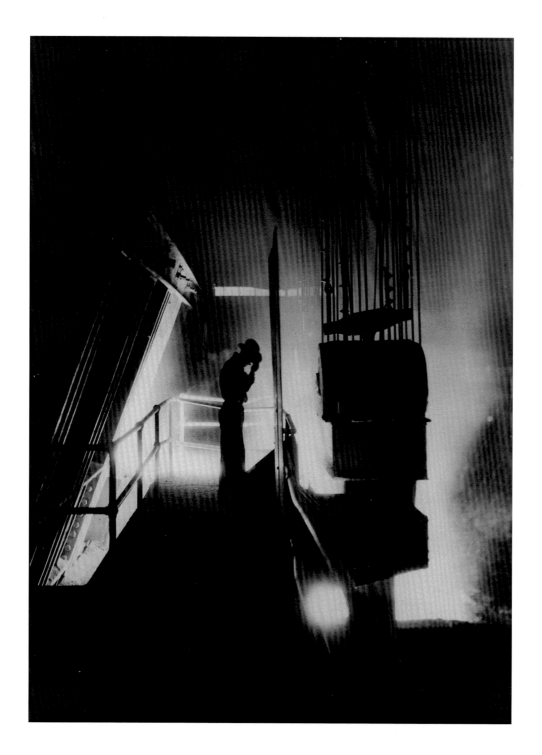

138

Plate 56.
Margaret Bourke-White,
*Testing the Heat, Ford Motor
Company,* 1930

Plate 57. Margaret Bourke-White, *Chrysler Building, New York*, ca. 1930–31

Plate 58.
Margaret Bourke-White,
Rosenbaum Grain Corporation,
Chicago, 1931

141

Plate 59.
Margaret Bourke-White,
Chrysler Corporation,
1932

Plate 60.
Margaret Bourke-White,
*Goodyear Tire and Rubber
Company, "Traffic,"* 1933

Plate 61.
Margaret Bourke-White,
Looking Up inside Sending Tower,
N.B.C., Bellmore, L.I., 1933

144

Plate 62. Margaret Bourke-White, *Delman Shoes*, 1933

Plate 63.
Margaret Bourke-White,
International Silver, 1933

146

Plate 64.
Margaret Bourke-White,
Fort Peck Dam, Montana,
1936

Plate 65.
Margaret Bourke-White,
Wind Tunnel Construction,
Fort Peck Dam, Montana,
1936

148

Plate 66. Margaret Bourke-White, *Men in St. Louis, Missouri*, 1935

Plate 67.
Margaret Bourke-White,
[Okefenokee Swamp, Georgia], for the
project *You Have Seen Their Faces*,
July 21, 1936

Plate 68. Margaret Bourke-White, *[Montgomery, Alabama]*,
for the project *You Have Seen Their Faces,* July 22, 1936

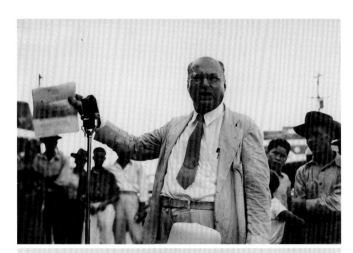

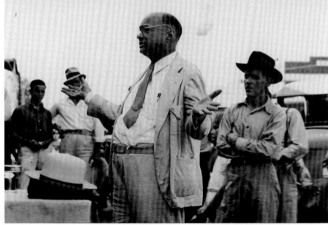

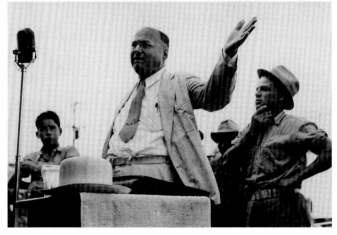

Plate 69. Margaret Bourke-White, [Caxton, Mississippi], for the project *You Have Seen Their Faces*, July 24, 1936

Plate 70. Margaret Bourke-White, *[To Heaven or Hell—Which?]*, for the project *You Have Seen Their Faces*, 1936

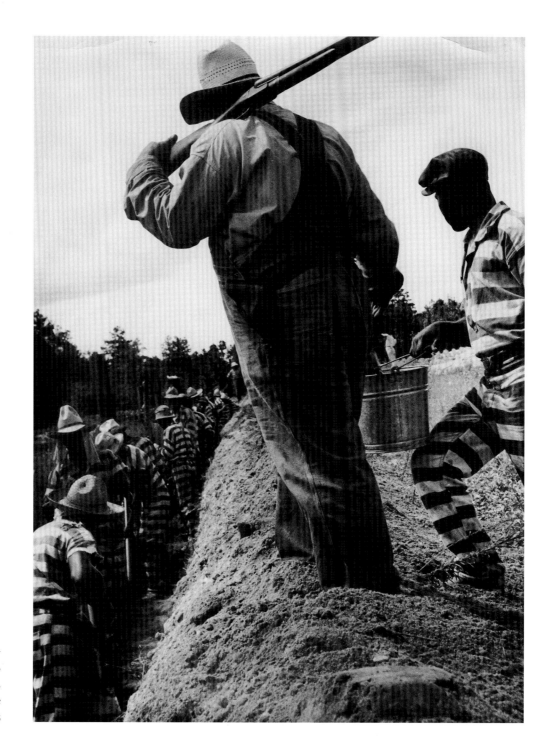

Plate 71.
Margaret Bourke-White,
[Hood's Chapel, Georgia],
for the project *You Have
Seen Their Faces*, 1936

154

Plate 72. Margaret Bourke-White, *[Iron Mountain, Tennessee]*, for the project *You Have Seen Their Faces*, 1937

Plate 73.
Margaret Bourke-White,
[Clinton, Louisiana], for
the project *You Have
Seen Their Faces*, 1937

156

Plate 74. Margaret Bourke-White, *[Natchez, Mississippi]*,
for the project *You Have Seen Their Faces*, 1937

157

Plate 75. Margaret Bourke-White, *[Ringgold, Georgia]*, for the
project *You Have Seen Their Faces*, March 23, 1937

Afterword

This catalogue and accompanying exhibition bring together the work of Berenice Abbott, Walker Evans, and Margaret Bourke-White with the hope of advancing a dialogue about documentary photography: what it looked like in the 1930s, what forces contributed to its ascendance, and what, if anything, distinguished it as an artistic practice with particular sway in the United States. Abbott, Evans, and Bourke-White serve as the case studies for this exploration because—as we hope the essays and selected photographs demonstrate—the work of each exemplifies a unique facet of the genre. Abbott's photographs, with their emphasis on architectural detail, construction sites, and dramatic juxtapositions, seek to reveal the changing nature of social and economic relationships. Evans's work, with its focus on the passage of time and on the artifacts and materials of an old, vernacular America, connects to documentary's anthropological side; his camera becomes a tool for recording and observing public space. Bourke-White's images, in their fusion of the pageantry of industry with individual drama and (sometimes heartbreaking) narrative, reveal documentary's characteristic emotional appeal.

Each artist thus demonstrates a specific characteristic of 1930s documentary, yet the relationship made here between the three artists is not always one of difference; indeed, the readers and viewers are encouraged to draw formal comparisons between the three photographers' work. Shared formal interests are not all that link these artists, however. Many connections between Abbott, Evans, and Bourke-White relate to historical experience more than anything else. For instance—and this is no small point—all three artists matured within the orbit of the historical avant-garde, each in his or her own way deeply indebted to and influenced by European modernisms. All three also used their knowledge of this history not to copy an already worked out model of artistic practice, but as a starting point in their search for another approach that would be equally radical (on both an aesthetic and political level), yet American (and often more accessible). In fact, it is precisely this idiosyncratic mix of influences and methods, in which elements from the European avant-garde fuse with distinctly American histories, commercial interests combine with the demands of museum spaces, and commissions for hire overlap with independent work, that might be described as the defining feature of an *American Modern* practice.

But while this fluid approach to documentary photography characterized work produced in the 1930s, as the Depression ended and the United States entered World War II and, later, the Cold War, such a working method no longer seemed historically viable. During the Cold War, the United States would seek to create an image of itself

as both prosperous and democratic. This image—designed to provide a compelling alternative, for both war-torn Europe and the developing world, to the Soviet Union's promise of socialist equality—ensured that international anticommunism would be a key feature of U.S. politics. Consequently, the more radical elements of the New Deal era, including the Federal Art Project and Resettlement Administration/Farm Security Administration in which Abbott and Evans found a home, even if only tentatively, were quashed by McCarthyism. An early sign of change arrived in 1942, when Roy Stryker moved the FSA into the Office of War Information, hoping to save the agency from destruction—a move that only worked temporarily. Yet, despite these momentous changes in the political landscape, New Deal liberalism, with its overt commitment to positive public action and its valorization of the common man, survived as the consensus credo of American political culture, evidenced in part by the persistent image of the American dream. The quotidian was still celebrated, though gone was any deeper concern with exposing the conditions of poverty, disaster, and deprivation.

These changing political realities mirrored changes in the art world. One of the most significant of these—at least for photographers such as Abbott, Evans, and Bourke-White—came in December 1940, when the Museum of Modern Art in New York established its permanent Department of Photography, with Beaumont Newhall serving as its first curator. Newhall's inaugural show, *Sixty Photographs,* emphasized photography as an art of individual expression rather than focusing on its history as a media-driven and popularly based medium. Though the exhibition featured work by a range of artists, including Abbott and Evans, Alfred Stieglitz—who had struggled to establish photography as a creative "high art" for over forty years—was represented by twice as many pictures as any other participant. The decision to highlight Stieglitz's role conveniently situated MoMA as his logical successor and as the new official arbiter of standards of photographic quality, craftsmanship, and perception.[1]

In 1947 Edward Steichen succeeded Newhall as the department's curator. Steichen oriented his exhibitions toward a more popular audience than did Newhall, and he demonstrated real interest in documentary as a genre, but not as it had existed in the 1930s. Two exhibitions evidence this point particularly well: *The Family of Man,* which went on view in 1955, and *The Bitter Years, 1935–1942,* which was held in 1962. *The Family of Man* comprised over five hundred images, featured accompanying captions by the poet Carl Sandburg, and sought to demonstrate that the human experiences of birth, work, love, and death are universal and as such trump any differences of geography, ethnicity, or social and economic status. Much has been written about *The Family of Man,* with the most searing and insightful criticism coming from authors who have attacked the exhibition for its naive sentimentality, its self-deception, and its assumption that there is in fact some kind of universal human condition.[2] But *The Family of Man* was also an important event—not only does it remain one of the most successful photography exhibitions ever, but it also illustrates how the American tradition of social documentary photography, as it had been practiced by artists such as Abbott, Evans, and Bourke-White in the 1930s, became inseparable in the 1950s from the promotional aspects of an advertisement for the American dream. The look of 1930s documentary photography was maintained and the rhetoric of realism and precision utilized, but the images themselves, as a group, depended on the unspecified nature of abstraction: the images only worked as depictions of a universal human condition. *The Bitter Years* similarly demonstrated the joint processes of aestheticization and

museumification that documentary photography underwent at midcentury. The exhibition simultaneously situated social documentary as a historical mode of production and, in the words of Rexford Tugwell, the former head of the RA/FSA, sealed the fate of FSA photography as "an art form."[3]

Moreover, as the documentary tradition of the 1930s was transformed into a more or less purely aesthetic practice in the 1940s and 1950s, and documentary photography, conceived as a historical model of production, slowly accepted its place on the museum's walls in the 1960s, a new form of photographic practice—one based in abstraction and formal play—gained momentum. The creation of *Aperture* magazine in 1952 served as one of the first formal canonizations of this new practice, and the growing popularity of abstract work by artists such as Aaron Siskind (who had once worked as a documentary photographer), Eliot Porter, and Frederick Sommer solidified the trend. In this new atmosphere, artists such as Abbott, Evans, and Bourke-White—who had been so crucial to the development and vitality of America's photographic culture—struggled to secure their place in its history. In this regard, the parallels between these three figures' historical experiences continued into the 1940s and beyond. Each essentially disappeared from the art world's center stage to pursue other—sometimes quirky—interests.

In 1939, after the publication of *Changing New York,* Abbott ended her affiliation with the FAP and largely abandoned the type of documentary practice she had helped to define in the preceding decade. Although she struggled for nearly twenty years to find the proper outlet for her new endeavor, Abbott began as early as 1939 to pursue an interest in scientific photography. While she labored and persisted in this field for many years, writing passionately about the importance of photographing science and declaring science to be the most "now" field of study, it was not until 1957, when she was hired by the Physical Science Study Committee at the Massachusetts Institute of Technology to help develop illustrations for high school physics textbooks, that she finally found stable employment. The affiliation, however, lasted only a short while, and in 1961 she was let go (for reasons Abbott believed related in part to her gender). After Abbott returned to New York in 1961, her health began to deteriorate; she had long suffered with lung diseases, and early in 1962, doctors removed a part of one of her lungs. Fleeing New York's polluted air, Abbott moved to Maine in 1966 and focused much of her attention on printing until her death in 1991. In the 1970s and 1980s, as art historians mined photography's past, Abbott was to some extent rediscovered as one of documentary's grandes dames, yet the impact and meaning of her documentary vision still remains understudied.

After his *American Photographs* exhibition in 1938, Evans also largely abandoned documentary practice as he had defined it in the decade previous. Instead, he focused on making photographs of passengers in the New York City subways and wrote book and movie reviews for *Time* magazine. In 1945 he took a full-time job as a photographer for *Fortune* magazine, which occupied the next two decades. His final job was as a photography professor at Yale University. During his time at Yale and in his retirement in the years that followed, Evans increasingly used interviews and lectures as opportunities to reflect on his work of the 1930s and on the influence and nature of documentary photography. It was during his last years (he died in 1975) that Evans described his own practice as "lyric documentary." The term itself was not new: Evans's dear friend James Agee used the concept in 1946 to describe the work of Helen Levitt. In contrast, Agee had used the word *static* to describe Evans's work.[4] Both descriptions

were, for Agee, terms of honor. Why Evans eventually swapped one phrase for the other remains—to some extent—a mystery.

By the end of the 1930s, as the conflicts that would give way to the Second World War spread, Bourke-White's coverage of world events came to more clearly define her photographs, and her identity as a photojournalist overshadowed her previous documentary practice. She was accredited as a war correspondent with the U.S. Air Force in 1942 and accompanied troops on numerous photographic missions; for the rest of her career, her assignments for *Life* magazine took her around the world photographing newsworthy events and world leaders. Some of the iconic photographs that she made for the weekly newsmagazine during these years include German air raids on Moscow (1941), Nazi atrocities (1945), Mahatma Gandhi at his spinning wheel (1946), and the violence and grief that erupted during the Korean War (1952). While traces of the stylistic and narrative hyperbole that characterize her 1930s photography can be found in her later work, Bourke-White tempered her dramatic angles and fictional melodramas in her photojournalistic coverage of the 1940s and 1950s. The effects of war, it would seem, required less embellishment from the photographer to communicate their horrors. Bourke-White continued to work for *Life* as one of its most famous photojournalists until the late 1950s, when her struggle with Parkinson's disease made it increasingly difficult for her to make photographs. She died from complications of the disease in 1971.

Thus, after their heyday in the 1930s, Abbott, Evans, and Bourke-White all followed paths—not always predictable—away from the very genre they helped to create and define. The fact that today there is renewed interest in their 1930s work and that an exhibition such as *American Modern* should appear is not surprising given contemporary photographers' renewed interest in documentary. In no small part their interest emerges from the dire economic circumstances that face our globalized world (circumstances not unlike those facing the world during the Depression), as well as from the surfacing of shocking images of pain and human rights abuses in places ranging from Darfur to Abu Ghraib. But while the documentary image has reemerged in contemporary art, its appearance differs from the 1930s documentary photography explored in this exhibition in that contemporary examples have tended to overtly mix fact and fiction. In its current form, the genre demonstrates a heightened awareness that photography is not, in the words of Roland Barthes, a "message without a code." But the return of the documentary mode is notable not only because it differs from its historical predecessors but also because it breaks with the practices of postmodern photographers such as Sherrie Levine and Cindy Sherman. While such 1980s photographers tended to privilege image over subject and discourse over interaction, contemporary art's new documentarians—artists like David Goldblatt, Walid Raad, and Emily Jacir, all of whom record war, devastation, inequality—also seek to maintain (as did Abbott, Evans, and Bourke-White) a vital connection to the exterior world and to operate in an international and political public sphere. Thus as this catalogue and exhibition look back to one of the most creative and industrious moments of documentary production, they also seek to shed light on the contemporary use of the documentary mode.

Notes

1. See John Raeburn, *A Staggering Revolution: A Cultural History of Thirties Photography* (Urbana: University of Illinois Press, 2006), 293–301.

2. Roland Barthes, "The Great Family of Man," in *Mythologies* (New York: Hill and Wang, 1957); and Susan Sontag, *On Photography* (New York: Farrar, Straus, Giroux, 1977), are among the most insightful analyses.

3. Maren Stange, *Symbols of Ideal Life: Social Documentary Photography in America 1890–1950* (Cambridge: Cambridge University Press, 1989), 134.

4. James Agee, introduction to *A Way of Seeing: Photographs of New York by Helen Levitt* (New York: Viking Press, 1946).

Chronology

Framed by two important events in U.S. history—the crash of the New York stock market in 1929 and the bombing of the U.S. naval base at Pearl Harbor in 1941—this chronology focuses on the intersections between the photographers Berenice Abbott (1898–1991), Walker Evans (1903–1975), and Margaret Bourke-White (1904–1971). In order to highlight the increasing popular interest in photography during the 1930s, this chronology pays special attention to exhibitions and major publications that often featured all three photographers.

1929

Evans lives in Brooklyn and begins a series of photographs focusing on the Brooklyn Bridge and New York City.

January: Abbott visits New York City. Taken by the immense changes that occurred during her eight-year absence, she is inspired to start a project to document the city. During this trip, Abbott also visits her mother in Cleveland, Ohio, where she contacts Bourke-White, whose industrial photographs she admires.
—Bourke-White's *Otis Steel: Open Hearth* is published in *Nation's Business*, a magazine with a circulation over 300,000. *The Story of Steel*, a limited-edition booklet of Bourke-White's photographs of the Otis Steel mill, is published specifically for corporate clients of Otis Steel and introduces Bourke-White's photography to several large industries. She is subsequently hired to photograph inside the factory of the Lincoln Electric Company.

February: The Harvard Society for Contemporary Art opens its doors with a show of American painters, including Thomas Hart Benton, George Bellows, Rockwell Kent, Georgia O'Keeffe, and Edward Hopper. Cofounded by Lincoln Kirstein and fellow Harvard graduates Edward Warburg and John Walker III, the gallery seeks to promote contemporary artists, who are often overlooked by museums.

May: Publisher Henry R. Luce approaches Bourke-White with a potential job offer.
—Abbott moves from Paris to New York City, bringing with her Eugène Atget's archive of photographs and negatives.

Once in New York, she establishes a portrait studio and starts accepting commercial work. Through a recommendation by Bourke-White, she is commissioned by *Fortune*, a new magazine to be launched by Henry R. Luce of Time Inc. in 1930, to photograph American businessmen. She also begins to photograph the city of New York independently, a project she will work on for the next ten years.

May–June: Five photographs by Abbott are exhibited in the German Werkbund's *Film und Foto* exhibition, held in Stuttgart. This exhibition, which celebrates the New Vision approach to photography, allows mass audiences to view contemporary avant-garde photography alongside scientific, medical, and reportage photographs. Traveling to Zurich, Berlin, Danzig, and Vienna, it is also the first major exhibition to display modern American photography in Germany, Switzerland, and Austria.

June: Abbott's photograph *Hester Street* is published in the Paris journal *Transition*.

June–July: Henry Luce hires Bourke-White as staff photographer for *Fortune* magazine, and she begins working on her first assignments. Bourke-White's photographs will appear in most issues of the magazine, often as a series of photographs on a specific topic.

August: Abbott's photographs of New York skyscrapers are published in the Surrealist journal *Variétés*.
—"New York in the Making," illustrated with a photograph by Evans, is published in the journal *Alhambra*. This is most likely Evans's first published photograph. During this year, he begins a friendship with Lincoln Kirstein, cofounder and principal editor of the literary journal *Hound and Horn*. Kirstein, through his editorial duties and involvement with the Harvard Society for Contemporary Art, plays a key role in introducing Americans to modern art.

September: Abbott's essay on Atget is published in *Creative Art*.

October 24 and 29: The New York stock market crashes, signaling an economic downturn that will turn into a depression by the early 1930s.

Winter: Bourke-White is commissioned by the Chrysler Corporation to photograph the construction of the Chrysler Building in New York City.

December: Bourke-White's "Portfolio of Five Industrial Photographs" is published in *Architectural Record*.

1930

Alma Reed opens Delphic Studios in New York City, a gallery that primarily focuses on Mexican art but also features contemporary photography, including exhibitions by photographers Ansel Adams and Edward Weston.
—Abbott and Evans meet in New York City. Abbott introduces Evans to the work of Atget and allows him to use her darkroom facilities.
—Abbott coordinates the publication of *Atget, photographe de Paris* with an introduction by Pierre Mac Orlan (Paris: Henri Jonqueres; New York: E. Weyhe). This publication consists of prints from Atget's glass-plate negatives owned by Abbott. She is also instrumental in organizing the first exhibition of Atget's photographs in New York City at the Weyhe gallery. She will regularly print Atget's negatives and actively promote his work until she sells his archive to the Museum of Modern Art in 1968.
—During this year, Abbott also begins research on Mathew Brady's photographs of the U.S. Civil War for the German publication *Die alte Photographie* by Camille Recht (Paris: Henri Jonqueres). She is drawn to Brady's more straightforward approach to image making as well as to the idea of recording pivotal moments in U.S. history. Influenced by both photographers, Abbott buys an 8 × 10-inch view camera.
—Evans quits his Wall Street job and moves to a new apartment in Manhattan, planning to set up a studio and photo-

graph full time. He works with a large-format camera (6½ × 8½ inches) and glass-plate negatives along with smaller-format cameras.
—Bourke-White photographs Ford's River Rouge plant in Dearborn, Michigan. One of her photographs wins the Art Directors Club medal the following year, and she is included in the *Men and Machines* exhibition at the Museum of Peaceful Arts in New York.

January: The first issue of *Fortune* is released.

February: The Bridge: A Poem by Hart Crane with three photographs by Walker Evans is published as a limited-edition book by Black Sun Press, Paris. New York publisher Horace Liveright prints first and second trade editions with varying frontispieces by Evans.

Summer: Bourke-White travels to Germany, photographing major German industries. She then spends five weeks in the Soviet Union photographing the massive industrial projects and installations under Stalin's Five-Year Plan. This is her first of three consecutive summers spent working in the USSR.
—Evans travels to Cape Cod and spends time with the painter-illustrator Ben Shahn. He will return to the cape in late November over the Thanksgiving holiday. During this time, some of his photographs are published in the journals *USA* and *Architectural Record,* and his photographs of New York City are included in the *International Lichtbild* exhibition in Munich, a follow-up exhibition to *Film und Foto* that travels for two years.

October: "New York City: Four Photographs by Walker Evans" is published in *Hound and Horn.* Evans will publish photographs periodically in *Hound and Horn* through 1934.

November 7–29: International Photography at the Harvard Society for Contemporary Art in Cambridge, Massachusetts, includes works by Abbott, Evans, and Bourke-White. Organized by Lincoln Kirstein, the show's 171 exhibits follow an interdisciplinary model as exemplified by the *Film und Foto* exhibition

and László Moholy-Nagy's 1927 book *Malerei, Fotographie, Film.*

Winter: Bourke-White closes her studio in Cleveland, Ohio, and opens a studio in New York's Chrysler Building.

December: "Walker Evans' Photographic Studies" is published in *Creative Art.*

1931

Abbott applies unsuccessfully for a John Simon Guggenheim Memorial Foundation Fellowship to support her project to produce "a documentary interpretation of New York City in photographs."
—Evans's friendship with Lincoln Kirstein develops during conversations at Muriel Draper's New York salon. At this time he shares a studio with Ben Shahn.

February: "Soviet Panorama" in *Fortune* features Bourke-White's photographs from the USSR. Later that year she publishes *Eyes on Russia* (New York: Simon and Schuster) and continues to work on assignments concerning the Soviet Union.

March–April: Evans travels in the Northeast with Lincoln Kirstein and John Brooks Wheelwright on a project photographing Victorian architecture in the United States.

April: A photograph of the Empire State Building by Bourke-White is published in *Creative Art.*

April–May: Evans works with the photographer Ralph Steiner to improve his technical skills.

April 18–May 8: Photographs by 3 Americans at John Becker Gallery, New York, featuring Evans, Bourke-White, and Ralph Steiner.

May: Frank Lloyd Wright's "The Tyranny of the Skyscraper" is published in *Creative Art* with photographs by Evans.

June: Kirstein and Evans return to the Boston area to continue the Victorian architecture project. Evans will photograph in

Provincetown, Martha's Vineyard, and upstate New York over the summer.

June 24: A photograph by Evans is on the cover of the journal *Advertising and Selling.*

Summer: The Soviet government invites Bourke-White back to the USSR. She spends most of her time in Magnitogorsk, an industrial complex on the site of the world's richest source of iron ore.

October: "The Reappearance of Photography," a review by Evans of six photo-books, is published in *Hound and Horn,* and includes Abbott's *Atget, photographe de Paris.*

November: Julien Levy opens his art gallery at 602 Madison Avenue in New York City. The gallery's focus is contemporary art, specifically photography and film. His first exhibition is a retrospective of American photography that pays homage to Alfred Stieglitz and his role in defining photography in the United States.

1932

January: Four of Abbott's photographs are shown in an exhibition celebrating the opening of the Museum of the City of New York's new building on Fifth Avenue.
—"Office and Studio of Margaret Bourke-White" is published in *Architectural Forum.* Bourke-White's photographs are also published in the *New York Times Magazine, Vanity Fair,* and *World's Work.*

January–April: Evans is hired to take photographs on a private cruise to Tahiti hosted by Oliver Jennings (a founder of Standard Oil) and his wife, Isabel. Evans shoots footage for his film, *Travel Notes.*

February: With help from the Museum of the City of New York's director, Hardinge Scholle, Abbott photographs the Rockefeller Center construction site.

February 1–19: Modern Photographs by Walker Evans and George Platt Lynes at the Julien Levy Gallery.

February 7–25: Modern Photography at Home and Abroad at the Albright Art Gallery in Buffalo, New York, includes photographs by Abbott, Evans, and Bourke-White.

February–September: A six-part series of articles published in the *New York Times Magazine* on the theme of everyday life in the Soviet Union features Bourke-White's photographs of Soviet citizens.

March 1–31: Philadelphia International Salon of Photography at the 69th Street Branch of the Pennsylvania Museum of Art includes photographs by Abbott, Evans, and Bourke-White.

March 8–31: International Photographers at the Brooklyn Museum in New York includes photographs by Abbott, Evans, and Bourke-White.

Spring: Charles Cross's *Picture of America* (New York: Simon and Schuster) is published. As one of the first modern photo-books published in the United States, it focuses on the crisis of U.S. capitalism set off by the 1929 stock market crash.
—*America as Americans See It,* edited by Fred J. Ringel (New York: Literary Guild), is published. Seeking to educate readers on the complexity of American culture, this text is illustrated with works by 100 American artists, including Evans and Bourke-White.

May 2–June 11: Photographs of New York by New York Photographers at the Julien Levy Gallery includes works by Abbott, Evans, and Bourke-White.

May 3–May 31: Murals and Photomurals at the Museum of Modern Art in New York City includes Abbott's maquette for a photomural.

Summer: Four photographs by Abbott are published in the April-June issue of *Hound and Horn.*
—Bourke-White returns to Germany to photograph the Ger-

man military. She then travels to the Soviet Union. There, in addition to taking still photographs, she produces her first and only film footage, which results in two short travelogues released as *Eyes on Russia* and *Red Republic.*

September 26–October 15: Photographs by Berenice Abbott at the Julien Levy Gallery.

October: "Mathew B. Brady 1823–1896" by Charles Flato is published in *Hound and Horn.* This important essay contextualizes Brady's photographs as visual literature, not just scientific observations, and reexamines his role in defining a documentary approach to photography. Kirstein promotes Brady because his photographic records of the Civil War connected the new interest in social documents to a distinctly American tradition.

October 15–November 5: Exhibition of Portrait Photography, Old and New, at the Julien Levy Gallery, includes works by Abbott.

October 18–November 5: Exhibition of Photographs for Art and Industry at the Art Centre sponsored by the National Alliance of Art and Industry and the Pictorial Photographers of America. Cited in the *New York Times* as the first national exhibition of photographs for commerce, industry, and science, the exhibition includes photographs by Evans and Bourke-White.

November 8: Franklin Delano Roosevelt defeats President Herbert Hoover to become the thirty-second president of the United States. At this moment, the nation faces sharp increases in bank failures, farm foreclosures, and factory closings.

1933

Abbott's second application for a Guggenheim fellowship to document New York City is denied.

March 4: Franklin Delano Roosevelt is inaugurated as president and immediately initiates economic and social mea-

sures, called the New Deal, to fight rising unemployment and economic depression.

Spring: Evans meets Diego Rivera and Frida Kahlo when Rivera is in New York City painting his controversial (and later destroyed) mural *Man at the Crossroads* for the RCA Building in Rockefeller Plaza.

May–June: Evans travels to Cuba to take photographs for Carleton Beals's book *The Crime of Cuba,* an investigation of the waning regime of President Gerardo Machado and the network of American financial backing that supported him. With this project, Evans fine-tunes his sense of photographic sequencing; his photographs are organized as a separate photoessay at the end of the text. While in Cuba, Evans meets Ernest Hemingway.

July–August: Evans is commissioned to photograph Rivera's mural sequence *Portrait of America* at the New Workers' School; he also photographs Kahlo's paintings. Some of the photographs from this series are published in *Vanity Fair.*

August: Beals's *The Crime of Cuba* (Philadelphia: J. B. Lippincott) is published with thirty-one aquatone reproductions of photographs by Walker Evans.

September 25–October 16: Photographs by Henri Cartier-Bresson and an Exhibition of Anti-Graphic Photography at the Julien Levy Gallery. Under "anti-graphic photography," Levy included works by Americans Abbott, Evans, Lee Miller, Creighton Peet, and Man Ray.

November 16–December 8: Walker Evans: Photographs of Nineteenth-Century Houses at the Museum of Modern Art features Evans's photographs from the 1931 Victorian architecture project. These works are exhibited in conjunction with a retrospective exhibition on the painter Edward Hopper.

December: Bourke-White is commissioned to produce two large photographic murals for the rotunda of Rockefeller Center. Her murals focus on the themes of radio production

and transmission. Shortly thereafter, she receives another mural commission for the Soviet Consulate in New York City.

1934

This Is New York: The First Modern Photographic Book of New York, edited by Gilbert Seldes and Leigh Irwin (New York: David Kemp), includes photographs by Abbott, Evans, and Bourke-White.
—Annual Leica exhibitions begin, sponsored by E. Leitz, Inc., makers of Leica cameras. These exhibitions, which open at Rockefeller Center and later travel around the United States, include photographs made from 35mm cameras by both amateur and professional photographers.
—Bourke-White moves her studio from the Chrysler Building to 521 Fifth Avenue to save money as the Depression deepens.
—*USSR Photographs* (New York: Argus Press), a portfolio of Bourke-White's photographs of the Soviet Union, is published.

February–March: Evans travels to Florida to take publicity photographs at Hobe Sound, a resort developed by Joseph Verner Reed, Evans's classmate at Phillips Andover. During this trip, Evans begins to focus on photographing roadside scenes.

March: An exhibition of Abbott's photographs is held at the New School for Social Research in New York City. Abbott only recently starting teaching photography at the school, a post she will hold through 1958.

March 1–30: *Photographs by Margaret Bourke-White,* a solo exhibition celebrating the museum's first acquisition of Bourke-White's photographs, is held at the Addison Gallery of American Art, Phillips Academy, Andover, Massachusetts.

March 6–April 30: *Machine Art* at the Museum of Modern Art features machine-made objects, such as ball bearings, labora-tory flasks, and propellers, to showcase the aesthetics of industrial design.

Spring: Evans begins work on assignments for *Fortune* magazine. He travels to Westchester County in New York to photograph a Communist summer camp with Dwight Macdonald, staff writer for *Fortune,* and Geoffrey Hellman, writer for the *New Yorker.* Their article, "The Communist Party," will be published in the September issue. Evans continues to submit photo-essays and photographs to *Fortune* through 1965 and will be hired as a full-time staff photographer in 1945.

May: Diego Rivera's *Portrait of America,* with text by Bertram D. Wolfe (New York: Covici, Friede), is published with several of Evans's photographs of Rivera's New York murals.
—Photographs by Bourke-White are exhibited at the New School for Social Research.

May 9: The West Coast waterfront strike begins. Maritime workers go on strike against the shipping industry, citing poor working conditions, unfair hiring practices, and the failure of ship owners to recognize independent unions. This strike, which leads to a general strike in San Francisco in July, is one of a series of strikes across the United States during this year, as Socialist and Communist parties work to construct more labor unions.

Summer: Abbott travels with architectural historian Henry-Russell Hitchcock Jr. along the East Coast to photograph pre–Civil War architecture for an upcoming exhibition, *The Urban Vernacular of the Thirties, Forties and Fifties: American Cities before the Civil War,* which opens at Yale University on November 3, 1934. During this trip, Abbott and Hitchcock also work on Hitchcock's upcoming exhibition on the architecture of H. H. Richardson.

June: Bourke-White gives a radio talk, "Opportunities for Young Women in the Field of Photography," on *Women's Radio Review,* NBC Radio.

August: *Fortune* commissions Bourke-White and writer James Agee to document the catastrophic drought in the Midwest. Their work will be published as "The Drought" in the December issue of *Fortune.*

Fall: The American Institute of Graphic Arts (AIGA) honors Evans's photographs for *The Crime of Cuba.* In addition, the book is selected for a traveling exhibition of illustrated books.

—Photographs by Abbott and Bourke-White are reproduced in the inaugural edition of *U.S. Camera 1935,* a yearly photographic publication edited by T.J. Maloney. The oversized annual includes a portfolio of around 200 mostly full-page reproductions of artistic and commissioned photographs, whose selection is strongly influenced by the photographer Edward Steichen.

October 6: A series of coast-to-coast radio broadcasts on American art prepared by the Museum of Modern Art begins. Every Saturday through January 26, 1935, a different area of artistic practice is discussed. Lincoln Kirstein's "Photography in the United States" broadcast is one of the first sustained attempts at formulating a history of photography for U.S. audiences. The lecture series is accompanied by a guidebook titled *Art in America in Modern Times,* edited by Holger Cahill and Alfred Barr Jr. (New York: Reynal and Hitchcock).

October 8: New York Photographs by Berenice Abbott opens at the Museum of the City of New York. Her first solo exhibition at the museum is so successful that it is extended from November to February 1935.

October–November: Elizabeth McCausland, writer and art critic for the liberal newspaper the *Springfield Republican,* sends Abbott her review of Abbott's October exhibition. This starts a series of letter exchanges that will lead to a thirty-year partnership. McCausland will become Abbott's collaborator on numerous projects, including the publication of *Changing New York.*

1935

Beaumont Newhall is hired by the Museum of Modern Art as the museum's librarian. He will later become the museum's first curator of photography when the Department of Photography is formally created in 1940.

—A special photography section is developed under the Resettlement Administration, a New Deal program that provides financial assistance to farmers and promotes the resettlement of displaced citizens during the Depression. Government-employed photographers record the harsh conditions of those who need aid as well as build broad public support for New Deal legislation. In 1937 the RA will become the Farm Security Administration, housed under the Department of Agriculture. Roy E. Stryker heads the section from 1935 to 1942, and in this post, he oversees and edits the work of numerous practitioners, including Evans, Dorothea Lange, Ben Shahn, Arthur Rothstein, and Russell Lee.

—The Works Progress Administration is formed to centralize the numerous public works projects that begin under Franklin D. Roosevelt's New Deal. The Federal Art Project, a small division of the WPA, focuses on providing employment to artists.

—Abbott's photographs are shown in exhibitions in Hartford, Connecticut, as well as Springfield and Cambridge, Massachusetts.

February–March: Evans travels south to New Orleans to photograph antebellum architecture and meets artist Jane Smith Ninas.

March–April: Elizabeth McCausland's "The Photography of Berenice Abbott" is published in *Trend* magazine, which for the first time casts Abbott's photographs in a political light.

Spring: Abbott and McCausland tour the Upper South and Midwest. During this trip they begin developing a photo-book project, a visual portrait of the entire nation. On their return, Abbott and McCausland jointly apply for a Guggenheim fel-

lowship, but their application is rejected because the scope of their project is deemed too large to accomplish.

April–May: Evans is commissioned to photograph the *African Negro Art* exhibition at the Museum of Modern Art. The catalogue features 477 photographs by Evans in four bound portfolios, of which fourteen sets are produced. An exhibition featuring a selection of these photographs later travels to sixteen sites over the next two years.

April 23–May 7: Documentary and Anti-Graphic: Photographs by Manuel Alvarez Bravo, Henri Cartier-Bresson, Walker Evans opens at the Julien Levy Gallery.

May 22: "Dust Changes America," an article by Bourke-White reflecting on her experiences photographing the Midwest drought, is published in the *Nation.*

June: Evans starts work on photographic projects for the Resettlement Administration.

June–July: Bourke-White struggles with *Fortune* over fees and her approach to photography.

September: Abbott finds out that her application for funding from the Federal Art Project has been accepted. This allows her to work full time on documenting the flux and change of New York City.

Fall: Photographs by Abbott and Bourke-White are reproduced in *U.S. Camera 1936,* edited by T.J. Maloney.
—The first annual *U.S. Camera* exhibition is held at Rockefeller Center in New York City. After two weeks in New York, these large exhibitions, mixing amateur and professional work, travel to over seventy-five cities across the United States.

October: Eastern Airlines commissions Bourke-White to take aerial photographs of their planes over the East Coast. Earlier in the year, Trans-World Airlines hired her to take aerial photographs of their transcontinental flights.
—Evans becomes a permanent staff member of the Resettle-

ment Administration and remains with the RA/FSA for almost two years.

November: Evans embarks on a more than four-month-long photographic tour of the Southeast and South, starting in Pennsylvania.

1936

The Photo League is formed in New York City. Instituted after the demise of the Film and Photo League one year earlier, the Photo League provides a community space for the production, exhibition, and discussion of photography. Founded by Sol Libsohn and Sid Grossman, it focuses on the social function of photography and aims to establish critical photographic values. Abbott and Bourke-White will serve on its advisory board at various times.
—Bourke-White joins the American Artists' Congress, an organization founded in response to the call of the Popular Front and the American Communist Party for the formation of literary and artistic groups to combat the spread of Fascism. Stuart Davis becomes one of the most vociferous promoters of the Congress, serving not only as the national executive secretary but also as the editor of the organization's magazine, *Art Front.* Abbott also joins and signs the 1936 "Call for an American Artists' Congress."
—*Coronet,* a monthly popular magazine featuring the visual arts and artistic photography, begins publication.
—Abbott and McCausland apply unsuccessfully for a second Guggenheim fellowship to support their national portrait project.
—Evans corresponds with Tom Mabry, executive director of the Museum of Modern Art, about making postcards for the museum's gift store.

January: Bourke-White meets Erskine Caldwell.

January 14–February 16: Henry-Russell Hitchcock Jr. mounts an exhibition on the architecture of H.H. Richardson, with pho-

tographs of architecture by Abbott, at the Museum of Modern Art. Hitchcock's book on Richardson, illustrated with Abbott's photographs, is published during this year.

February 19: Bourke-White's "Photographing This World" is published in the *Nation.*

March: Bourke-White signs an exclusive contract with NEA and Acme Newspictures. This contract establishes Acme as Bourke-White's sole agent for commercial work with advertisers and magazines.

May: One Thing Leads to Another: The Growth of an Industry, by Fred C. Kelly with photographs by Bourke-White (Boston: Houghton Mifflin), is published.

July: Meeting in Augusta, Georgia, Bourke-White and Erskine Caldwell begin a two-month journey through seven southern states. Their collaborative work on southern sharecroppers will be published as the photo-book *You Have Seen Their Faces.*

July–early September: On leave from the Resettlement Administration, Evans travels with James Agee to Hale County, Alabama, for an assignment on white sharecroppers for *Fortune.* Though *Fortune* rejects the article, their work becomes the basis for the 1941 book *Let Us Now Praise Famous Men.*

September: Abbott's "Photographer as Artist" is published in *Art Front.*
—After NEA and Acme Newspictures terminate their contract with Bourke-White because she repeatedly ignores their exclusivity clause, Bourke-White signs an exclusive contact with Time Inc. to work for *Life* magazine.

September 14–October 12: New Horizons in American Art at the Museum of Modern Art includes six photographs from Abbott's *Changing New York* series. The exhibition focuses on artwork produced under the Federal Art Project.

Fall: Photographs by Abbott and Bourke-White are reproduced in *U.S. Camera 1937.*

October: Bourke-White travels to Montana on her first assignment for *Life.*

October–December: Evans travels back and forth between New York City and Washington, D.C., in hopes of producing a film for the Works Progress Administration. He also begins to study the photographs of Mathew Brady located in the War Department's Signal Corp files and the Library of Congress.

November 3: Roosevelt is elected to a second term as president in a landslide victory over Alfred M. Landon.

November 23: The first issue of *Life* is released with a cover photograph by Bourke-White of the Fort Peck Dam. Bourke-White's piece on life in New Deal, Montana, officially introduces U.S. audiences to the photo-essay.

December 7–January 17, 1937: Fantastic Art, Dada, and Surrealism at the Museum of Modern Art includes three photographs by Evans under the subheading "Artists Independent of the Dada-Surrealist Movement."

1937

Edward Weston is the first photographer to receive a Guggenheim fellowship.
—*Look* magazine and *Popular Photography* begin publication.

January–February: Bourke-White photographs the floods in Kentucky for *Life,* then travels to Muncie, Indiana, to photograph the town made famous by the sociologists Helen and Robert Lynd. The Lynds, who pioneered the use of social surveys, first studied the interactions of the town and its people in 1924, publishing their findings in 1929 as *Middletown* (New York: Harcourt, Brace and Company). In 1935, Robert Lynd returned to Muncie to study the effects of the Depression on the town, publishing his findings as *Middletown in Transition* (New York: Harcourt, Brace and Company) in 1937.

February: Evans's last assignment for the Resettlement Administration (now officially the Farm Security Administration) is traveling with photographer Edwin Locke to document flood areas in Arkansas and Tennessee. The agency officially lets him go in late March.

March: Bourke-White and Caldwell return to the U.S. South to collect more material for *You Have Seen Their Faces.*

March 17–April 18: Beaumont Newhall's *Photography 1839–1937* opens at the Museum of Modern Art and later travels to more than twenty cities in the United States. As a comprehensive exhibition, it seeks to educate the general public on the entire history of photography, with some 841 items displayed on all four floors of the museum. Photographs by Abbott, Evans, and Bourke-White are shown in the exhibition and illustrated in the catalogue under the heading "Contemporary Photography." For the exhibition, Abbott lends Newhall some of her Atget albums, and Evans helps him secure loans of several photographs by Mathew Brady.

April: Abbott's review of *Photography 1839–1937* is published in *Art Front.* She critiques the exhibition for not investigating the social implications of photography. She argues that as a popular form of communication, documentary photographs are selectively created by photographers "to present a point of view and an objective" and are not simply neutral documents.

Summer: Bourke-White photographs for *Life* in the Arctic and then in Hollywood.

September: Evans works with Agee on an article for *Fortune* covering a Caribbean cruise on the Ward Line's *Oriente.* Their work is published as "Six Days at Sea."

October 6–November 1: Review Exhibition at Our New Address at the Julien Levy Gallery, 15 East 57th Street, includes works by Abbott and Evans.

October 20: Abbott's *Changing New York,* featuring over 100 of her photographs, opens at the Museum of the City of New York.

November: Bourke-White and Erskine Caldwell's photo-book *You Have Seen Their Faces* is published. The Gold Seal edition (New York: Modern Age Books) is a paperback with 24 pages, and the first edition (New York: Viking Press) is a hardback with 190 pages. Several photographs from this trip are previewed in the *Life* magazine article "The South of Erskine Caldwell Is Photographed by Margaret Bourke-White."

1938

U.S. Camera Magazine begins publication.
—*Forty Acres and a Steel Mule,* by Herman Clarence Nixon (Chapel Hill: University of North Carolina Press), includes photographs by Evans and other FSA photographers.
—Abbott has a one-person show at the Hudson D. Walker Gallery in midtown Manhattan that focuses on work completed outside of the Federal Art Project.

January: Abbott's New York project is featured in *Life.*

January–February: Bourke-White is on assignment in Jersey City to cover Mayor Frank Hague.

February: Evans begins working on his subway series in New York City using a concealed 35mm camera, sometimes working with Helen Levitt. He will continue to work on this project for the next three years.

March: Land of the Free by Archibald MacLeish (New York: Harcourt, Brace) is published. MacLeish calls his project "a book of photographs illustrated by a poem, a sound track of America." Most of the photographs come from the Farm Security Administration, including images by Evans; some twenty photographs come from other sources, including commercial works by Bourke-White.
—"Documentary Approach to Photography," written by Beaumont Newhall, is published in *Parnassus,* the journal of the College Art Association. In this essay Newhall names Abbott, Bourke-White, and Evans, along with Ralph Steiner, as East

Coast exemplars of documentary photography, with their "simple, straightforward photographs of great technical excellence." He stresses that, to create documentary photographs, photographers must possess a serious sociological intent. He adds that, within documentary, the photographic series achieves the greatest significance and that the complete documentary project involves editing the photographs and arranging the sequence of images and text.

Spring: Bourke-White and Erskine Caldwell travel to Spain and Czechoslovakia. Staying only briefly in Spain, the majority of their five-month trip is spent working on their upcoming book on the Sudetenland crisis, *North of the Danube.*

April: Roofs for 40 Million at the Maison Française at Rockefeller Center includes twelve prints by Abbott. Organized by An American Group, this exhibition brings attention to the nation's housing crisis.

April 18–29: The First International Photographic Exposition is held at Grand Central Palace in New York City and includes works by Abbott, Evans, and Bourke-White. Organized by Willard Morgan and underwritten by over 100 manufacturers and retailers of photographic equipment, this well-attended exposition features some 3,000 photographs from a variety of genres.

August–September: Popular Photography publishes two articles focusing on Abbott and her photographic process.

September 28–November 18: Walker Evans: American Photographs is the first major exhibition at the Museum of Modern Art to focus on one photographer. The exhibition of 100 photographs will travel to ten locations over the next two years with a slightly altered checklist as *American Photographs by Walker Evans.* The catalogue, *American Photographs* (New York: Museum of Modern Art), which includes an essay by Lincoln Kirstein, is a major photo-book in its own right.

Fall: Photographs by Bourke-White and Evans are reproduced in *U.S. Camera 1939.* This edition features a section covering the work of FSA photographers, including several photographs by Evans, with an essay by Edward Steichen.

October: Robert Taft publishes *Photography and the American Scene, a Social History 1839–1889* (New York: Macmillan).

December: Robert W. Marks's article "Chronicler of Our Times: In the Hands of Berenice Abbott the Camera Is an Instrument of Social Documentation" is published in *Coronet.*

1939

Documents of America, a Farm Security Administration traveling exhibition sponsored by the Museum of Modern Art, tours the United States.
—Evans's photographs are published in *Scribner's Magazine, Architectural Review, Harper's Bazaar,* and *Fortune.*

January–February: Abbott's review of Taft's *Photography and the American Scene* appears in *U.S. Camera Magazine.*

February: Bourke-White and Erskine Caldwell are married in Silver City, Nevada.

April: Abbott's *Changing New York* with a foreword by Audrey MacMahon and caption text by Elizabeth McCausland is published (New York: E. P. Dutton). The photo-book brings to a close her documentary project on New York, which amassed over 300 negatives as well as supplementary research files produced by draftsmen, writers, and researchers hired by the Federal Art Project.
—Abbott resigns from the FAP and begins fund-raising for a project investigating the relationship between art and science. Her unpublished statement "Photography and Science" outlines her primary focus for the next twenty years: the interpretation and imaging of scientific principles through photography.
—*North of the Danube* by Bourke-White and Caldwell (New York: Viking Press) is published.

April 30: The 1939 New York World's Fair opens. Structured around the theme of "Building the World of Tomorrow," the fair proffers the myth of the machine age, an unqualified belief in the power of science and technology to provide economic prosperity and personal freedom.

May: Abbott's article "My Ideas on Camera Design" is published in the magazine *Popular Photography.*

May 10–September 30: The exhibition *Art in Our Time* celebrates the tenth anniversary of the Museum of Modern Art and the opening of its new building. Beaumont Newhall organizes the photography section, "Seven American Photographers," and writes the section's introduction in the catalogue. Photographers include Abbott, Evans, Ralph Steiner, Ansel Adams, Brett Weston, Man Ray, and Harold E. Edgerton.

June: Bourke-White and Caldwell discuss their trip to Czechoslovakia at the Photo-League, which holds an exhibition of Bourke-White's photographs from *North of the Danube.*

September 1: German troops invade Poland. Two days later Great Britain and France declare war on Germany.

Fall: Two photographs by Bourke-White are included in *U.S. Camera Annual 1940.*

October: Bourke-White travels to England for *Life* to cover the war.

December: Bourke-White travels from England to Romania to cover the Balkan region.

1940

The Department of Photography is established at the Museum of Modern Art, with Beaumont Newhall as curator.
—Ansel Adams organizes "A Pageant of Photography" at the San Francisco World's Fair. Structured along the lines of Newhall's *Photography 1834–1937,* it includes one-person exhibi-

tions by Abbott and Bourke-White, while Evans is included in the FSA section.
—*The Last Rivet: The Story of Rockefeller Center* (New York: Columbia University Press) is published. The book includes photographs by Abbott and Bourke-White.

January: Abbott's essay "The View Camera" is published in *Graphic Graflex Photography,* edited by Willard D. Morgan and Henry M. Lester (New York: Morgan and Lester). During this year, Abbott begins experimenting with waveform photography.

January–March: Still on assignment for *Life,* Bourke-White travels from Eastern Europe to Turkey, Syria, and Egypt.

February: Abbott's "My Favorite Picture" is published in *Popular Photography.* Her response, a "myriad-faceted picture" composed of over a thousand different negatives expressing the complexity of lived experience, highlights her interests in seriality and montage.
—*February 9:* Abbott gives a talk titled "Civic Documentary History" at a conference on photography sponsored by the Institute of Women's Professional Relations. Other presenters include Roy Stryker, Beaumont Newhall, and Edward Steichen.

March: A joint exhibition of photographs by members of the Photo League and the American Artists Congress, at the Photo League Galleries, 31 East 21st Street, includes works by Abbott and Bourke-White.
—Evans receives a Guggenheim fellowship.

April: Bourke-White quits *Life* to work for *PM,* a new national newspaper that includes high-quality photographic reproductions.

May 10: Winston Churchill replaces Neville Chamberlain as prime minister of Great Britain. On the same day, Germany invades Belgium, Holland, and France using Blitzkrieg tactics. Belgium and Holland fall by the end of the month and Paris is taken over two weeks later.

June: The first issue of *PM* is published. Due to its price—five cents, in comparison to two cents for the *New York Times*—coupled with its liberal bent, the newspaper struggles to take off.

July: The Battle of Britain, a major air battle of World War II, begins.

Fall: Bourke-White's photograph *Camel Corps, Syria* is included in the *U.S. Camera Annual 1941.*
—"Colon: From *Let Us Now Praise Famous Men,*" by James Agee and Walker Evans, is published in *New Directions in Prose and Poetry 1940.* A preview of the forthcoming book, the article features four photographs by Evans.

October: Several of Evans's FSA photographs are published in Sherwood Anderson's *Home Town: Photographs by Farm Security Administration Photographers* (New York: Alliance Book) and in the journal *Survey Graphic.*
—After resigning from *PM,* Bourke-White renegotiates with *Life* and is hired on contract.

November: Bourke-White collaborates with Caldwell on a *Life* assignment to photograph the "state of America." The material is not used by *Life* but is published by Bourke-White and Caldwell as the photo-book *Say, Is This the USA?*

November 5: Roosevelt is reelected as president of the United States, becoming the only president to serve more than two terms.

December 31–January 12, 1941: Sixty Photographs: A Survey of Camera Esthetics at the Museum of Modern Art includes photographs by Evans and Abbott.

1941

U.S. Camera Magazine changes its format and becomes a monthly publication.
—Abbott, Bourke-White, Ruth Alexander, and Toni Frissell are featured in the Columbia Pictures short "Women in Photography," produced and photographed by Irving Browning.
—Abbott's "Eugène Atget" is published in the journal *The Complete Photographer.*

March–September: Bourke-White and Caldwell begin an extended trip, visiting China and then arriving in Moscow in May. They witness the invasion of the Soviet Union by German troops on June 22. Bourke-White, the only foreign photographer in Moscow at the time, photographs the German bombing of the city during the summer. She also becomes the first American photographer to photograph Stalin.

May–June: Evans photographs in Bridgeport, Connecticut, on assignment for *Fortune.* His photo-essay on the city's economic boom, which is tied to the production of armaments and supplies for both national defense and European allies, is published as "Bridgeport's War Factories" in the September issue.

June: Abbott's *A Guide to Better Photography* (New York: Crown Publishers) is published, featuring her own works and examples by other contemporary photographers including Evans. The book combines technical information with a history of photography and photographic aesthetics.
—Bourke-White and Caldwell's *Say, Is This the U.S.A.?* (New York: Duell, Sloan and Pierce) is published.

Summer: In the Image of America, an FSA exhibition sponsored by the Photographic Society of America, is held at the Museum of Science and Industry in Rockefeller Center and later travels to the Franklin Institute in Philadelphia.

July: Evans and Agee's *Let Us Now Praise Famous Men: Three Tenant Families* (Boston: Houghton Mifflin) is published.

August: Evans and Bourke-White are among the photographers whose works are shown in an exhibition sponsored by the Manhattan Camera Club of New York to benefit the British War Relief Society.

September: Roy E. Stryker's "Documentary Photography," published in *The Complete Photographer,* features works by FSA photographers, including Evans.

Fall: Evans's *Wheaton College Photographs,* with a foreword by J. Edgar Park (Norton, MA: Wheaton College), is published.

October: Evans marries Jane Smith Ninas in Rockville, Maryland.

November: 12 Million Black Voices: A Folk History of the Negro in the United States by Richard Wright and Edwin Rosskam (New York: Viking) is published. As photo-editor, Rosskam interweaves photographs, many of them taken by FSA photographers, with written text by the novelist Richard Wright. One of Evans's photographs is printed on the dust jacket.

November–December: Evans travels to Florida on commission for Karl A. Bickel's *The Mangrove Coast,* to be published in 1942.

December 7: Pearl Harbor is bombed by Japanese aircraft. The following day the United States declares war on Japan, ushering the country into World War II.

NOTE: Sources consulted in compiling this chronology include: Vicki Goldberg, *Margaret Bourke White: A Biography* (New York: Harper & Row, 1986); James R. Mellow, *Walker Evans* (New York: Basic Books, 1999); John Raeburn, *A Staggering Revolution: A Cultural History of Thirties Photography* (Urbana: University of Illinois Press, 2006); Ingrid Schaffner and Lisa Jacobs, eds., *Julien Levy: Portrait of an Art Gallery* (Cambridge, MA: MIT Press, 1998); and Bonnie Yochelson, *Berenice Abbott: Changing New York* (New York: New Press/Museum of the City of New York, 1997).

Berenice Abbott

The El at Columbus and Broadway, New York, 1929
Gelatin silver print
5^{15}/$_{16}$ × 8 inches
The Metropolitan Museum of Art, Ford Motor Company
Collection, Gift of Ford Motor Company and John C.
Waddell, 1987, 1987.100.156

**Union Square: Lincoln Statue,* 1929
Gelatin silver print
8 × 10 inches
Photography Collection, Miriam and Ira D. Wallach
Division of Art, Prints and Photographs,
The New York Public Library, Astor, Lenox, and Tilden
Foundations
p. 35

**[Early New York Scrapbook],* 1929–30
Gelatin silver prints on mount
Dimensions variable
The Metropolitan Museum of Art, Gift of Emanuel Gerard,
1979–84, 1979.678.9-.16; 1982.1180.10-.17 [p. 36]; 1982.1180.96-
.105; 1981.1246.65-.73 [p. 37]

Untitled, ca. 1929–30
Gelatin silver print
8^{15}/$_{16}$ × 7^{1}/$_{16}$ inches

The Art Institute of Chicago, Julien Levy Collection,
Gift of Jean and Julien Levy, 1978.1032

**Hooverville, Central Park,* ca. 1931
Gelatin silver print
8 × 10 inches
Photography Collection, Miriam and Ira D. Wallach
Division of Art, Prints and Photographs,
The New York Public Library, Astor, Lenox, and Tilden
Foundations
p. 38

Ferry: West St. Foot of Liberty St., New York, 1931
Gelatin silver print
7^{5}/$_{8}$ × 9^{5}/$_{8}$ inches
Collection of Norma B. Marin, Courtesy Meredith Ward
Fine Art

**Lower East Side (Corner Orchard and Stanton),* ca. 1932
Gelatin silver print
4^{7}/$_{8}$ × 6^{3}/$_{4}$ inches
Howard Greenberg Gallery
p. 39

**Rockefeller Plaza,* 1932
Gelatin silver print
8 × 10 inches

*Reproduced in catalogue

Photography Collection, Miriam and Ira D. Wallach
Division of Art, Prints and Photographs,
The New York Public Library, Astor, Lenox, and Tilden
Foundations
p. 40

Rockefeller Center, ca. 1932
Gelatin silver print
11 × 8⅞ inches
The Art Institute of Chicago, Julien Levy Collection,
Gift of Jean and Julien Levy, 1978.1031
p. 41

[Design for Rockefeller Center Mural], 1932
Gelatin silver print
4¼ × 8⅛ inches
Amon Carter Museum, P1988.7
p. 42

Church and Graveyard in Enfield, Massachusetts, ca. 1932
Gelatin silver print
7⁹⁄₁₆ × 9⁹⁄₁₆ inches
Worcester Art Museum, Stoddard Acquisition Fund,
1986.40

Boston, 70–73 Beacon Street. Granite houses of about 1835–40,
1934
Gelatin silver print
7½ × 9½ inches
Davison Art Center, Wesleyan University, 1979.30.4.13

*Baltimore, Southeast Corner Asquith and McElderry Streets.
Brick shops and houses of about 1850–55*, 1934
Gelatin silver print
7¼ × 9½ inches
Davison Art Center, Wesleyan University, 1979.30.4.33

Norris Dam, Tennessee, 1935
Gelatin silver print
10 × 8 inches

Commerce Graphics
p. 43

Portrait of a Miner, Greenview, West Virginia, 1935
Gelatin silver print
10 × 8 inches
Commerce Graphics
p. 44

Main Street, Colliersville, TN, 1935
Gelatin silver print
8 × 10 inches
Photography Collection, Miriam and Ira D. Wallach
Division of Art, Prints and Photographs,
The New York Public Library, Astor, Lenox, and Tilden
Foundations
p. 45

[White Horse Tavern], ca. 1935
Gelatin silver print
7¼ × 9⅜ inches
Howard Greenberg Gallery

Murray Hill Hotel, 1935
Gelatin silver print
9½ × 7½ inches
Museum of the City of New York, 40.140.176
p. ii (Frontispiece)

Daily News Building, 1935
Gelatin silver print
9⅝ × 7⅝ inches
Museum of the City of New York, 40.140.52
p. 46

Squibb Building with Sherry Netherland in Background, 1935
Gelatin silver print
9½ × 6½ inches
Collection of Norma B. Marin, Courtesy Meredith Ward
Fine Art
p. 47

Church of God, 1936
Gelatin silver print
7⅝ × 9½ inches
Collection of Norma B. Marin, Courtesy Meredith Ward
Fine Art

Pine Street: US Treasury in Foreground, 1936
Gelatin silver print
9⅝ × 7¹⁵⁄₁₆ inches
Amon Carter Museum, P1986.31

DePeyster Statue, Bowling Green, New York, 1936
Gelatin silver print
9⅜ × 7⅜ inches
Museum of the City of New York
p. 48

Canyon, Broadway and Exchange Place, 1936
Gelatin silver print
9⁵⁄₁₆ × 7½ inches
National Gallery of Art, Gift of Marvin Breckinridge
Patterson, 2000.148.1
p. 49

Canyon: 46th Street and Lexington Avenue, Looking West, 1936
Gelatin silver print
9⅞ × 7¹⁵⁄₁₆ inches
Addison Gallery of American Art, Phillips Academy,
Andover, Massachusetts, Museum Purchase

Herald Square, 1936
Gelatin silver print
8 × 9⅝ inches
Collection of Norma B. Marin, Courtesy Meredith Ward
Fine Art
p. 50

Wall Street and Stock Exchange, 1936
Platinum print, printed later
8¹¹⁄₁₆ × 6⅞ inches

The Art Institute of Chicago, Restricted Gift of Edward
Byron Smith, 1984.1175

Construction Old and New, 1936
Gelatin silver print
9½ × 7½ inches
Museum of the City of New York, 49.282.150
p. 51

*"El" Station Interior, Sixth and Ninth Avenue Lines, Downtown Side,
72nd Street and Columbus Avenue,* 1936
Gelatin silver print
7½ × 9½ inches
Museum of the City of New York, 40.140.72
p. 52

Fourth Avenue, No. 154, 1936
Gelatin silver print
7½ × 9½ inches
Museum of the City of New York, 40.140.110
p. 53

Manhattan Bridge Looking Up, 1936
Gelatin silver print
19⅜ × 15⅜ inches
The Art Institute of Chicago, Works Progress
Administration Allocation, 1943.1414
p. 54

*Seventh Avenue Looking North from 35th Street,
New York,* 1936
Gelatin silver print
18⅞ × 14⅝ inches
The Art Institute of Chicago, Works Progress
Administration Allocation, 1943.1410
p. 55

Stanton Street, Nos. 328–332, Manhattan, 1937
Gelatin silver print
7⅜ × 9⅜ inches

The Art Institute of Chicago, Works Progress
Administration Allocation, 1943.1394
p. 56

*Bread Store, 259 Bleecker Street, 1937
Gelatin silver print
9¹⁄₂ × 7¹⁄₂ inches
Museum of the City of New York, 49.282.57
p. 57

South Street, Nos. 151–166, 1937
Gelatin silver print
7⁵⁄₈ × 9⁵⁄₈ inches
Collection of Norma B. Marin, Courtesy Meredith Ward
Fine Art

*Hell Gate Bridge, 1937
Gelatin silver print
7⁷⁄₈ × 9⁵⁄₈ inches
Collection of Norma B. Marin, Courtesy Meredith Ward
Fine Art
p. 58

Father Duffy, Times Square, 1937
Gelatin silver print
9³⁄₈ × 7⁵⁄₈ inches
Collection of Norma B. Marin, Courtesy Meredith Ward
Fine Art

*Flatiron Building, Madison Square, 1938
Gelatin silver print
9¹⁄₄ × 7¹⁄₂ inches
Museum of the City of New York, 49.282.77
p. 59

Rockefeller Center Parking Space, 40 West 49th Street, 1938
Gelatin silver print
7¹⁵⁄₁₆ × 9¹⁵⁄₁₆ inches
National Gallery of Art, Patrons' Permanent Fund,
2001.67.1

Original cover proposal for Changing New York, 1938
Gelatin silver print with handwritten annotations
20¹⁄₂ × 19¹¹⁄₁₆ inches
Elizabeth McCausland Papers, Archives of American Art,
Smithsonian Institution

Walker Evans

*Untitled (Brooklyn Shipyard), 1928–29
Gelatin silver print
2³⁄₈ × 4¹⁄₄ inches
Addison Gallery of American Art, Phillips Academy,
Andover, Massachusetts, Gift of Arnold H. Crane, 1985.46.63
p. 83

Brooklyn Bridge, 1929–30
Gelatin silver print
2¹⁄₂ × 1⁵⁄₈ inches
Addison Gallery of American Art, Phillips Academy,
Andover, Massachusetts, Gift of Arnold H. Crane

Manhattan, ca. 1929–30
Gelatin silver print, printed later
4³⁄₁₆ × 2³⁄₈ inches
Addison Gallery of American Art, Phillips Academy,
Andover, Massachusetts, Gift of Arnold H. Crane

Votive Candles, New York City, ca. 1929
Gelatin silver print
9¹⁵⁄₁₆ × 6⁷⁄₈ inches
The J. Paul Getty Museum, 84.XM.956.44

[New York City Street Corner, High Angle View], 1929
Gelatin silver print
7¹⁄₄ × 5 inches
The J. Paul Getty Museum, 84.XM.956.47

*[Lunchroom Window, New York], 1929
Gelatin silver print
4⁵⁄₈ × 7¹⁄₄ inches

The Metropolitan Museum of Art, Gift of Arnold H. Crane, 1971 (1971.646.35)
p. 84

Girl in Fulton Street, New York, 1929
Gelatin silver print
6$\frac{1}{8}$ × 4$\frac{1}{2}$ inches
The Art Institute of Chicago, Gift of Mrs. James Ward Thorne, 1962.159

Roadside Gas Sign, Truro, Massachusetts, 1929
Gelatin silver print
4$\frac{9}{16}$ × 6$\frac{5}{8}$ inches
The Art Institute of Chicago, Gift of Mrs. James Ward Thorne, 1962.155

[Chrysler Building Construction, New York], 1930
Gelatin silver print
6$\frac{3}{16}$ × 4$\frac{15}{16}$ inches
J. Paul Getty Museum, 84.XM.956.136
p. 85

Posed Portraits, New York, 1931
Gelatin silver print
8$\frac{1}{16}$ × 5$\frac{5}{8}$ inches
The Art Institute of Chicago, Gift of Mrs. James Ward Thorne, 1962.169
p. 86

Gothic Gate near Poughkeepsie, New York, 1931
Gelatin silver print
6$\frac{1}{8}$ × 7$\frac{11}{16}$ inches
Museum of Modern Art, Gift of Lincoln Kirstein, 58.1933
p. 87

Greek House, Dedham, Massachusetts, 1932
Gelatin silver print
4$\frac{1}{4}$ × 6$\frac{1}{8}$ inches
Museum of Modern Art, Gift of Lincoln Kirstein, 97.1933
p. 88

Untitled (Three Men Against City Buildings), aka *South Street, New York*, ca. 1932
Gelatin silver print
5$\frac{3}{4}$ × 7$\frac{3}{4}$ inches
Collection of Norma B. Marin, Courtesy Meredith Ward Fine Art

Untitled (Cinema), 1933
Gelatin silver print
6$\frac{3}{16}$ × 7$\frac{1}{2}$ inches
The Art Institute of Chicago, Gift of Arnold H. Crane, 1970.313
p. 89

People in Downtown Havana, 1933
Gelatin silver print
5$\frac{15}{16}$ × 9 inches
The Metropolitan Museum of Art, Gift of Lincoln Kirstein, 1952 (52.562.7)
p. 90

Coal Dock Workers, Havana, 1933
Gelatin silver print
5 × 7 inches
The Metropolitan Museum of Art, Purchase, The Horace W. Goldsmith Foundation Gift, through Joyce and Robert Menschel, 1990 (1990.1143)
p. 91

Coal Loader, Havana, 1933
Gelatin silver print
7$\frac{3}{16}$ × 5$\frac{5}{8}$ inches
The Art Institute of Chicago, Gift of Mrs. James Ward Thorne, 1962.165

Camp Nitgedaiget, 1934
Gelatin silver print
5$\frac{3}{4}$ × 8$\frac{11}{16}$ inches
Gary Davis Collection

Demonstration and Picketing Organized by Communists, NYC Waterfront, 1934
Gelatin silver print
6 × 7¾ inches
Gary Davis Collection
p. 92

Breakfast Room, Belle Grove Plantation, White Chapel, Louisiana, 1935
Gelatin silver print
7^{15}⁄₁₆ × 9^{15}⁄₁₆ inches
National Gallery of Art, Horace W. Goldsmith Foundation through Robert and Joyce Menschel, 1989.69.5
p. 93

West Virginia Living Room, 1935
Gelatin silver print
7½ × 9½ inches
High Museum of Art, Purchase with funds from the Atlanta Foundation, 75.45
p. 94

Birmingham Steel Mill and Workers' Houses, 1936
Gelatin silver print
7^{1}⁄₁₆ × 9^{3}⁄₁₆ inches
Museum of Modern Art, Anonymous Fund, 404.1938.7
p. 95

Frame Houses in Virginia, 1936
Gelatin silver print
6¾ × 7^{15}⁄₁₆ inches
The Art Institute of Chicago, Gift of Mrs. James Ward Thorne, 1962.172
p. 96

Frame Houses in Virginia, 1936
Gelatin silver print
5⅜ × 7¾ inches

The Art Institute of Chicago, Gift of Mrs. James Ward Thorne, 1962.173
p. 97

Ferry and Wharf Goods. Vicksburg, Mississippi, 1936
Gelatin silver print
7⅜ × 9⅝ inches
Photography Collection, Miriam and Ira D. Wallach Division of Art, Prints and Photograph,
The New York Public Library, Astor, Lenox, and Tilden Foundations

[Barber Shops, Vicksburg, Mississippi], 1936
Gelatin silver print
7⅛ × 9⅛ inches
The Metropolitan Museum of Art, Purchase, Marlene Nathan Meyerson Family Foundation Gift, in memory of David Nathan Meyerson; and Pat and John Rosenwald and Lila Acheson Wallace Gifts, 1999 (1999.237.1)
p. 98

[Barbershop Façade, Vicksburg, Mississippi], 1936
Gelatin silver print on postcard stock
5^{7}⁄₁₆ × 3^{13}⁄₃₂ inches
The J. Paul Getty Museum, 84.XM.956.306
p. 99

[Barbershop, Mississippi], 1936
Gelatin silver print, printed later
7^{5}⁄₁₆ × 9^{5}⁄₁₆ inches
Bank of America collection
p. 100

Storefronts, Vicksburg, Mississippi, 1936
Gelatin silver print
6⅝ × 9^{1}⁄₁₆ inches
Photography Collection, Harry Ransom Humanities Research Center, The University of Texas at Austin, 968:001:050

Minstrel Showbill, 1936
Gelatin silver print
9½ × 7⅝ inches
National Gallery of Art, Gift of Mary and David Robinson, 1995.35.16
p. 101

Penny Picture Display, Savannah, 1936
Gelatin silver print
8½ × 6¹¹⁄₁₆ inches
Amon Carter Museum, P1987.4.1
p. 102

Barber Shop Interior, Atlanta, 1936
Gelatin silver print
7⅜ × 9⅛ inches
National Gallery of Art, Horace W. Goldsmith Foundation through Robert and Joyce Menschel, 1989.69.8

Houses and Billboards in Atlanta, 1936
Gelatin silver print
6½ × 9⅛ inches
Museum of Modern Art, New York, 303.1963

Alabama Tenant Farmer Wife [Allie Mae Burroughs], 1936
Gelatin silver print
8⅛ × 6 inches
Photography Collection, Harry Ransom Humanities Research Center, The University of Texas at Austin, 968:001:003
p. 103

William Edward (Bud) Fields, 1936
Gelatin silver print
6½ × 5¹⁄₁₆ inches
Photography Collection, Harry Ransom Humanities Research Center, The University of Texas at Austin, 968:001:017

Bud Fields and His Family, Hale County, Alabama, 1936
Gelatin silver print
6½ × 8¾ inches
Photography Collection, Harry Ransom Humanities Research Center, The University of Texas at Austin, 968:001:019
p. 104

Bud Fields and His Family, 1936
Gelatin silver print
7¼ × 8½ inches
Photography Collection, Harry Ransom Humanities Research Center, The University of Texas at Austin, 968:001:064
p. 105

Fireplace and Objects in a Bedroom of Burroughs' Home, 1936
Gelatin silver print
9¼ × 7⅛ inches
Photography Collection, Harry Ransom Humanities Research Center, The University of Texas at Austin, 968:001:009

Sunday Singing, Tingle Family, 1936
Gelatin silver print
5⅛ × 7½ inches
Photography Collection, Harry Ransom Humanities Research Center, The University of Texas at Austin, 968:001:067

Negro Sharecropper's Cabin, 1936
Gelatin silver print
5 × 8⅝ inches
Photography Collection, Harry Ransom Humanities Research Center, The University of Texas at Austin, 968:001:053
p. 106

View of Railroad Station, Edwards, Mississippi, 1936
Gelatin silver print
7$\frac{3}{8}$ × 9$\frac{1}{2}$ inches
Photography Collection, Miriam and Ira D. Wallach
Division of Art, Prints and Photographs,
The New York Public Library, Astor, Lenox, and Tilden
Foundations
p. 107

Margaret Bourke-White

The Towering Smokestacks of the Otis Steel Co., Cleveland,
1927–28
Gelatin silver print
13$\frac{1}{8}$ × 7$\frac{5}{16}$ inches
Museum of Modern Art, Anonymous Gift, 45.1964
p. 133

Pouring Metal, Otis Steel Company, 1927–28
Gelatin silver print
12$\frac{3}{4}$ × 9$\frac{1}{2}$ inches
Margaret Bourke-White Collection, Special Collections
Research Center, Syracuse University Library
p. 134

Mountains of Ore, Otis Steel Company, 1927–28
Gelatin silver print
13 × 9$\frac{1}{2}$ inches
Margaret Bourke-White Collection, Special Collections
Research Center, Syracuse University Library
p. 135

*March of the Dynamos; Hydro-Generators, Niagara Falls Power
Company, 1928*
Gelatin silver print
13$\frac{1}{4}$ × 9$\frac{1}{4}$ inches
Margaret Bourke-White Collection, Special Collections
Research Center, Syracuse University Library

Ore Loading, Great Lakes, 1929
Gelatin silver print
11$\frac{1}{2}$ × 8 inches
Margaret Bourke-White Collection, Special Collections
Research Center, Syracuse University Library

First National Bank, Boston, 1929
Gelatin silver print
12 × 9$\frac{1}{4}$ inches
Margaret Bourke-White Collection, Special Collections
Research Center, Syracuse University Library
p. 136

Watch Hands, Elgin Watch Company, 1929
Gelatin silver print
9$\frac{1}{2}$ × 6$\frac{3}{4}$ inches
Margaret Bourke-White Collection, Special Collections
Research Center, Syracuse University Library

Swift, 1929
Gelatin silver print
13$\frac{1}{2}$ × 9$\frac{1}{4}$ inches
Margaret Bourke-White Collection, Special Collections
Research Center, Syracuse University Library
p. 137

Testing the Heat, Ford Motor Company, 1930
Gelatin silver print
12$\frac{3}{4}$ × 9 inches
Margaret Bourke-White Collection, Special Collections
Research Center, Syracuse University Library
p. 138

A Generator Shell, Dnieperstroi, 1930
Gelatin silver print
13$\frac{1}{4}$ × 9$\frac{1}{4}$ inches
Museum of Modern Art, Gift of the photographer,
154.1974

Early Russia, Dnieperstroi, 1930
Gelatin silver print
19³⁄₈ × 13¹³⁄₁₆ inches
Amon Carter Museum, Gift of James Maroney, Inc., New York, New York, P1980.24

Chrysler Building, New York, ca. 1930–31
Gelatin silver print
5³⁄₈ × 3³⁄₄ inches
The Metropolitan Museum of Art, Ford Motor Company Collection, Gift of Ford Motor Company and John C. Waddell, 1987, 1987.1100.338
p. 139

Hudson River Bridge, ca. 1930–32
Gelatin silver print
13¹⁄₄ × 9¹⁄₄ inches
Margaret Bourke-White Collection, Special Collections Research Center, Syracuse University Library

Rosenbaum Grain Corporation, Chicago, 1931
Gelatin silver print
13³⁄₈ × 9¹⁄₂ inches
Margaret Bourke-White Collection, Special Collections Research Center, Syracuse University Library
p. 140

Airplane Propellers [TWA], ca. 1932
Gelatin silver print
13¹⁄₈ × 9³⁄₁₆ inches
Worcester Art Museum, Worcester, Massachusetts, Gift of Sanford Griffith, 1972.48

Coated Paper Hanging to Dry, Oxford Paper Company, 1932
Gelatin silver print
9¹⁄₄ × 13¹⁄₄ inches
Gary Davis Collection

Chrysler Corporation, 1932
Gelatin silver print
13 × 9 inches

Museum of Modern Art, Gift of the photographer, 149.1974
p. 141

Goodyear Tire and Rubber Company, "Traffic," 1933
Gelatin silver print
12¹⁄₂ × 9¹⁄₄ inches
Margaret Bourke-White Collection, Special Collections Research Center, Syracuse University Library
p. 142

Looking Up inside Sending Tower, N.B.C., Bellmore, L.I., 1933
Gelatin silver print
12⁵⁄₈ × 10¹⁄₄ inches
Addison Gallery of American Art, Phillips Academy, Andover, Massachusetts, Museum Purchase
p. 143

NBC Transmission Coils, 1933
Gelatin silver print
9⁵⁄₁₆ × 13¹⁄₄ inches
Addison Gallery of American Art, Phillips Academy, Andover, Massachusetts, Museum Purchase

Delman Shoes, 1933
Gelatin silver print
9 × 13 inches
Margaret Bourke-White Collection, Special Collections Research Center, Syracuse University Library
p. 144

International Silver, 1933
Gelatin silver print
13¹⁄₂ × 9¹⁄₂ inches
Margaret Bourke-White Collection, Special Collections Research Center, Syracuse University Library
p. 145

Scorched Earth, 1934
Gelatin silver print
9³⁄₄ × 13¹⁄₂ inches

Margaret Bourke-White Collection, Special Collections
Research Center, Syracuse University Library

Drought Area, 1934
Gelatin silver print
9¼ × 13¼ inches
Margaret Bourke-White Collection, Special Collections
Research Center, Syracuse University Library

Fort Peck Dam, Montana, 1936
Gelatin silver print
13 × 10¼ inches
Museum of Modern Art, Gift of Life Magazine, 47.1964
p. 146

Wind Tunnel Construction, Fort Peck Dam, Montana, 1936
Gelatin silver print
13 × 10 inches
Museum of Modern Art, Gift of the photographer,
152.1974
p. 147

Men in St. Louis, Missouri, 1935
Gelatin silver print
9½ × 13½ inches
Margaret Bourke-White Collection, Special Collections
Research Center, Syracuse University Library
p. 148

[Okefenokee Swamp, Georgia], 1936
Gelatin silver print
13½ × 9⅝ inches
Colby College Museum of Art, Gift of Mrs. Helen Caldwell
Cushman, 1964.028
p. 149

[Montgomery, Alabama], 1936
Gelatin silver print
9¾ × 13½ inches

Margaret Bourke-White Collection, Special Collections
Research Center, Syracuse University Library
p. 150

[Caxton, Mississippi], 1936
Three gelatin silver prints
20¾ × 9½ inches, 6¾ × 9½ inches each
Margaret Bourke-White Collection, Special Collections
Research Center, Syracuse University Library
p. 151

[To Heaven or Hell—Which?], 1936
Gelatin silver print
10½ × 13½ inches
Margaret Bourke-White Collection, Special Collections
Research Center, Syracuse University Library
p. 152

[Hood's Chapel, Georgia], 1936
Gelatin silver print
13¼ × 9¾ inches
Margaret Bourke-White Collection, Special Collections
Research Center, Syracuse University Library
p. 153

[Elbow Creek, Arkansas], 1936–37
Gelatin silver print
9¼ × 13¼ inches
Colby College Museum of Art, Gift of Mrs. Helen Caldwell
Cushman, 1964.041

[Nettleton, Arkansas], 1937
Gelatin silver print
13¼ × 10 inches
Margaret Bourke-White Collection, Special Collections
Research Center, Syracuse University Library

[Iron Mountain, Tennessee], 1937
Gelatin silver print
9 × 13¼ inches

Margaret Bourke-White Collection, Special Collections
Research Center, Syracuse University Library
p. 154

*[Clinton, Louisiana], 1937
Gelatin silver print
13¼ × 10 inches
Museum of Modern Art, Gift of the photographer,
140.1974
p. 155

*[Natchez, Mississippi], 1937
Gelatin silver print
9¾ × 13¼ inches
Margaret Bourke-White Collection, Special Collections
Research Center, Syracuse University Library
p. 156

*[Ringgold, Georgia], 1937
Gelatin silver print
6¾ × 9½ inches
Margaret Bourke-White Collection, Special Collections
Research Center, Syracuse University Library
p. 157

World's Highest Standard of Living, 1937
Gelatin silver print, printed later
21⅞ × 28¹⁵⁄₁₆ inches
The Art Institute of Chicago, Gift of Boardroom, Inc.,
1992.560

Waitresses at the New Deal Pool Room, 1937
Gelatin silver print
9⅞ × 13⅜ inches
Gary Davis Collection

*Man Walking across Cofferdams during Construction
of Grand Coulee Dam*, ca. 1937
Gelatin silver print
10¾ × 14 inches
Gary Davis Collection

Cows on Display in the Borden Co. Newly Designed Milking Pens,
1939
Gelatin silver print
10 × 13¼ inches
Gary Davis Collection

Aluminum Company of America Stranding Machine, 1939
Gelatin silver print
13½ × 10 inches
Gary Davis Collection

Page numbers in italics refer to illustrations.

Abbott, Berenice, 1–2, 6, 8, 10–30, 158, 163–75; American Artists' Congress membership, 14, 121, 170, 174; and Atget, 4, 11, 31n23, 81n4, 163, 164, 165, 166, 172; and Bourke-White, 131n55, 163; and Brady, 4, 31n16, 31n23, 164; and "civic documentary history," 29, 34n58, 174; commercial work of, 4, 60 109, 163; and Communist Party, 31n18; and "democratic" image, 21–22; and Evans, 164; in exhibitions, 4, 12, 62, 164–69, 172–74; FAP funding, 5, 23, 65, 159, 170, 173; financial struggles of, 7, 12, 32n30, 108; and "Great Democratic Book," 21–23, 26, 122, 131n52; and Guggenheim Foundation, 12, 18, 32n30, 165, 167, 169–70; labor photographs of, 17–18, 32n26; and McCausland, collaboration with, 12–13, 15, 16–17, 169; and McCausland, personal relationship with, 12–14, 31n13, 31n18, 169; New School teaching position, 12, 168; in Paris, 4, 5, 11, 31n23, 163; portrait of nation project, 15, 18–19, 30n9, 31–32n25, 32n40; race in photography of, 15, 31–32n25; realism and, 5, 10–11, 30, 30n3, 124; relationship to viewer, 10–11, 22, 28, 30; and Richardson, 168, 170–71; scientific inquiry of, 9, 160, 173; seriality in work of, 32n40; and social utility of photography, 21–23, 29–30, 159; talk on "Civic Documentary History," 174; and "usable past," 15, 22, 31n23; in "Women in Photography" short, 175

—PHOTOGRAPHS: *Barn, Halfway House, near Allentown, Pennsylvania*, 20, *20*; *Bread Store, 259 Bleecker Street*, 25, *57*; *Canyon: Broadway and Exchange Place*, 25, *49*, 114; *Coke Ovens, Cascade, West Virginia*, 16–17, *17*; *Construction Old and New*, 23, *51*; *Daily News Building*, 23, *46*; *DePeyster Statue, Bowling Green, New York*, 12, 24, 48; *[Design for Rockefeller Center Mural]*, 42, 167; *Dirt Farmer, Hertzel, West Virginia*, 15, 16; *[Early New York Scrapbook]*, 4, 11, 36–37, 30n9; *"El" Station Interior, Sixth and Ninth Avenue Lines, Downtown Side, 72nd Street and Columbus Avenue*, 25–28, 52; *Flatiron Building, Madison Square*, 24, 59; *Fourth Avenue, No. 154*, 28–29, 34n57, 53, 114; *Hell Gate Bridge*, 12, 58; *Herald Square*, 50; *Hester Street*, 164; *Hooverville, Central Park*, 13, 38; *Lower East Side (Corner Orchard and Stanton)*, 12, 39; *Main Street, Colliersville, TN*, 45; *Manhattan Bridge Looking Up*, 25, 54, *Murray Hill Hotel, ii, 1; Norris Dam, Tennessee*, 18, 32n29, 43; *Portrait of a Miner, Greenview, West Virginia*, 44; *Primitive Cultivation, Arkansas*, 17–18, *17*; *Rockefeller Center*, 12, 18, 41, 166, 167, 174; *Rockefeller Plaza*, 40, 167, 174; *Seventh Avenue Looking North from 35th Street, New York*, 55; *Squibb Building with Sherry Netherland in Background*, 24, 47; *Stanton Street, Nos. 328–332, Manhattan*, 56; *Sunday Afternoon, Colliersville, TN*, 19, *19*; *Tempo of the City: 1, Fifth Avenue and 44th Street*, 23; *Union Square*, 11, 35

—PUBLICATIONS: *Changing New York*, 6, 7, 8, 10, 11, 12, 13, 22, 23–29, 30n1, 33n48, 33nn50–51, 33n56, 34n57, 65, 114, 131n55, 114, 160, 164, 166, 169, 170, 171, 173; "Eugène Atget," 175; *A Guide to Better Photography*, 30n3, 175; "My Favorite Picture," 174; "My Ideas on Camera Design," 174; "Photographer as Artist," 171; "Photography and Science," 173; "The View Camera," 174

Abu Ghraib, 161

Acme Theater, 129n14

Adams, Ansel, 164, 174

Addison Gallery of American Art, 168

advertising: in Abbott's work, 28; as art, 4, 8; and Bourke-White, 109, 111, 114–15, 130n22, 171; in Evans's work, 76–77, 166; and popularization of photography, 3–4

Advertising and Selling (journal), 166

aesthetics, 1; "democratic," 15; documentary, 16, 27, 123, 159–60; industrial, 66, 109–10, 112–13, 130n23; realist, 29, 72

Agee, James: and Bourke-White, collaboration with, 121, 130–31n43; "The Drought," 169; and Evans, collaboration with, 66–67, 78, 121, 160–61, 171, 172; *Let Us Now Praise Famous Men,* 8, 30n1, 67, 121, 122, 123, 131n58, 169, 171, 175; "Life and Circumstance," 123; "Six Days at Sea," 172

agriculture, 10, 60, 167, 169; farmers and workers, 15, 21, 67, 121. *See also* Resettlement Administration/Farm Security Administration

Albright Art Gallery, *Modern Photography at Home and Abroad,* 166

Alexander, Ruth, 175

Alhambra (journal), 164

amateur photography, 3, 15, 170

American Artists' Congress, 14, 121, 170, 174; "Call for an American Artists' Congress," 170

American Communist Party, 31n18, 121, 168, 170

American dream, 159

An American Group, *Roofs for 40 Million,* 173

American Institute of Graphic Arts (AIGA), 169

Anderson, Sherwood, *Home Town: Photographs by Farm Security Administration Photographers,* 175

Andrews, Lew, "Walker Evans' *American Photographs:* The Sequential Arrangement," 82n18

Aperture, 160

Architectural Forum, 166

Architectural Record, 164, 165

Architectural Review, 173

architecture: in Abbott's *Changing New York,* 12, 24, 26–27, 28, 158; and Bourke-White's method, 125–26; destruction of, 12, 25; 33n46, 33n56; in Evans's work, 64–65, 70, 72, 77, 78, 167; industrial, 117; McCausland on 29, 333n56; monuments, 19–20; of New Deal, 6, 18, 32n29; in ruins, 27–29; of rural America, 14, 74; as symbol of modernism, 1

Art Director's Club, 165

Art Front, 170, 171, 172

art photography, 3, 4, 8, 13, 60, 61, 63, 80–81

Atget, Eugène, 4, 11, 31n23, 81n4, 163, 172, 175; in *Atget, photographe de Paris,* 164, 165, 166

audience, 1, 5, 18, 75 ; active, 16, 22, 27–28, 30; affect of, 26, 125, 158; as historical observer, 19, 24, 28, 29; mass, 6, 22, 28, 118, 164; photographer and, 10–11, 16, 18, 72–73, 75–76, 79; photographic subject and, 15–16, 21, 78, 125; reformist, 3; as social agent, 18, 28 , 30, 125

authorial control, 68, 73, 80

avant-garde, 11, 80, 112, 118, 158, 164

Ayer, N.W., and Son, 109, 119, 130n36

Barnes, Djuna, 30n5

Barr, Alfred, Jr., 69, 70, 71; *Art in America in Modern Times,* 169

Barr, Peter, *Becoming Documentary,* 32n50

Barthes, Roland, 161

Beals, Carleton, *The Crime of Cuba,* 167, 169

Bellows, George, 163

Benton, Hart Thomas, 163

Bergreen, Laurence, *James Agee: A Life,* 140–31n43

Bickels, Karl A., *The Mangrove Coast,* 176

Bourke-White, Margaret, 1–2, 8, 10, 30, 108–28, 163–75; aerial photography, 170; and Caldwell, collaboration with, 122, 124, 127–28, 131n51, 171, 175; and Caldwell, personal relationship with, 122, 170, 173; and Chapman, 129n3; cinematic approach of, 110, 113, 118, 124–26; commercial photography of, 7, 60, 65, 108–9, 129n4, 130n22, 171; and Eisenstein, 129n14; in exhibitions, 4, 62, 165–68, 171, 172, 174, 175; films of (*Eyes on Russia* and *Red Republic*), 130n32, 167; at Ford Motor Company, 109, 119, 130n36, 165; *Fortune* work, 114–15, 120–21, 126, 164, 165, 170; Germany visit of, 165, 166–67; industrial imagery of, 4, 6, 62, 66, 108–11, 115, 117–19; museum negotiations by, 61; narrative in work of, 122, 123, 125–26, 128; at Otis Steel, 4, 109–10, 129nn4–5, 163, 169, 170; Parkinson's disease of, 161; as photojournalist, 9, 108, 126, 128, 161; radio talk on "Opportunities for Young Women in Photography," 168; social turn in work of, 108–9, 115, 121, 124–25; Soviet photography's influence on, 5, 112, 114, 115, 129n14; Soviet Union visits of, 120–21, 130n23, 165, 166, 167, 168, 175; White tutorial with,

109; in "Women in Photography" short, 175; World War II coverage by, 9, 161, 174
—PHOTOGRAPHS: *Belmont, Florida*, 21; *Camel Corps, Syria*, 175; *[Caxton, Mississippi]*, 126, 132n69, 151; *Chrysler Building, New York*, 139, 164; *Chrysler Corporation*, 66, 114, 116, 118, 119, 141; *[Clinton, Louisiana]*, 126–27, 155; *Delman Shoes*, 111, 113, 123, 144; *First National Bank, Boston*, 113, 136; *Fort Peck Dam, Montana*, 111, 117, 119, 146, 171; *Generators in Electric Plant*, 111, 111; *Goodyear Tire and Rubber Company, "Traffic,"* 114, 142; *[Hood's Chapel, Georgia]*, 125, 153; *International Silver*, 111, 112–13, 145; *[Iron Mountain, Tennessee]*, 125, 154; *Looking Up inside Sending Tower, N.B.C., Belmore, L.I.*, 110, 143; *Men in St. Louis, Missouri*, 111, 148; *[Montgomery, Alabama]*, 123, 150; *Mountains of Ore, Otis Steel Company*, 66, 110, 124, 126, 135; *[Natchez, Mississippi]*, 127, 156; *New York City*, 114, 114; *[Okefenokee Swamp, Georgia]*, 124, 149; *One Thing Leads to Another*, 171; *Otis Steel Company—Pioneer*, 109, 129n5; *Otis Steel: Open Hearth*, 163; *Pouring Metal, Otis Steel Company*, 110, 134; *[Ringgold, Georgia]*, 127, 157; *Rosenbaum Grain Corporation, Chicago*, 117, 126, 140; *Say, Is This the U.S.A.?*, 131n51, 175; *Scorched Earth*, 121, 123, 123; *The Story of Steel*, 163; *Swift*, 116, 120, 137; *Testing the Heat, Ford Motor Company*, 119, 138; *[To Heaven or Hell—Which?]*, 123, 152; *The Towering Smokestacks of the Otis Steel Co., Cleveland*, 111, 132n70, 133; *200 Ton Ladle, Otis Steel*, 115; *Wind Tunnel Construction, Fort Peck Dam, Montana*, 119, 147
—PUBLICATIONS: "The Drought" (with Agee), 130–31n43, 169; "Dust Changes America," 170; *Eyes on Russia*, 121, 165; *North of Danube* (with Caldwell), 131n51, 173, 174; "Office and Studio of Margaret Bourke-White," 166; *One Thing Leads to Another* (Kelly), 171; "Photographing This World," 171; "Portfolio of Five Industrial Photographs," 164; *Say, Is This the U.S.A.?* (with Caldwell), 131n51, 175; ""The South of Erskine Caldwell Is Photographed by Margaret Bourke-White," 172; *USSR Photographs*, 168; *You Have Seen Their Faces* (with Caldwell), 7–8, 21, 29, 30n1, 120, 122–27, 128, 131nn51–52, 131n58, 132n68, 132n70, 132n79, 149–57, 171, 172
Brady, Mathew, 4, 31n16, 31n23, 70, 164, 167, 171, 172
Brannan, Beverly, 67–68
Bravo, Manuel Álvarez, 65, 169
British War Relief Society, 175

Brooklyn Museum, *International Photographs*, 166
Brooks, Van Wyck, on "usable past," 14–15, 22, 72, 82n16
Browning, Irving, "Women in Photography," 175
Bruehl, Anton, 65, 109, 112, 129n15; *Top Hats*, 113
Burnham, Daniel, 33n46
Burroughs, Allie Mae, 21, 67, 79; in *Alabama Tenant Farmer Wife*, 21, 67, 68, 103, 123
Burroughs family, 67, 79

Cahill, Holger, 15, 22, 30n5, 71, 72; *Art in America in Modern Times*, 169; "Artists of the People," 31n23
Caldwell, Erskine: and Bourke-White, collaboration with, 122, 124, 127–28, 131n51, 171, 175; and Bourke-White, personal relationship with, 122, 170, 173; *North of Danube*, 131n51, 173, 174; *Say, Is This the U.S.A.?*, 131n51, 175; "The South of Erskine Caldwell Is Photographed by Margaret Bourke-White," 172; *Tobacco Road*, 128, 133; *You Have Seen Their Faces*, 7, 21, 29, 30n1, 120, 122, 123, 125, 128, 131n51, 131n58, 132n69, 171, 172
capitalism, 10, 12, 166; in Bourke-White's work, 4, 109–13, 117, 119–21; critiques of, 16, 25, 29, 75, 80; Soule on, 112. *See also* consumerism
Cartier-Bresson, Henri, 65, 170, 167
Case Western Reserve University, 109
Chamberlain, Neville, 174
Chaplin, Charlie, 118; *Modern Times*, 119, 119
Chapman, Everett, 129n3
Churchill, Winston, 174
Civil War, U.S., 4, 31n16, 164, 167, 168
Cleveland Museum of Art, 115
Cold War, 158–59
College Art Association, 172
Collins, Frances, 73
Columbia University Teacher's College, 109
communism, 159, 168; American Communist Party, 31n18, 121, 168, 170; "The Communist Party," 168
The Complete Photographer (journal), 175, 176
consumerism: commodity image, 111–13; illustrated in photography, 109–13, 122; and photography market, 4, 8, 10, 22, 70, 109, 122, 128. *See also* capitalism
Cook, Waldo, 12

191

Cornell University, 109, 129n3

Coronet (magazine), 170

Courter, Elodie, 73

Cowley, Malcolm, 30n5

Crane, Hart, *The Bridge: A Poem,* 165

Creative Art (journal), 164, 165

Cross, Charles, *Picture of America,* 166

cultural memory, photography and, 7–8, 24–25

Curtis, James, 81n7

Daily Worker, 121

Daughters of the American Revolution (DAR), 13

Davis, Stuart, 170

Delphic Studios, 65, 164

democracy, art of, 14–15, 21–22; and American governance, 23, 159; audience participation in, 22, 27–28; "Great Democratic Book" and, 21–23, 26, 122, 131n52

De Peyster, Colonel Abraham, 24

Depression. *See* Great Depression

documentary film, 7, 68

documentary photography, 1–3, 6–7, 158, 161; of Abbott, 29–30, 172; aesthetics of, 16, 27, 123, 159–60; American tradition of, 4, 7, 167; art vs., 69, 80; in art museum, 8, 10, 60–61, 75–76, 79, 160; of Bourke-White, 123–25, 128; ethics of, 7; of Evans, 64, 160; expansion of, in mass media, 4, 8–9, 30n2, 62, 70, 108–9; federally funded, 7, 8; for hire, 60, 65, 158; Kirstein on, 62, 64, 65; McCausland on, 21; narrative in, 115, 124; Newhall on, 172–73; realism and, 11, 15–16, 29; as science, 8–9; social, 3, 14, 62, 108, 128, 159; "straight," 3, 14, 30; technological advancement and, 11, 25, 30n3, 80, 110; temporality of, 64–65

Dovzhenko, Alexander, *Earth,* 125, 125

Draper, Muriel, 165

Drought. *See* Great Drought

Duchamp, Marcel, 30n5

Dust Bowl, 117, 121, 123

Dutton, E. P., 23, 26, 28, 29, 33n48

Eastern Airlines, 170

Edgerton, Harold E., 174

Eisenstein, Sergei, 129n14

Emergency Relief Bureau, 23. *See also* Federal Art Project

Evans, Walker, 1, 2, 10, 60–80, 158, 161, 163–75; and Agee, 66–67, 121, 160–61, 171, 172; and Abbott, 164; and Brady, 70, 171, 172; exhibitions of, 62, 65, 70, 72, 164–67, 170–75 (*see also below,* at MoMA); exposure in work of, 116, 117; FAP work of, 65, 159; film (*Travel Notes*) by, 166; financial struggles of, 108–9; formalism of, 30, 124; *Fortune* work, 160, 168, 171, 172, 173, 175; Hale County Project of, 21, 67, 79, 171; *Hound and Horn* review, 81n4; and Kirstein, 61, 63–65, 69, 73, 164, 165; and Mabry, 69, 170; at MoMA (employment and exhibitions), 4, 60–61, 62, 68, 69–80, 74–75, 82n20, 160, 165, 173; in New York, 5, 9, 163; photographic technology used by, 82n24; postcard project, 70, 81n13, 170; RA/FSA work, 60, 62, 65, 66–67, 68, 70, 170; and Rivera, 167, 168; and Stryker, conflict with, 7, 9n5, 67, 68–69, 79–80, 169, 176

—PHOTOGRAPHS: *Alabama Tenant Farmer Wife [Allie Mae Burroughs],* 21, 67, 68, 79, 103, 123; *[Barbershop Façade, Vicksburg, Mississippi],* 65, 81n7, 99; *[Barbershop, Mississippi],* 65, 100; *[Barber Shops, Vicksburg, Mississippi],* 65, 70, 81n7, 98; *Birmingham Steel Mill and Workers' Houses,* 66, 78, 95; *Breakfast Room, Belle Grove Plantation, White Chapel, Louisiana,* 93; *Bud Fields and His Family,* 78–79, 105, 123; *Bud Fields and His Family, Hale County, Alabama,* 78–79, 104, 123; *[Chrysler Building Construction, New York],* 85, 114; *Coal Dock Workers, Havana,* 64, 91; *Demonstration and Picketing Organized by Communists, NYC Waterfront,* 92; *Frame Houses in Virginia* (frontal), 78, 97; *Frame Houses in Virginia* (profile), 74, 78, 96; *Gothic Gate near Poughkeepsie, New York,* 64, 87; *Greek House, Dedham, Massachusetts,* 64–65, 88; *[Lunchroom Window, New York City],* 64, 84; *Minstrel Showbill,* 76, 101, 123; *Negro Sharecropper's Cabin,* 106; *Penny Picture Display, Savannah,* 70, 71 (detail used as postcard), 74, 102, 123; *People in Downtown Havana,* 64, 90; *Posed Portraits, New York,* 64, 86; *Roadside Store Between Tuscaloosa and Greensboro,* 77, 77; *[S.S. Leviathan, New York City],* 63, 63; *[Street Scene, Vicksburg, Mississippi],* 65–66, 66, 81n7; *Untitled (Brooklyn Shipyard),* 63, 83; *Untitled (Cinema),* 65, 89; *View of Railroad Station, Edwards, Mississippi,* 107; *West Virginia Living Room,* 77, 94

—PUBLICATIONS: *American Photographs* (MoMA catalogue), 8, 21, 29, 30n1, 60, 73, 82n18, 173, 160; *The Bridge: A Poem By Hart Crane,* 165; "Bridgeport's War Factories," 175; "The Commu-

192

nist Party" (with Macdonald and Hellman), 168; *The Crime of Cuba* (Beals), 167, 169; *Let Us Now Praise Famous Men* (with Agee), 8, 30n1, 67, 121, 122, 123, 131n58, 171, 175; "Life and Circumstances" (*Fortune* series), 67, 69, 123; *The Mangrove Coast* (Bickel), 176; "New York City: Four Photographs by Walker Evans," 165; "The Reappearance of Photography," 63; "Three Tenant Families," 67–68, 67, 82n23; "Six Days at Sea" (with Agee), 172; "Walker Evans' Photographic Studies," 165; *Wheaton College Photographs,* 176

everyday life, photography of, 1, 2, 5, 66, 72, 159, 166

Farm Security Administration. *See* Resettlement Administration/ Farm Security Administration

Fascism, 14, 31n18, 121, 170

Federal Art Project (FAP), 15, 159, 160, 169, 171, 172; Abbot employed by, 5, 23, 65, 170, 173; Cahill administration of, 15; Evans employed by, 65

Fields, Bud, and family, 67, 78, 104–5

Fields, Lily Rogers, 79

Film and Photo League, 170

Film und Foto, 164, 165

Fischer, John, 32n40

Flato, Charles, "Mathew B. Brady, 1823–1896," 167

Ford Motor Company, River Rouge Plant, 109, 119, 120, 129n6, 164

Fortune (magazine), 3, 108, 116, 128; Bourke-White employed by, 114–15, 120–21, 126, 164, 165, 170; "The Communist Party," 168; "The Drought," 130–31n43, 169; Evans employed by, 160, 168, 171, 172, 173, 175; "Life and Circumstances" series, 67, 69, 123; and Luce, 3, 114; patronage of documentary photography by, 7, 30n2; "Soviet Panorama," 165

Frank, Waldo, *America and Alfred Stieglitz: A Collective Portrait,* 31n14

Franklin Institute, *Summer: In the Image of America,* 175

Freytag-Loringhoven, Baroness Elsa von, 30n5

Frissell, Toni, 176

Gandhi, Mahatma, 161

Goldberg, Vicki, 130n23

Goldblatt, David, 161

Goodyear, A. Conger, 70, 81–82n14

Goodyear Tire, 114

Graphic Graflex Photography, 174

"Great Democratic Book," 21–23, 26, 122, 131n52

Great Depression, 1, 2, 5–7, 8, 11, 114–15, 168; in Abbott's work, 16; in Bourke-White's work, 108–9, 111, 117, 119, 121, 122, 124, 126, 128; economic effects of, 10, 14, 80, 112, 161, 171; in Evans's work, 80; and industrialization, 108–9; labor and unemployment during, 116, 117, 119, 167; RA/FSA photographs of, 16, 32n40, 62, 169; recovery from, 9, 158, 167; stock market crash and, 5, 12, 108, 113, 163, 164, 166; suffering caused by, 108, 121, 126; toll on photography market of, 65. *See also* New Deal

Great Drought, 121, 123, 130–31n43, 169, 170

Green, Silas, 76

Grossman, Sid, 170

Guggenheim Foundation, John Simon, 12, 18, 20, 165, 167, 171, 174

Hague, Frank, 172

Harper's Bazaar, 173

Hartmann, Sadakichi, 30n5

Harvard Society for Contemporary Art, 4, 62, 65, 69, 163, 164, 165

Havel, Hippolyte, 30n5

Hellman, Geoffrey, "The Communist Party," 168

Hemingway, Ernest, 167

Hine, Lewis, 3, 9n2, 62

Hitchcock, Henry Russell, Jr., 33n48, 168, 170–71

Hollywood, 110, 118, 125, 172

Hoover, Herbert, 167

Hopper, Edward, 70, 163, 167

Hound and Horn, 63, 69, 74, 81n4, 164, 165, 166, 167

I Am a Fugitive from a Chain Gang, 125

Ignatovich, Boris, *Dynamo,* 112, 112

immigration, 3, 10, 32n40

industrialization, 5, 111, 112; in Abbott's work, 18; aesthetic of, 66, 109–10, 112–13, 130n23; in Bourke-White's work, 4, 6, 62, 66, 108–11, 115, 117–19; decline of, 108–9, 128; in Evans's work, 61, 80; image of corporate America and, 115, 120; and industrial landscape, 66, 119, 126; relationship of laborers and machines during, 108–9, 115–16, 117–19, 120–21

Institute of Women's Professional Relations, 174

International Photography, 165

Irwin, Leigh, *This Is New York: The First Modern Photographic Book of New York*, 168

Jacir, Emily, 161

James, Henry, 5, 9n4

Jennings, Oliver and Isabel, 166

Jim Crow laws, 19, 31–32n25. *See also* race

John Becker Gallery, 65, *Photographs by 3 Americans*, 165

Josephson, Matthew, 30n5

Kahlo, Frida, 167

Keller, Judith, 67–68

Kelly, Fred C., *One Thing Leads to Another: The Growth of an Industry*, 171

Kent, Rockwell, 163

Kirstein, Lincoln, 163, 167; *American Photographs* (with Evans), 30n1, 173; on documentary, 62–63, 65; and Evans, 61, 63–65, 69, 73, 164, 165; "Photography in the United States," 169

Korean War, 161

Kulas, E. J., 109, 129n3

Kurtz, Ronald, 31n13

labor, 3, 13, 18; alienated, 16–17; factory work, 32n26, 108–9, 116–17, 118–19 ; in film, 118–19; machine, 111, 115–16; mining, 3, 18, 121; of photography, 4, 60–61, 69, 70, 80; strike, 168; unemployment, 13, 119, 121, 167

Landon, Alfred M., 171

landscape, 17; agricultural, 8, 121, 123, 125; American, 73, 74, 76, 80; "American Scene" and, 5; industrial, 66, 119, 126; urban, 4, 11, 23, 25–26

Lang, Fritz, *Metropolis*, 118

Langdren, Michael, 13

Lange, Dorothea, 10, 21, 62, 169; *American Exodus: A Record of Human Erosion*, 21, 30n1, 128; *Migrant Mother*, 32n40; *Woman of the High Plains*, 22, 22

Lee, Russell, 169

Leica exhibitions, 168

Leitz, E., 168

Lester, Henry M., 174

Levine, Sherrie, 161

Levitt, Helen, 73, 82n18, 160, 172

Levy, Julien, 4, 169

Levy, Julien, Gallery, 65, 166; *Documentary and Anti-Graphic*, 170; *Exhibition of Portrait Photography, Old and New*, 167; *Modern Photographs by Walker Evans and George Platt Lynes*, 166; *Photographs by Berenice Abbott*, 167; *Photographs by Henri Cartier-Bresson and an Exhibition of Anti-Graphic Photography*, 167; *Photographs of New York by New York Photographers*, 166; *Review Exhibition at Our New Address*, 172

liberalism, 29, 159

Library of Congress, 171

Libsohn, Sol, 170

Life (magazine), 3, 10, 117, 119; Bourke-White employed by, 108, 114–15, 128, 161, 171, 172, 174–75; Evans employed by, 76; patronage of documentary photography, 7, 132n79

Light, James, 30n5

Light, Susan, 30n5

Lincoln Electric Company, 163

Little Carnegie Theater, 118

Liveright, Horace, 165

Locke, Edwin, 172

Look (magazine), 30n2, 171

Luce, Henry, 3, 10, 114–15, 121, 163

Lynd, Helen and Robert, *Middletown*, 171; *Middletown in Transition*, 171

Mabry, Thomas, 69–70, 73, 170

Macdonald, Dwight, "The Communist Party," 168

Machado, Gerardo, 167

machine age, 108, 174. *See also* industrialization

MacLeish, Archibald, 10; *Land of the Free*, 30n1, 172

MacMahon, Audrey, 173

Maloney, T. J., 169, 170

Manhattan Camera Club of New York, 175

Marin, Norma, 31n13

Marks, Robert W., "Chronicler of Our Times: In the Hands of Berenice Abbott," 173

Marsh, Neil C., 126

Massachusetts Institute of Technology (MIT), 160

mass media, 7, 8–9; audience of, 6, 22, 28, 118, 164; conventions of, 6, 122, 124, 128; expansion of photography in, 4, 30n2, 62, 70, 108–9; film and, 118; rise of, 2, 80

Mayer, Grace, 12

McCarthyism, 159

McCausland, Elizabeth, 10, 12–29, 31n16; and Abbott, collaboration with, 12–13, 15, 16–17, 169; and Abbott, personal relationship with, 12–14, 31n13, 31n18, 169; on architecture, 29, 33n56; "The Barns Travel West," 15, 19; *Changing New York* and, 131n55, 173; on documentary photography, 21; "Dusk over America," 15, 17; "Great Democratic Book" and, 21–23, 26, 122, 131n52; Guggenheim foundation and, 32n30, 170; "Photographic Books," 32n35, 33n51; "The Photography of Berenice Abbott," 32n26, 169; and portrait of a nation project, 15, 18–19, 30n9, 31–32n25, 32n40; *Springfield Republican* work, 12–13, 31n10, 169; "Stieglitz and the American Tradition," 31n14; "usable past" and, 32n29

McMahon, Audrey, 33n48

memory, cultural, 7–8, 24–25

Millay, Edna, 30n5

Millay, Norma, 30n5

Miller, Dorothy, 71

Miller, Lee, 65, 167

Mitchell, W. J. T., 32n38

modern artist, ideal of, 60, 68, 69, 80–81, 158, 171

modernism, 1, 5, 6, 10; representation of American, 109–10; European, 71–72, 158; MoMA and, 71–72, 82n16; Mumford on, 111; realist, 29; Terry Smith on, 130n23

Moholy-Nagy, László, *Maleri, Fotographie, Film*, 165

Morgan, Willard, 173, 174

Mumford, Lewis, 8, 33n48, 111, 119; *America and Alfred Stieglitz: A Collective Portrait*, 31n14

Museum of the City of New York, 12, 166; *New York Photographs by Berenice Abbott*, 169; *Changing New York*, 172

Museum of Modern Art (MoMA), New York, 164, 168, 170–71; American modernism and, 71–72, 82n16; Barr at, 69, 70, 71; Department of Photography, 159, 169; Evans employed by, 4, 60–61, 62, 69–71, 72, 79–80, 170; founding of, 62; Newhall at, 8, 131n60, 159, 169

—EXHIBITIONS: *African Negro Art*, 70, 170; *American Folk Art*, 71, 72; *American Sources of Modern Art*, 71; *Art in Our Time*, 174; *The Bitter Years*, 159; *The Family of Man*, 159; *Fantastic Art, Surrealism, and Dada*, 70, 171; *Homer, Ryder, Eakins*, 71; *Machine Art*, 168; *Murals and Photomurals*, 166; *New Horizons in American Art*, 171; *Photography 1839–1937*, 172; *Sixty Photographs*, 159, 175; *Walker Evans: American Photographs*, 4, 60, 61, 62, 68, 72–80, 81, 74–75, 82n18, 82n20, 82n23, 173; *Walker Evans: Photographs of Nineteenth-Century Houses*, 167

Museum of Peaceful Arts, *Men and Machines*, 165

Museum of Science and Industry, *Summer: In the Image of America*, 175

museums: exhibition of photography, 2, 4, 6, 10, 65, 160; patronage of documentary photographers, 4, 60–61, 62, 69–72, 79–80, 173. See also *specific museums*

Nadar, Félix, 116

The Nation, 121, 170, 171

National Alliance of Art and Industry, *Exhibition of Photographs for Art and Industry*, 167

National Association for the Advancement of Colored People (NAACP), 13

nationalism, 14, 23, 76

Nation's Business, 163

Nazism, 161

NEA and Acme Newspictures, 171

New Bedford Strike, 13

New Deal, 5–6, 8, 29, 78; Federal Art Project (FAP) and, 5, 15, 159, 169; Resettlement Administration/Farm Security Administration (RA/FSA) and, 5, 8, 9n5, 30, 65, 76, 159; Roosevelt and, 5, 62, 167, 169; Tennessee Valley Authority (TVA) and, 32n29; Works Progress Administration (WPA) and, 15, 169, 171. See also Great Depression; *individual federal projects*

Newhall, Beaumont, 169, 174; "Documentary Approach to Photography," 172–73; *Photography*, 8, 70, 131n60, 159, 172, 174; *Sixty Photographs*, 159

New Masses, 121

New Republic, 112

New School for Social Research, 12, 168

"New Vision," 164

New Worker's School, 167

New York, 9, 23, 33n50, 36–37; as art world center, 4, 5, 8; Brooklyn Bridge, 63, 163; built environment of, 10, 12, 24; Central Park, 13, 38; Chrysler Building, 85, 114, 139, 164, 165; Daily News Building, 46; development of documentary photography and, 8; Flatiron Building, 24, 33n46, 59; Greenwich Village, 11, 15; Herald Square, 50; Lower East Side, 3, 12, 39; modernization of, 1, 23–24, 25, 34n57; Rockefeller Center, 12, 16, 41–42, 167; Union Square, 35; Wall Street, 1, 25, 164; World's Fair (1939), 26, 174

New Yorker, 8, 168

New York Historical Society, 12

New York Post, 122, 131n58

New York Public Library, 26

New York Times, 167, 175; magazine, 120, 166

Nickel, Douglas, "*American Photographs* Revisited," 82n18

Ninas, Jane Smith, 169, 176

Nixon, Herman Clarence, *Forty Acres and a Steel Mule,* 172

Norris Dam, 8, 32n29, 43

O'Keeffe, Georgia, 163

O'Neill, Eugene, 30n5

Otis Steel, Bourke-White at, 4, 109–10, 129nn4–5, 133–35, 163, 169, 170

Outerbridge, Paul, 109

Paris, 11, 31n23, 62, 116, 163, 165, 174

Park, J. Edgar, 176

Parks, Gordon, 132n79

Parnassus, 172

Pearl Harbor, 163, 176. *See also* World War II

Peet, Creighton, 167

Pennsylvania Museum of Art, *Philadelphia International Salon of Photography,* 166

Pentecostalism, 123

Philadelphia Record, 122

photo-book, 7–8, 10, 30n1; "democratic" appeal of 21–23, 26, 122, 131n52; emergence of, 166; McCausland on, 32n35, 33n51; reader of, 29, 30; and popularity of documentary photography and, 60, 76; publishing industry and, 23; text

and image relationship, 20–21, 28. *See also* Abbott, Berenice, publications: *Changing New York;* Bourke-White, Margaret, publications: *You Have Seen Their Faces;* Evans, Walker, publications: *Let Us Now Praise Famous Men*

photo-essay, 32n38, 167, 168, 171, 175

photographer: as artist, 60, 69; audience and, 10–11, 16, 18, 72–73, 75–76, 79; gendering of, 117; photographic subject and, 19, 64, 79, 116–17, 127; race and role of, 15–16, 132n79

photographic enlarger, 82n24

Photographic Society of America, 175

photojournalism, 9, 108, 126, 128, 161

Photo League, 170, 174

photomontage, 4, 174

Pictorialism, 3, 62, 63

Pictorial Photographers of America, *Exhibition of Photographs for Art and Industry,* 167

PM (magazine), 174, 175

Popular Front, 31n18, 170. *See also* American Communist Party

Popular Photography (magazine), 171, 173, 174

Porter, Eliot, 160

portraiture, 4; by Abbott, 11, 12, 13, 62, 65, 163; by Bourke-White, 121; by Evans, 7, 21, 64, 67, 68, 78–79, 86; posed vs. unposed, 64, 65, 81n7

poverty, 5, 80, 124, 159; and American identity, 77; on display in art museum, 8, 75; social documentary photography and, 3

progressivism, 24, 74; and New Deal, 5, 18, 69; and social documentary photography, 3, 6, 62

publishing industry: competition between photographers and, 131n58; ownership vs. authorship and, 8; photo-book market and, 23; popularity of photography and, 3–4, 5; revision of *Changing New York* and, 26–29

Purdue University, 109, 129n3

Raad, Walid, 161

race, 3, 10, 123; in Abbott's work, 15, 31–32n25; Jim Crow laws, 19, 31–32n25; of photographer, 15–16, 132n79; social construction of, 76

Raeburn, John, *A Staggering Revolution: A Cultural History of Thirties Photography,* 131n56

Ray, Man, 30n5, 167, 174

Realism, 5, 16; defined, 10–11, 15, 26, 29, 30, 30n3, 159

Recht, Camille, *Die alte Photographie,* 164

Reed, Alma, 164

Reed, Joseph Verner, 168

Renger-Patzsch, Albert, 81n4

Resettlement Administration/Farm Security Administration (RA/FSA), 5, 8, 9n5, 21, 72; *The Bitter Years,* 159–60; Depression imagery of, 16, 32n40, 62, 169; *Documents of America,* 173; Evans employed by, 60, 62, 65, 66–67, 68, 70, 170; *Forty Acres and a Steel Mule,* 172; *Photographs by Farm Security Administration Photographers,* 175; photography project of, 30, 76, 77, 80, 132n79, 160; under Stryker, 7, 67, 159, 169, 176; *Summer: In the Image of America* exhibition, 175; under Tugwell, 5, 160

Richardson, H. H., 168, 170–71

Riis, Jacob, 3, 9n2

Ringel, Fred J., *America as Americans See It,* 166

Rivera, Diego: *Man at the Crossroads,* 167; *Portrait of America,* 167, 168

Rodchenko, Aleksandr, 114

Roh, Franz, 81n4

Roosevelt, Franklin D., 5, 62, 167, 169, 171, 175. *See also* New Deal

Rosskam, Edwin, *12 Million Black Voices,* 176

Rothschild, Lincoln, 33n48

Rothstein, Arthur, 62, 169

Russian Constructivism, 5

Ruttmann, Walther, *Symphony of a Great City,* 118

Saab, Joan, *For the Millions: American Art and Culture between the Wars,* 82n16

Sacco, Ferdinando Nicola, 12

Sandburg, Carl, 159

Sander, August, 81n

Scholle, Hardinge, 12, 166

Scientific American, 120

Scribner's (magazine), 173

Seldes, Gilbert, *This Is New York: The First Modern Photographic Book of New York,* 168

Shahn, Ben, 62, 165, 169

Sheeler, Charles, 109, 115, 129n6, 130n23, 130n36

Sherman, Cindy, 161

Siskind, Aaron, 160

Smith, Terry, 130n23

Smith College, 73

socialism, 159, 168

Sommer, Frederick, 160

Soule, George, 112

Soviet Union: art of, 112, 114, 125; Bourke-White and, 5, 116, 117, 118, 120–121, 130n23, 165, 166, 167, 168, 175; Consulate, 168; Five-Year Plan in, 121; German invasion of, 175; socialist promise of, 159

Springfield Republican (periodical), 12, 31n10, 169

Stalin, Joseph, 165, 175

Stange, Maren, *Symbols of Ideal Life,* 32n40

Steedley, Lizzie, 124

Steichen, Edward, 81n4, 159, 169, 173, 174

Steiner, Ralph, 109, 165, 172, 174

Stieglitz, Alfred, 3, 13, 63, 80, 159, 166

stock market crash of 1929, 5, 12, 13, 108, 113, 163, 164, 166

Stomberg, John, 132n72

Stott, William, *Documentary Expression and Thirties America,* 131n56

Stowe, Harriet Beecher, *Uncle Tom's Cabin,* 122

"straight" photography, 3, 14, 30

Strand, Paul, *New York,* xiv, 1

Stryker, Roy, 32n40, 174; conception of documentary photography, 69; "Documentary Photography," 176; and Evans, 7, 9n5, 67, 68–69, 79–80, 169, 176; RA/FSA, administration of, 67, 159, 169

Sundell, Michael, 1, 19

Survey Graphic (magazine), 30n2, 76, 175

Taft, Robert, *Photography and the American Scene,* 5, 9n4, 173

Taylor, Paul, *American Exodus: A Record of Human Erosion,* 21, 30n1, 128

Tennessee Valley Authority (TVA), 32n29. *See also* New Deal

Time (magazine), 3, 160

Tingle family, 67, 79

Trachtenberg, Alan, *Reading American Photographs,* 82n18, 82n23

Trade Winds (magazine), 120, 129n4

Transition (magazine), 164

Trans-World Airlines, 170
Trend (magazine), 13, 169
Tugwell, Rexford, 5, 160

Union Trust Company of Cleveland, 120, 129n4
University of Michigan, 109, 129n3
urbanization, 8, 10, 23, 24
USA (journal), 165
"usable past," 14–15, 16, 22; Abbott and, 31n23; Brooks and,
 72; McCausland and, 32n29
U.S. Air Force, 161
U.S. Camera, 169, 170, 171, 172, 173, 174, 175
U.S. Civil War, 4, 31n16, 164, 167, 168
U.S. Congress, 6
U.S. Department of Agriculture, 169
U.S. Office of War Information, 159
U.S. War Department, 4, 171

Van Gogh, Vincent, 72
Vanity Fair (magazine), 166, 167
Vanzetti, Bartolomeo, 12
Variétés, 164
Vertov, Dziga, 118; *Man with a Movie Camera,* 112, 130n32
viewer. *See* audience

Walker, Hudson D., Gallery, 172
Walker, John, III, 163
Warburg, Edward, 163

Weber and Heilbroner, 112
West Coast waterfront strike, 168
Weston, Brett, 174
Weston, Edward, 164, 171
Weyhe Gallery, 65, 164
Wheelwright, John Brooks, 64, 165
White, Clarence, 109, 129n15
Whitney Museum of American Art, 72
Wolfe, Bertram D., 168
Women's Radio Review, 168
Worker's Film and Photo League, "History of Russian Film,"
 129n14
Works Progress Administration (WPA), 15, 169, 171
World's Fair: New York (1939), 26, 174; San Francisco (1940), 174
World's Work, 166
World War I, 62
World War II, 11, 72, 159, 174; American Communist Party
 and, 31n18; Battle of Britain, 175; Blitzkrieg, 174; bombing
 of Soviet Union, 175; Bourke-White's coverage of, 9, 161,
 174; Great Depression and, 9, 158; Pearl Harbor, 163, 176;
 U.S. entry into, 158, 176
Wright, Frank Lloyd, "The Tyranny of the Skyscraper," 165
Wright, Richard, 10; *12 Million Black Voices,* 30n1, 176

Yale University, 160; *The Urban Vernacular of the Thirties* exhibi-
 tion, 168
Yochelson, Bonnie, 11, 13, 33n48
Young, Stark, 79

TEXT: 8.5/15 CAECILIA
DISPLAY: ROCKWELL EXTRA BOLD
DESIGNER: SANDY DROOKER
PRODUCTION COORDINATOR: PAM AUGSPURGER
COMPOSITOR: INTEGRATED COMPOSITION SYSTEMS
PREPRESS: IOCOLOR
PRINTER: FRIESENS